Decorative Ironwork — Wrought Iron Latticework, Gates, & Railings

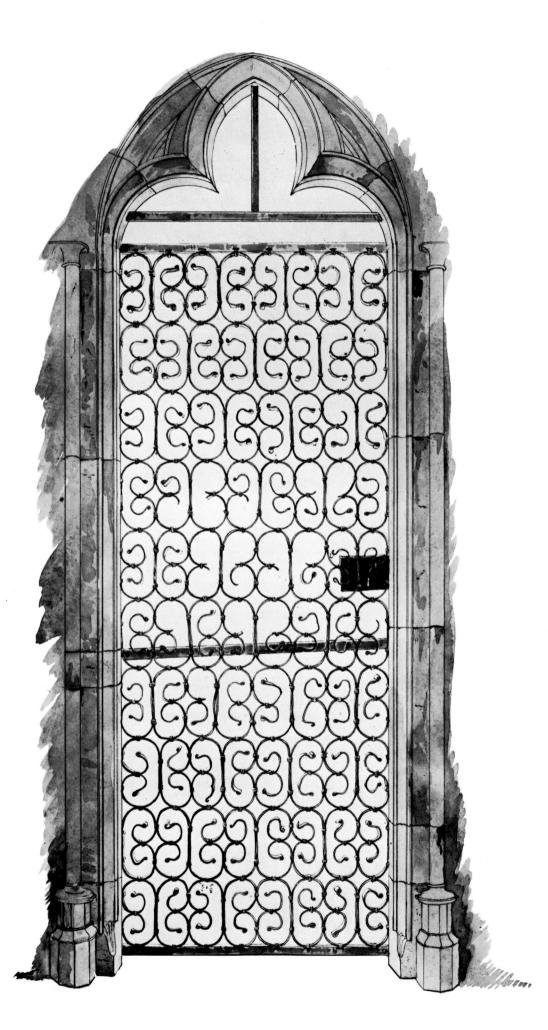

Gate to the Chapel of St. Anselm, Canterbury Cathedral, ca. 1333.
Victoria and Albert Museum, London.

Margarete Baur-Heinhold

Decorative Ironwork

Wrought Iron Latticework, Gates, & Railings

Schiffer *Publishing Ltd*

77 Lower Valley Road, Atglen, PA 19310

Library of Congress Cataloging-in-Publication Data

Baur-Heinhold, Margarete.
 Decorative ironwork--wrought iron latticework, gates,
railings / Margarete Baur-Heinhold.
 p. cm.
 Includes bibliographical references and index.
 ISBN 0-7643-0036-9
 1. Ironwork--Europe--History. I. Title.
NK8242.B38 1996
739.4'7'4--dc20 96-9448
 CIP

Printed in the United States of America

ISBN: 0-7643-0036-9

Translated by Dr. Edward Force, Central Connecticut State University
Dust jacket design: Baur & Belli Design, Munich, utilizing illustra-
tion #225.

1996 Book Design by Michael William Potts.

Published by Schiffer Publishing, Ltd.
77 Lower Valley Road
Atglen, PA 19310
Phone: (610) 593-1777
Fax: (610) 593-2002

Please write for a free catalog.
This book may be purchased from the publisher.
Please include $2.95 for shipping.
Try your bookstore first.

We are interested in hearing from
authors with book ideas on related subjects.

Contents

History, Techniques, Basic Forms 7

Development of Types, 12th to 20th Century 19

New Times, Old Forms, New Forms 44

Illustrations 45

Bibliography 173

Photo Credits 174

Index 175

History, Techniques, Basic Forms

Man invented the fence for protection. When this may have happened can no longer be determined exactly.

The iron fence, of which we are speaking here exclusively, first appeared in the twelfth century. The reason for the lack of earlier evidence may be found first of all in the susceptibility of the material to weather influences, as well as in the possibility of melting down iron and turning forms that have fallen out of fashion into those that suit a new era.

Even when man had learned over the course of centuries to give an impression of swinging lightness through filigreed delicacy and to turn the protection into a decoration, the purpose nevertheless remained unmistakable. Window bars, doors and gates, the entries and choir grids of churches, the honorific gates of castles and royal residences, park fences and fountain gratings all protect life and property. In bygone days, fences also protected the peace of the dead, whether around a grave in the open or as the gate to a mausoleum.

Grids that separate spaces can also be regarded as protection in a broader sense. On the one hand, they protect the spheres of living, eating and working space in private life. They give the feeling of snugness, the private atmosphere in guest areas and maintain the extent of the space, not dividing it into fragments. The view is free, but at the same time, the areas for various activities of life, for the smaller society, are created.

A Brief Historical Introduction

The knowledge of how to obtain and work iron did not, of course, come in one stroke, but was preceded by developments extending over thousands of years. The Iron Age thus indicates an epoch of human history that practically all peoples have gone through, but that did not arrive for them all at the same time. It was preceded by the Bronze Age, in which man had learned to produce alloys of copper and tin.

Like a great many achievements of stages of cultural development, the ability to work iron probably emerged first in the Near East, in Egypt and Mesopotamia. It is generally known that there were times when iron was considered more valuable than gold. Several pearls or drops have been found in Gerzah, Egypt. They were dated to the time around 3500 B.C. and, like objects found in Mesopotamia, are made of meteoric iron. This material, fallen from the heavens, may have had magical powers ascribed to it. Therefore it can be assumed that these pearls of iron were worn not only as jewelry, but — above all else — as amulets.

Another of the earliest known examples of cast iron was also found in Mesopotamia. This was a dagger blade, only partly remaining, that was dated to about 2800 B.C. The weapon indicates that man had learned to melt iron. But research has also shown that even in these oldest cultural lands, in the second century before Christ, the use of iron to a greater extent cannot be assumed. It is nevertheless indicated as possible that at the end of that milennium a genuine iron industry was being built up.

From Mesopotamia and Egypt, the knowledge of iron production and its appropriate working probably moved to Greece and the

1. Rodericus Zamorensis, Mirror of Human Life, circa 1475.

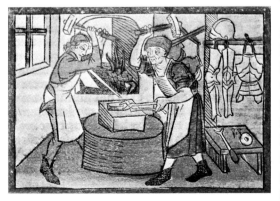

Aegean Islands only at the beginning of the first century, and from there it spread into all of Europe. In the sixth century B.C., the preparatory process may well have been finished in central Europe and the Mediterranean area.

Now that the obtaining and working of iron in large quantities was possible, and there was no further link with the meteorites that fell from the heavens, iron no longer had any magical, supernatural significance. It became the material for utensils, and in all the centuries for which we have knowledge of this material and its utility, iron jewelry may have a certain magical siginficance only during World War I [in Germany when iron jewelry was made in exchange for gold jewelry that was donated to the government for the war effort- ed.]. "I gave gold for iron," it was said: the gold was sacrificed, the iron became a symbol of the sacrifices of women for the fatherland, and thus for husbands, sons and grandsons.

Even though the technique of smelting and working iron may have been widespread in Europe since the sixth century B.C., yet no objects have survived from the early times except a few tools found in excavations here and there. Although they were very much rusted, indeed almost destroyed, it is still possible to define them as to material and use. There are weapons such as knives and arrowheads, but also plowshares and similar tools. They can be dated approximately on the basis of the ceramics found with them.

Next to the potter, the smith is the oldest artisan. In the antique world, handiwork was largely the job of slaves and thus not very highly respected. This changed with the dawn of the Middle Ages. Numerous cloisters required handicrafts of the monks as a rule of their order: "ora et labora". In the later Middle Ages, a free bourgeois ironworking industry was built up in the growing cities, and regulated by firm, strict guild rules.

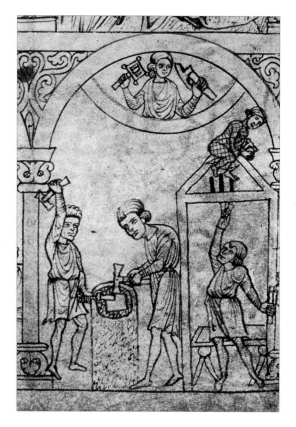

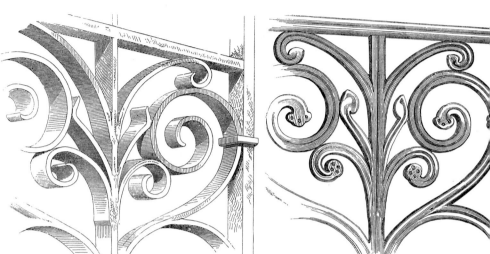

The monastery and church schools taught the seven liberal arts, the "artes liberales" — grammar, rhetoric, dialectic, arithmetic, geometry, astronomy and music. Along with them, the "artes mechanicae" were established in the twelfth century. Hugo von St. Victor made up a list of them around 1130: weaving, weapon smithing, seafaring, agriculture, hunting, medicine and drama. For the "weapon smithing" it was explained that this also included construction work and blacksmithing, and these tasks were divided into forging and casting work.

There were, in turn, several branches of the smith's handiwork which were organized into guilds: crude smithing, nail, horseshoe, instrument and hammer smithing, as well as gunsmithing. The guilds punished any venture into another guild's territory with heavy fines, which could culminate in the loss of a man's right to practice a handicraft. In the smaller cities, the occupations practiced in the past lived on into the twentieth century in the names of houses.

Technique and Restoration

Technical details can be omitted here. The smith knows his occupation; he was an apprentice, is a journeyman or master, he has learned his craft with hammer, anvil and the fire of the forge. Someone strange to the pro-

fession should allow himself the pleasure of watching a smith at his work. He will be able to learn that nothing has really changed since man learned to work iron.

The legends tell of Hephaistos, the artistic smith of the gods, whose forge did not glow any differently than they do today, and whose artistic weapons and armor were likewise shaped on the anvil with hammer and tongs. On Greek vase illustrations, the tools are not shown differently — with the exception of the shape of the anvil — than they appear today. A powerful man swings the hammer with his right hand, while his other hand, or maybe an apprentice, holds the piece of work with the tongs. The shape of the forge may have changed, and perhaps that of the water trough too, into which the piece of work is dipped to cool it; in any case, the elements remain the same.

Since long ago, then, iron has been brought to red heat in the forge — a special type of coke is needed to do it — and beaten with a hammer as long as it remains red-hot, then cooled, heated and hammered again. The processes are repeated until the iron achieves the desired quality. Through this process of heating, striking and cooling, the iron, coarsely crystallized in its crude state, is changed to a finely crystallized state, a physical process whose impor-

tance was known already in the early days of ironworking. The iron becomes more elastic in this manner, it can be stretched and bent more easily, and at the same time it is made less breakable. Much is prepared in advance nowadays, but the last fine work, the final preparation, still remains a handicraft to this day, requiring heating, hammering and shaping.

Early in the fourteenth century, the drawing of wire was invented, so that the smith could work on the finer parts with components already prepared.

Of the three main tools, anvil, hammer and tongs, only the anvil changed essentially with the refinement of the smithing technique. The German word *Amboss* comes from the Old High German *anaboz*, meaning "what one strikes on." The verb *bozan* meant "to strike". At first the anvil was only round or square, and in the Bronze and early Iron Ages the striking surface was made of stone or bronze, but since the Latène era it was made of iron. The present-day form with the side horns has been developed since the early Middle Ages. At first there was just one round horn, which appears to have been intended for making iron rings. The change to a short horn came in the 18th century, and can be seen in an 1850 copperplate.

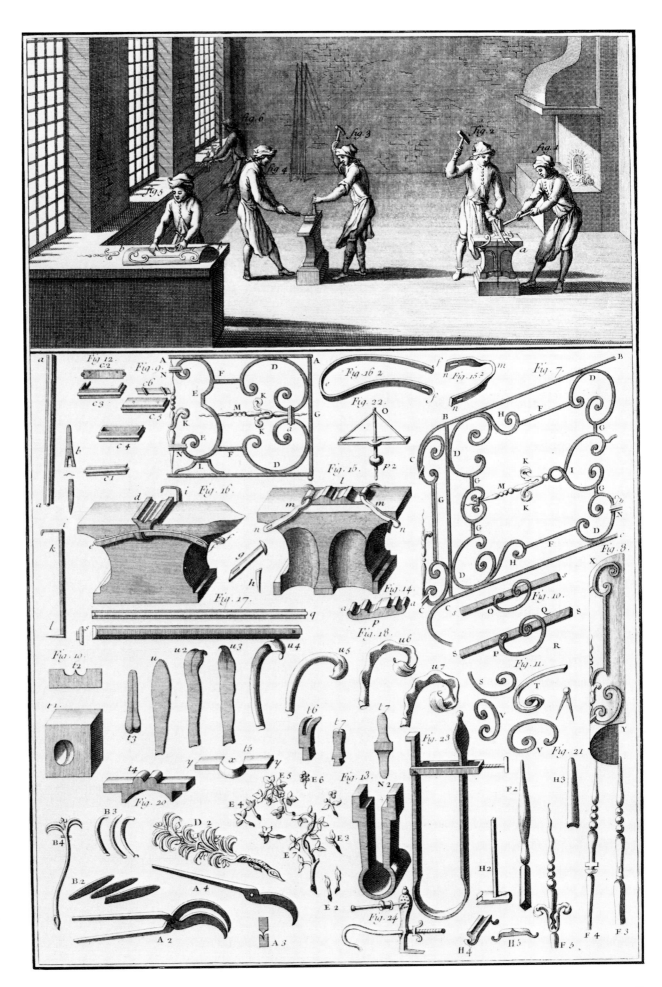

4. Duhamel du Monceau, Art du Serrurier, 1767, forging in stamps.

The form of the present-day anvil includes all the aids that the smith needs. On the horns, the square, round or flat rods supplied by the iron industry can be bent into the intended, desired shapes; rings and pipes can be put together.

The technique of the smith has changed in only one minor detail. Instead of using only coke, a special smithing coal is also used, and where one large fire used to provide heat to several smiths at the same time, now several small forges burn. They save steps and thus save time. Several hoods and protectors also provide for greater safety.

To cool the pieces of work, there is now a depression in the anvil. The anvil itself stands on a wooden block, so that the hardness of the hammer blow is somewhat absorbed by the nature of the wood.

Among the smith's equipment, there is also a bending device, on which the rod can be bent or stretched.

To enlighten the admirer of wrought iron, a few terms might well be explained. Out of the industrially prepared rods, thickened bars are made by heating and cooling. The bar can then be pierced at the thickened point and a second bar can be pushed through it. The result is a three-dimensional effect, a play of light and shadow, that constituted the only ornamentation of the earlier undecorated grids of diamonds, squares and rectangles.

In the Renaisaance, additional decorations were included: circles or plant ornamentation that was likewise pierced, so that the liveliest play of shadows developed a relief-like effect on the inherently flat gratings.

Branchings of the rod offered the possibility of having flat bars grow out of the rod like plants, and they could be rolled into spirals or simple curves.

The staff can also be split and then twisted in the vise with turning irons or fire tongs. Dividing the rod into four sections results in a motif that appears again and again in the Renaissance, either alone or in connection

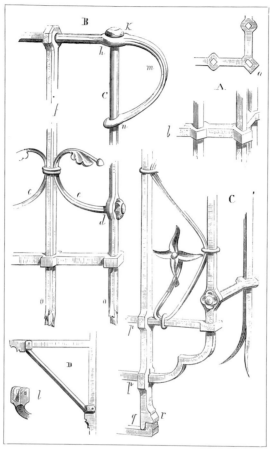

with the cross- flower. This flower came into being in the Gothic era, but was still used frequently for decoration in the Renaissance, especially for the top of the grating. The spindle can be made out of the rod by branching, as described above, but it can also be made by welding together, and appropriate bends or arched bulges of four rods can be produced. The shaping was done over a wooden pattern, which was then burned away.

Additional decorations made by cutting out, notching and ribbing, engraving and chasing, can be applied to the rods as to the attached ornamental parts. This creative work can be observed particularly well on the cemetery fence in Lenggries (#219, 220).

To put the individual parts together to form a grating, it was necessary, apart from perforation, to use various techniques which likewise remained the same over the centu-

ries, only being used more or less often in the individual epochs; they emerge and then fade into the background again, depending on the ornamental style of the epoch.

The simplest form of attachment is riveting. Rivets in their basic form can have either flat or round heads, forming in this way a strict decoration, or they can be made into particular ornamentation by being made with rosettes in a number of more or less imaginative shapes.

A further means of uniting the individual parts is by linking them. They can be attached with simple pieces of flat iron, or they can be jointed and have decorative elements added. They add a lace-like character to the strictly geometrical four-angled shapes, as on the Scaliger graves at Verona. The links played a major role in the early days, until the end of the Renaissance, in terms of decoration, means of jointing, and technical necessity. In the Baroque era, since the gratings appeared to negate the heaviness of the material, and since their shapes made it look all but impossible for them to have been created with a hammer, these links disappeared for the most part.

The decorative elements such as plants, flowers, garlands, shells and rocailles were welded on. The thickening of the binding would only have disturbed the elegance of the fluid effect. Some of the earliest pieces still remaining from the twelfth century are on the cathedral at Le Puy (#44). In the abbey of Ourscamp (#6) from the thirteenth century are the plantlike growth of curves and spirals from a stem.

To decorate the gratings, along with the simple basic forms, there are also shapes made of sheet iron which were added to the gratings around shrines very early in the Gothic era. They could be cut and painted, also cut in relief form, usually had color added, or they were engraved, chased or etched. Punches were used as well as files, awls or chisels, depending on the delicacy of the work.

In the Alpine area, cutout sheet iron remained popular until well into the 18th century. It enjoyed its widest extent and most frequent use in the Renaissance and Baroque eras, times when this type of art had long since been given up in France. The German gratings were always considerably more dominated by motifs and patterns than the works of Italy or France.

Frequently used ornamentation was produced in a drop forge. The shape was cut into a block of iron, and the raw material was beaten into it either hot or cold. The excess material could be carried away in a canal, or taken off to the side. Individual decorative parts, though, such as rosettes on rivets, were not made in a drop forge alone, even in the early days, but were also cast, usually in light alloys.

Sometimes it is not easy to tell forged and cast iron apart, especially when they have been worked very carefully afterward. Here the non-expert can easily be deceived. The great days of cast iron, of course, began only with the Industrial Age which saw massive park fences produced in the middle of the nineteenth century.

No gratings, as noted above, have survived from before the year 1000. The first specimens come from the twelfth century, are religious in nature, and were made for interior use. These are essentially the protective grids around shrines and tombs. The susceptibility of iron to rust causes much destruction and even affects materials in interiors when dampness can reach them.

That there must have been gratings made of iron as early as the Carolingian era, the eighth and ninth centuries, is suggested by the bronze gratings in the palace chapel at Aachen, which were made at the end of the eighth century. Bronze casting was promoted by Charlemagne, who had a bronze works established in Aachen. It was famous for its

products until the leadership in the art of bronze casting passed to Hildesheim under Bishop Bernward in the eleventh century. At the time of the Carolingian gratings from the palace chapel, ironworking must already have attained such a high level that similar gratings could have been forged of iron, but they simply have not survived.

Protiective Coatings / Restoration

Every object made of iron must be given a protective coating; otherwise it will rust and decompose in a short time. Maintenance and restoration are more important than ever today, whether for the small grid on a balcony, the garden gate in the yard of a private home, or the big gratings of bygone epochs.

Minor rust damage can be removed with emery paper or a wire brush. After thoroughly removing the rust — not the slightest bit must be left, otherwise the rust will eat away the iron under the protective coating — the iron should be painted with minium, the preserving red lead that was formerly in general use. After that, the special paint for iron is applied in the desired color. Two coats are recommended. This work can be done on the spot and call for no prerequisites except care and patience.

The restoration of large gratings with considerable rust damage should be done in a workshop. The grating must be removed, and must usually be dismantled into its components. Then it is cleaned with sandblast and file. Only thus can the extent of the rust damage be determined exactly. If parts have already been rusted through, they must be removed. Copies based on available intact pieces must be made and then attached. After completion and assembly, the grid is cleaned again by sandblasting and then given a close examination. Once again, one must be sure that even the smallest bits of rust have been removed, so that no consuming rust un-

der the protective coating will ruin all the expensive work. The conservation of the object would then not last very long.

The large objects, particularly the complicated, branched gratings, are zinc-plated today. This corrosion protection can be applied more easily than minium with modern procedures. The zinc bath and the spraying process reach the smallest angles, thus providing an unbroken protective coating. Applying minium with a brush is considerably more troublesome and takes up a great deal more time, as well as including the danger of the protective coating not being completely solid. The corrosion protection of zinc should last twenty to thirty years. After being zinc-plated, the iron is coated twice with special paint.

Color

Fences are usually painted one color today, either black or iron gray. The color of iron in a natural state is a bright, gleaming silver, but in air it darkens to a gray that is often called "iron gray". The protective coating is applied either in a similar shade or in black.

Not all fences, though, were painted a single color from the beginning. On the contrary, bright colors were generally used from Gothic times, as far as the remaining examples let us conclude, to the era of Classicism, which extensively rejected bright colors. Flower grids were often painted in natural colors, and the bearing and supporting pieces were also painted in various colors, while decorations in bright colors and particularly in gold were used extensively. Gratings inside buildings are still found with original, or at least copied, multicolored painting. One of the finest examples of a multicolored grating is the rose grating in Stams, in the Inn Valley, which likewise continues the use of color in interiors (#336).

In Baroque times, though, the second possibility for gratings was also utilized. The large, richly ornamented park fences, as well as the larger church gratings in Germany, such as the park fence of the Residence in Würzburg (#241-245) or the entry grating in the church at Amorbach (#342-343), with their lavish shapes of intertwined twigs, leaves, shells, ribbons, rocailles, flowers and animals, offer such a varied play of lines, light and shadow that the eye is overworked and colors are really not necessary. The fences in Britain and France are more statuesque, tectonic, if one can use this term to refer to the grating and its material. Bearing and supporting pieces are strictly separated from each other, the verticals generally dominate as simple rods, and here perhaps a single color of paint is used, usually green. All the art and all the splendor are concentrated in the crowns, such as those of the park fences at Versailles (#231), the fence of the Hospital of St. James in Besançon (#228), and many others.

In the twentieth century, with all its richness of ornamentation, this tendency still dominates in the big park fence at Buckingham Palace in London. Thus here too, the color is concentrated in the crownings. The elaborate coats of arms are set off in the heraldic colors and richly surrounded with gold.

Spanish gratings are likewise rather flat, but attach very lavish friezes to their vertical members, decorated very colorfully with figures, animals and coats of arms.

This use of color ended in the eighteenth century. Classicism preferred white or iron-gray paint, with at most a few individual decorations highlighted in a little gold. A new burst of color appeared in the historic styles. In Art Nouveau, white paint was used again, but the air pollution in the cities, which remains to this day, requires careful maintenance and really makes white paint a luxury.

Basic Shapes and Ornaments

There are basic shapes — and this surely is a matter of the nature of the material and

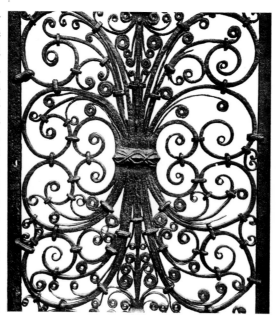

its unchanging ways of being worked — that have varied over the centuries according to the styles of the times and nations, but have remained the same in principle.

Every piece of forged ironwork, be it grating or decoration, is based first of all on the rod. The material of which the smith forms his ornaments and puts them together to form a grating has been produced in raw form as a rod, whether hammered or rolled, since the fourteenth century. Water power and large iron forging hammers did the crude work. The possibility of using preformed parts led to refinements in the process of production. Iron splitting and cutting facilities were established to produce the shaped elements that were in common use, and could deliver great quantities of them. Through such preforming, the prerequisite for the production of incalculable quantities of wrought-iron gratings, required especially in the 17th and 18th centuries for secular as well as religious use, was created.

The simplest, most easily produced ornament is the turned four-angled staff, which

was used at all times and through all the centuries. These staffs were usually used only in vertical groups as the bottom of a grating, receiving their necessary support from simple horizontal frames. When they are of greater length, they are held together by an additional horizontal bar or a frieze which, like the crown, adds further decorative motifs.

A very early example of an interior design, formed of turned staffs, already existed in the fifteenth century. On a window grating of a house in Bourges, France (#58), the vertically positioned square staff was split and hammered into heart-shapes. Turned square staffs form the surface inside the horizontals. The heart shape still appears in our own times, and as before, the square staff is split, whether the resulting flat bars are bent into hearts or leaves. A decorative inner design is intended, here as otherwise (#361). The square staff often has been put back into use recently, since this type of decoration can be produced without a great deal of work and thus relatively inexpensively. Turned square staffs are also sold readymade today by the large forging works. The first great day of the square staff was in the Gothic time, and it is found occasionally in the subsequent style periods along with other types of staffs.

The flat staff, the flat iron, was also supplied by the rolling mills. It was seldom used for gratings in the fourteenth century, more for decoration, and only came into frequent use for gratings when the fillings were supposed to be lighter and more transparent.

A very early combination of square, flat and round bars is found in a Flemish window grating, from the end of the 16th century, at the museum in Rouen (#59). It is also noteworthy for the grid effect of round bars in a basket-weave pattern.

The round staff then dominated in the Renaissance, since it could more easily produce the ornamental style of the time. The Italians as well as the French preferred it, and both of them greatly influenced the Germans, who then became leaders in artistic smithing during this epoch.

7-9. Scrolls, leaves, spirals, Viollet-le-Duc, Vol. VI, pp. 69, 56, 60.

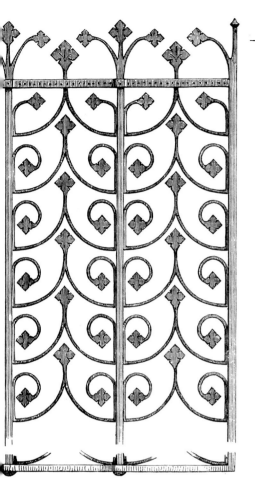
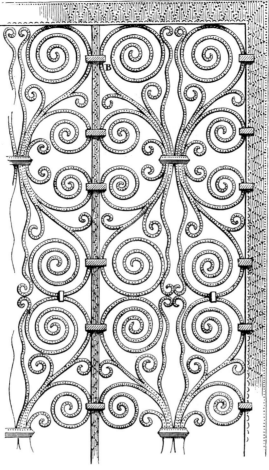
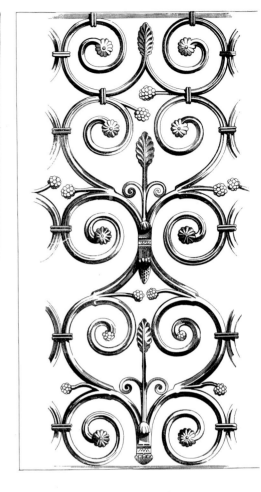

According to the surviving specimens, two shapes appeared simultaneously: the C and the scroll. The terminations of the C can end like the letter, they can also, somewhat rolled in, approach the spiral, or they can be forged into a leaf at the end, or even a cloverleaf. Then these individual elements are usually put in a row and bound together to form additional decoration. In the twelfth century, these elements stood clearly side by side; in the Renaissance, decorative elements were added, while in the Baroque era they sometimes became so strange that their basic shapes are hard to make out at times. The symbol seems to be taken from calligraphy, an opulent Baroque script: upper and lower lengths are no longer of the same size, but are lengthened or shortened, according to the space that they have to fill.

The scroll in its simplest form is a round or flat bar, usually bent in at one end, or more rarely a friable square staff. It was already a frequently used ornament in antique times. The scroll was a component of the Ionian and Corinthian capital, while in the archi-

tecture of the Renaissance and the Baroque it leads from horizontal to vertical components. In the art of smithing, the scroll has been used in many ways over the centuries. It also appears in various sizes in a grid, is attached in an opposing or the same direction, or develops out of a trunk in strictly symmetrical form.

One of the earliest surviving gratings, in the Musée de Cluny in Paris, was made in France and shows how much can be done with large and small, even, or alternating scrolls. The late Romanesque grating, from the 12th century, shows a plant-like design with luxuriant branchings and is a masterpiece of the smith's art. Depending on the buyer and the fashion of the times, the basic shape of the scrolls is more or less severe, sometimes even branching with playful pleasure, and additional ornaments are added, either welded or hammered on.

More or less contemporaneous with the C and the scroll are the spirals whose forms are sometimes almost impossible to distinguish from scrolls. The grating in a private

home in Spain shows a strict, clear form. No added features distract, and the beauty of the design speaks for itself. The spirals are generally rolled more tightly, and appear in the close rows of their bends like concentric circles from which here and there, especially in the Renaissance, a slim leaf, a slender twig, even a crosslike flower projects. The most charming, imaginative creations were made with light leaf decor at the ends of the rolls in the Romanesque, Renaissance, and late Baroque eras. Gentle tendrils add to the basic form, counteracting the turning motion on the one hand though likewise moved by centrifugal power on the other. The spiral, like the scroll, is not a figure of order when it stands alone, and only through opposing placement does a complete picture result. The spiral was not used much in the 19th century, perhaps as too confused and unclear, perhaps also as too self-centered. But it remains in the smith's treasury of shapes to this day, as seen in the work of Otto Baier of Munich (#374).

13

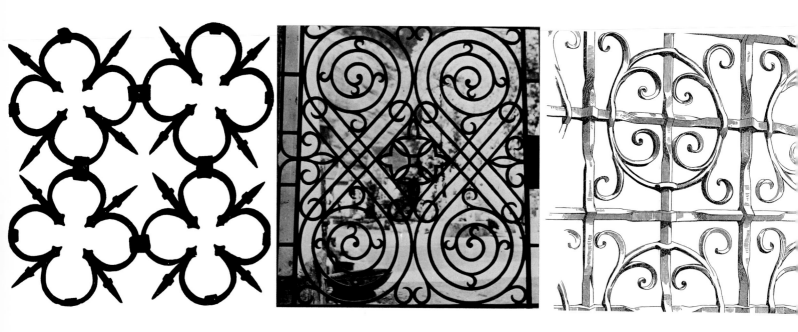

10. Quatrefoils with spears, Musèe le Secq de Tournelles, Rouen.

11. Infinite figure 8, entrance to St. Peter's Cemetery in Salzburg.

12. Squares formed with pierced square bars and inserted circles, Viollet-le-Duc, Vol. VI, p. 76.

The figure 8 form seems at first glance to be related to the spiral and the scroll, yet there is an inherent difference between them. The scroll and spiral end; the flowing figure 8 does not. It is a symbol of infinity and eternity, and therefore is used particularly on the gates of cemeteries. such as at St. Peter's in Salzburg (#11). It can appear in simple form or in varied shapes. It can form a thick network of small squares in the center of a work with its multiple curves. At the end of the 17th century, the flowing figure 8 appears to have lost popularity; it seldom appeared in the 18th century, and was almost completely forgotten. Making this figure is difficult and time-consuming, and requires especially great smithing ability.

The quatrefoil goes back, in terms of its basic shape, to the circle, inside which four segments of circles are drawn. Sometimes the circle around them is drawn, resulting in a particularly completed form, a clear boundary of the four quatrefoils from each other. The only decorations here are the attachments, which add three-dimensional accents. The quatrefoil can also be drawn inside a square; then the decoration is more subdued, not producing a diamond with curving sides.

Along with this simplest form of the quatrefoil, there are numerous decorations. The most lavish, and probably also the best-

known grating element, is the quatrefoil on the Scaliger graves in Verona. Ornaments such as sword handles are added to the corners of the circle segments, and the center holds the coat of arms, "the ladder" of the princely family. To the octagon that is drawn in the center, lilies are again added. Another favorite form of decoration consists of lances that project from the points of the circle segments.

The high point of the quatrefoil was in the high and late Gothic eras, thus in times when window tracery was the main decoration used in church windows, forming the frame for the colored glass design.

At this time, the quatrefoil, with its clear, simple rapport, was the most popular protection against intruders, and the tighter it was, the more privacy it also gave. In later years, the quatrefoil was never completely abandoned, but can be traced through the centuries, in simple or decorated form, alone or in combination with other ornamentation. In the neo-Gothic era it came back to intensive life, and even the twentieth century has taken it up in simple form (#351). The quatrefoil appears not only in forged form, made out of rods, but was also cut into or applied to sheet iron. This ornamentation appeared in fourteenth-century Florence just as it did in neo-Gothic times in the Houses of Parliament in London (#271).

The clear geometrical form is generally more typical of the Romance peoples, the French and Italians and those of areas strongly influenced by Italy, than of the Germans. In the smithing art, France held an absolute lead in the Gothic era, while Germany produced the greatest achievements in the Renaissance. It is not surprising that the Gothic motif of the quatrefoil appears frequently only in the early Renaissance in South Tyrol, at Proesels Castle (Baur-Heinhold, *Geschmiedetes Eisen*, p. 29) or the Porcia Castle (*Geschmiedetes Eisen*, p. 51) in Villach. Its migration northward from the centers of art took its own good time.

It has already been noted that the square bar was preferred in the Gothic era, which did not rule out the occasional use of flat or round bars. In the Renaissance, the round bar appeared in more eye-catching form as a more becoming element of form. At this time, flat and square staffs could also appear in a grating, though the round bar would, of course, dominate. Gratings with simple pierced bars, whether square or round, have survived only since the fifteenth century. Before that it might not have been worth the trouble to preserve and protect the undecorated grating properly. The material was melted down, as long as it was not eaten up by rust, and reused in more modern, presumably ornamented gratings.

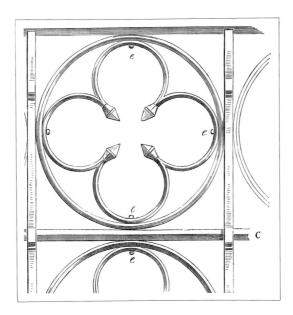

13. (Top) Quatrefoil inside a circle, Viollet-le-Duc, Vol. VIII, p. 360.

14. (Bottom) Scrolls with leaves extending from them, Voillet-le-Duc, Vol. VI, p. 67.

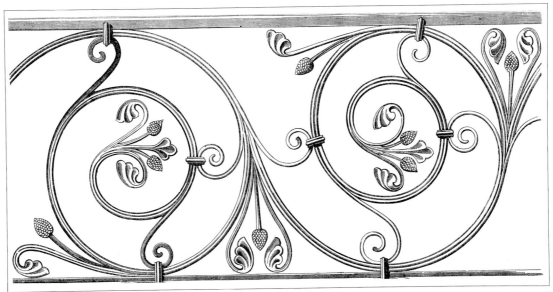

Today, preference has changed in favor of simple form. Bars laid one upon the other, forming a square, diamond or long rectangle, are turned into a charming ornament by thickenings at perforated and penetrated points by the resulting play of light and shadows and three-dimensional effect. Even when bars are not pierced, attachments produce charming ornamental effects.

This kind of grating can scarcely be dated, for it remained the same for centuries, and the handcrafting cannot be attributed with certainty to a particular span of time either. Sometimes these simple forms were decorated with a circle, a ring, or a ring with scroll-like branches, but this is also found in Gothic art as well as in the twentieth century, in the Beautiful Fountain in Nuremberg (#187f) and the forest cemetery in Munich-Solln (#354). The very artistic additions to the Beautiful Fountain enable one to deter-

mine when it was made. More will be said of this fountain below.

It was only in the Baroque era that the basic form of the diamond was varied to the extent of making it a typical identifying mark of the period. The sides of the diamond were bent, and the square bar was well suited to this shape, through which the firm lines created a better effect. The diamond could also stand alone as an ornament, as at Stams in Tyrol (#118), or it could also hold additional decoration by having verticals drawn from the acute angles, with rolled leaves sprouting from them (#75). The motif of the bent-edged diamond has been taken up again in our time, where the linking is done by attachments that are gilded, as they were in the eighteenth century (#375).

Flowers and leaves have survived from the early days of gratings, in the thirteenth century. In the beginning, they were rather flat,

whether they were forged, cast or cut. Here too, France produced very decorative designs, maintaining its leadership in the realm of the smith's art in Europe at that time. Flowers and leaves, rosettes and palmettes are somewhat flat at first, and even the rosettes are barely three-dimensional, but also flat. Together with the piercings of the gratings, they form only a flat surface with gentle relief. Sometimes they also form the frame for a diamond-shaped grating of perforated bars, such as a Spanish window grating of the 16th century, seen in the Victoria and Albert Museum in London (#63). These rosettes are now vigorously three-dimensional and look almost natural. Whereas the rosettes of the Spanish grating are just the framework for the even surface of the perforated grating, which only offers a play of light and shadow, in the Italian grating of the same time, the rosette forms the only decoration on a simple gridwork of flat bars.

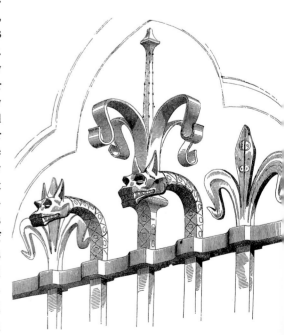

In the Renaissance, the spindle-flower was developed. It was then three-dimensional and gave the grating a much more fluid appearance. The spindle-flower can be set into the grating, or it can push into the space as it did in the 17th and 18th centuries, coming in a more or less emphatic manner in both large and small sizes. Its nicest, fully three-dimensional effect is disclosed, though, when it is attached as a crown, free from the linear nature of the grating itself. The spindle-flower can be tightly twisted or only a light, open spiral, but it is always made out of a round bar. A grating with a number of spindle-flowers can be seen in the cemetery at Lenggries, in Upper Bavaria (#217).

A particularly lovely example of the smith's art of the Renaissance is the cross-flower, which may be traced back, in terms of its basic concept, to the stone crowns of the pinnacles of Gothic buildings. Assembled of slightly bent leaves, equipped with stamens, it portrays an almost lifelike plant. The spindle-flower was also inserted as the inner part of the cross-flower, in place of the stamens. Particularly lovely spindle- and cross-flowers are found on the grating around the tomb of Emperor Maximilian in the Court Church at Innsbruck (#168), which include stamens as well as spindle-flowers. After the Renaissance, the cross-flower disappeared, but the spindle-flower lived on into our times.

The weighty, extensive cross-flower was just as unsuitable for use in the heavy, compact Baroque gratings as in the light, delicate Rococo types.

Flowers, though, do not repeat only in schematic, regular intervals as filling, as pure ornament, but can also have a life of their own. They form the basic component of a bouquet of flowers, and perhaps also of a tree of life, as on the crypt grating at the cemetery in Seligenstadt (#172), or they are only a flower bouquet without a deeper meaning, as in the dividing grating in Venice (#15). They are the dominant midpoint of a small, simple door grating at the cemetery in Lenggries (#218), and they are also used to this day as decorative motifs in a simple grating of diamonds formed by square rods (#363).

Crowns

When gratings are not set into an architectural frame, and therefore need defense against prohibited climbing and penetration, protection has to be added in the form of a crown. Here there are various basic shapes which appear again and again over the course of the centuries, depending on the fashions of the times or the preferences of a country.

A warlike character is shown by the crowns that include lances, particularly when their points, like barbs, are bent out (#17). In Gothic times they were pointed weapons, a characteristic that has lost much of its threatening aspect in the twentieth century. To be sure, lances were still attached to low garden fences, but what with their meager length, they scarcely constituted a threat any more, especially as a supporting horizontal bar gave sufficient foot- and hand-grip for anyone climbing over. Sometimes, the purely decorative purpose was indicated by athe absence of a point, so that only the shaft of the lance pointed upward, its threat mitigated by a tassel. The shafts of these lances sometimes formed the grating as a row of vertical bars held only by horizontal irons which in turn could be accompanied by all sorts of ornamentation. Crowns could extended to the front and rear, and the jagged palm leaves (or whatever) protected the area

of their enclosure well, such as the crowns on the gratings of the Scaliger graves in Verona (#201). The crown is actually dull and purely utilitarian, even though it looks pretty and significant in the drawing. It appears considerably more sensible than the grating crowns that were attached in the Renaissance with cross-flowers, spindles and leaves which look rather like lances here and there. Later, in the late Renaissance and the Baroque, the crowns lost more and more of their defensive character and, like the gratings themselves, became more decorative and ornamental, though they still prevented climbing or at least made it difficult. Decoration and protection are always inherent in these crowns, but they never become brutal tools, such as barbed wire.

The simple, obvious purpose of protection is minimized by the shrine crown, which adds figures, coats of arms, helmets and such to the gratings. These crowns are cut out of sheet iron, with the helmet decorations and accompanying spears forming the defense against invaders. In the Baroque era, there were monograms, coats of arms, symbols of the owner, or even lights added to the head of the crown. Decorative figures, at first fully flat, reflecting the times in form and painting, were added not only to the crowns but also, in the Renaissance, to the gratings. Figures were portrayed in silhouette form.

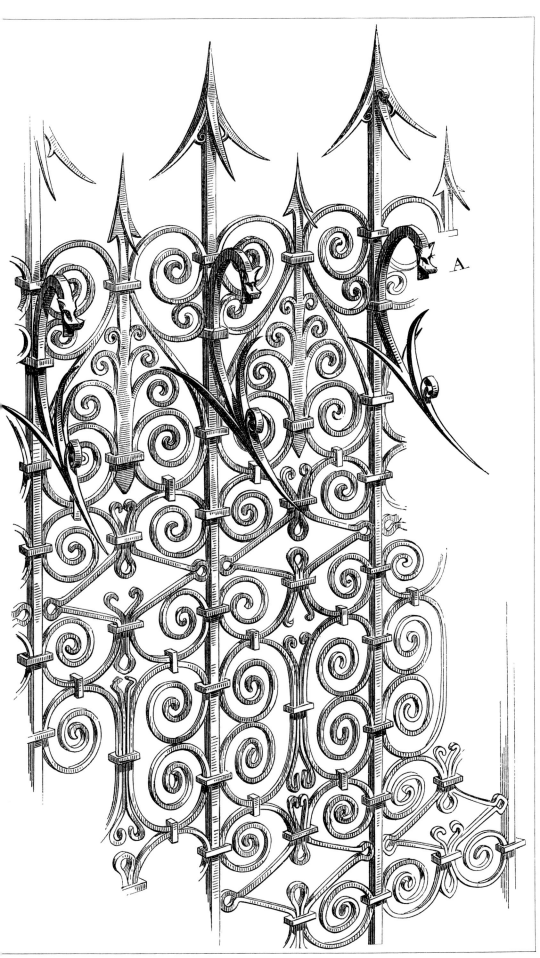

17. Crown with spears and barbs, Viollet-le-Duc, Vol. VI, p. 62.

It remained for the Baroque to add the three-dimensional figure to the grating or to add them on as crowns. In churches, they were usually figures of saints, particularly the Madonna and Child. The figure of a patron saint or a prince/bishop's coat of arms, three-dimensional with all its insignia, might form the center of the crown and be flanked by holy figures. Since the mood was not so completely strict in Baroque churches, three-dimensional naked cherubs also appear in gratings, such as in the Franciscan Church at Salzburg (#346), and sit atop crowns, as in the church at Amorbach (#342).

Here we have been speaking only of the basic forms of ornaments that were used in forged gratings from the twelfth century to the present. New forms were added in Baroque times, such as rosette-decorated gratings in cartouches — foreshadowed in the 16th century in Italy (#73), but now newly formed in broken frames — and they will be discussed as we observe objects of each time period. Bands, shells, cartouches and rocaille work all were completely new additions.

Masters and Patterns

As with almost all works in the Middle Ages, no masters' names are associated with iron forging. It can be assumed that the customer, the master of the foundry, or the architect drew a pattern, which was then carried out by the handworkers of the smiths' guild. Some gratings in French cathedrals suggest the influence of book painting, yet the basic form of the scroll is thoroughly suitable for being developed into rich ornament. Perhaps in the early days the smith also had more freedom to develop his own ideas in the grating and to decide which shapes the material allowed him to make. In the Renaissance, with its refined techniques, the pattern of calligraphy can be seen very clearly.

Over the years, as the artisans' abilities and tools became more refined, and as a wider assortment of pre-formed components became available, the customers also expected more. The master smiths had become more aware of their artistry and their personalities. One can also view the situation from the other side: since the customers had become more demanding, the handicraft was refined and new types of pre-formed parts were developed. In the Reanaissance, the first masters' names appeared as smiths signed their works with their full names, or with their business emblems. From old documents it can now be determined which master produced which articles and at which prices.

As the sculptors of Greece once let their statues speak through the inscriptions on their bodies, telling which sculptor had made them, so the Renaissance smith deliberately put his signature on the crown of a shrine in the cathedral of Avila (#306), saying: *Fizo esta obra maestro Joan Frances maestro major de las obras de fiero* (This work was made by master Juan Frances, grand master of iron forging). The inscription is cut in Gothic letters, and it may be one of the first signatures of a master.

The Spanish are said to have great pride, and it may be linked to this national characteristic that most master's names in the sixteenth century appeared in Spain.

Juan Frances of Toledo worked in Santiago de Compostela at the beginning of the sixteenth century. He created a grating in the Hospital Real. A Master Guillèn de Bourse made a grating in plateresque style for the Mondragon Chapel in the cathedral of Santiago de Compostela (#302). The chapel was erected by Canon Mondragon in 1522, at about the same time as the grating of the church at Hall in Tyrol (#300) was created. The similarity of the crowns makes one wonder whether there could have been direct connections between the buildings or whether there was just a similarity of style at that time.

In the sixteenth century, more masters' names appeared. Only rarely did a smith place his name in the middle of his work, as did the Spaniard Juan Frances, or as a crowning element, as did Hans Ruge on the grating in the Lüneburg Town Hall (*Geschmiedetes Eisen*, P. 36).

The artisans' symbols and names of Hans Schultes and Daniel Reichart, metalworkers of Erfurt, were placed on the sheet-iron pieces of the grating of a baptismal font in Erfurt. We know most of the names from documents: Georg Schmiedhammer was the maker of the grating around Maximilian's tomb in Innsbruck in 1573, Paulus Kuhn of Augsburg made the grating around the Beautiful Fountain in Nuremberg in 1587, and Wolf Guggenberger made the grid for the fountain in St. Florian (#181). Master Helleweg, like the Spanish Master Frances, signed his fountain screen at Neisse (#192) in the antique manner in the 17th century.

The more complicated the works became, the more patterns were needed. Not every smith was as talented in drawing as in smithing, and the customer's imagination was probably not always sufficient either. Pattern books were created which made it possible for even obscure master handworkers in town and country to more or less keep up with the great names of the profession. The high point of the pattern books and individual designs, and of their creators, will be dealt with below.

Development of Types
from the 12th to the 20th Century

Windows, Doors, Balconies

It is not always possible to determine beyond doubt what purposes the gratings preserved in museums actually served. As for the oldest of them, it can be assumed that they were tabernacle doors, protecting the holy objects, or confessional grids, protecting the anonymity of sinner and confessor. The early gratings were also used as doors to chapels and enclosures for shrines. Only a few are still serving the same purpose at the same place.

The earliest grating doors or fences, which uses they may well have had in the eleventh and twelfth centuries, have a similar appearance. The basic form is the scroll or the spiral, and national differences are barely recognizable. The grating of St. Swithin's shrine in Winchester Cathedral (#45) hardly differs from the grating in the Church of Santa Maria de Mellid at Coruña (#47), also from the twelfth century. The scroll has been rolled once or twice, and the ends have been bent in to form stylized leaves. The scrolls roll out of bundles that are held by links, so that they almost give the impression of stylized flower bouquets. Both gratings, which are among the earliest that have survived, have a live, growing-plant character and show such great similarity that one can assume that they were made if not by the same master, then at least with the influence of one on the other.

The grating from the shrine of St. Richard in Chichester Cathedral (#46), a later work from the thirteenth century, seems to reflect cool British objectivity. However, the grating has large holes in it today, and a goodly number of very tightly rolled spirals as well as smaller scroll endings have been broken out. In general, though, it seems evident that the growing-plant element had faded in the thirteenth century, at least in grating doors.

The grating, the door of which is missing, shows an artless, defensive enclosure very different from the window and shrine crowns of the high and late Gothic times on the Continent — in Germany, France, Italy and Spain. Figures cut out of sheet iron and painted in many colors stand in front of sharp-angled leaves on the St. Elisabeth Shrine in Marburg (#48). Dragons' heads, crabs and tracery crown a window grating in Barcelona (#50).

Tracery with pinnacles and spears protect sacrament houses (#49). Tracery from the stonemason's art was transmitted to iron. In Germany, the quatrefoil was often combined with tracery, both having their origin in the windows of the Gothic cathedrals, thus in the stonemason's art. Romanesque window gratings could scarcely have existed on secular buildings, nor can it be proved that any existed. Window glass was too expensive to have been used in large quantities, so the small windows in Romanesque churches were closed with thin sheets of marble or alabaster which let faint light come through.

In Gothic tracery windows, though, there appeared the colorful windowpanes, the glass paintings. The decoration was admired and transposed into other materials such as wrought iron. At first, though, the window grating was not an absolute necessity for the city house either. The glass was expensive, and the poorer bourgeois closed his windows with wooden shutters with, perhaps, a bit of glass set into the upper part. In addition, the authorities promoted security in the walled-in areas. Entrance and exit were checked at the gate, and when the sun set, the gates were closed and the householder secured his windows by closing his wooden shutters and placing iron bars in front of them. When the bull's-eye window became more widespread — they were already mentioned in the year 1000 — they were found only in the houses of the nobility and the richer burghers. A window grating was not necessary then.

One of the earliest confirmable security devices is a window grating at the bishop's palace near the cathedral in Barcelona (#50) which presumably can be attributed to the fourteenth century. Round bars go through it, making squares, a purposeful protection to all four sides. Only one small addition made of forged tracery and crab ornamentation with two dragons' heads definitely identifies the Gothic origin of the window grating, for the gridwork itself could occur at any time. The crown is a decorative addition and mitigates the severity of the grating.

The window gratings of a house in Brixen (#70), from the seventeenth century, contain the same type of gridwork, but everything has become much more graceful. The round bars are thinner, the crown of flat bars is curved gracefully, and the defensive character is hidden so that it looks as though only the decoration of the house was intended.

When the covering grid is omitted, the crown must become defensive, like the one with spears on the window grating of the cathedral in Ghent (#57), made around 1520. Along with lilies and tendrils, protection turns to decoration. The round bars that end as spears are held together by the horizontals so that rectangles are formed. This style also lived on through the centuries. The only decoration is the coat of arms.

This basic form also is found in a window grating at Rouen (#59). The defensive frieze is almost identical to the window grating at Ghent. Lilies, spears, hooks and tracery form the defensive grid and woven work like that of a basket forms the transition to the rounded arch between the "lances" of flat iron, which are also filled with scrolls. The simple horizontal member, which holds the vertical bars together in the window grating at Ghent, has become a natural-looking weave here. The entire protective grid is made of artistic ornamentation, showing none of the severity seen in the grating at Ghent.

19. *Flat bar with leaves and curls, Viollet-le-Duc, Vol. VI, p. 71.*

20. *Plaited work forming diamonds, Viollet-le-Duc, Vol. VI, p. 79.*

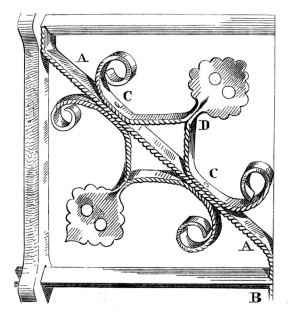

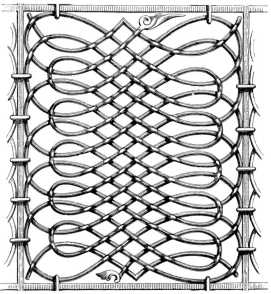

One of the most splendid window gratings was used at the monastery of Santa Cruz in Barcelona (#76). Here there is strong defense in the turned bars, with only a simply decorated band binding them together in the middle. Pierced round bars give additional strength. Scrolls in quatrefoil-like shapes have been lined up to make a frieze, along with sharp-angled leafy bushes for more protection, similar to the crowns of the Scaliger tombs in Verona (#201). The sizes and shapes of the windows make clear that this is not the protection of living quarters. Here a druggist's chamber is protected from illegal entry, protection as necessary then as it is now. The cutout in the lower part of the grid let one hand things in.

Window gratings with more or less space inside, greater or smaller distances from the wall, are still found in the twentieth century, whether on country or city houses, in simple or complex form. Window gratings that are flush with the wall, and that allow no view to the sides, are just as common. They too can be traced through the centuries. The pattern of the grating usually matches the ornamental style of the time, but it is simply not as closely linked with graphic artists as, let us say, the artistic additions made of wood. Designing them is not related to consistency and sturdiness to the same degree as the gratings, which lack the firm background of the wooden door. Flat iron bars, crossed at right angles, with rosettes at the meeting points, can be found not only in the seventeenth century, but also in the twentieth.

The seventeenth century saw the birth of a new kind of diamond design, found most often on windows. The bars are all bent in the middle (#120), and the space either remains empty or is filled with small scrolls and hooks.

Spain developed its own style, as applies both to window gratings as to larger park and church gratings. The vertical bars look as if they were twisted round bars with thicker areas, knots and knobs, ornamental balusters completely flat, and with acanthus leaves wound around. All these forms are also found in larger scale on the large iron gates and gratings in the churches, and over a long period of time from the sixteenth to the nineteenth century.

Spain has produced very dense window gratings. The bars of the women's chambers are spaced especially close together, for man's possessions were to be protected from unauthorized strange glances, and the women should see only a little of the world beyond the window, except the way to the church, and maybe also the way to the bullfight, traversed with an escort. This naturally applied only to the women; the more respectable, the more isolated, and the more elaborate their window gratings. The poor woman, of necessity, had to show herself more in public, to go shopping and do errands. For fresh air and time spent outdoors there was the patio and the atrium or inner courtyard. The more southerly the household, the more protected were their women, and the thicker were their gratings.

At the end of the seventeenth century, basket-type window gratings began to appear, with their lower half projecting, either semi-cylindrical or angular. In Baroque times and in the eighteenth century they became more widespread. They too can be understood in terms of the pressure of time, letting the outside world be seen inside. They allow a further view to the sides, far more than the rectangular window gratings, for now one can communicate with people on the street outside, if that is desired (#137).

The room opened onto the outdoors, but security was guaranteed nevertheless. In Switzerland, Austria and Germany, the window gratings bowed outward toward the street. The vertical bars were linked with ornaments: circles, scrolls, leaves, garlands depending on the ornamental style of the time. The ornaments gave necessary support and testified to bourgeois living culture; the renowned gratings in Basel are outstanding evidence of that. Naturally, the Swiss are reticent, not interested as much in chatting with someone on the street, so their window gratings are right-angled (#123).

The window gratings, be they straight-lined or bowed out, lend an air of movement and decoration to the smooth wall of the house, with the play of shadows adding ever-changing ornamentation.

In the Gothic era of the fourteenth century, the overhead grating was used for brightening up dark corridors or doorways. The use of artificial light was meager until the nineteenth century. Oil and petroleum lamps, which had to be tended constantly, were hung from the ceiling or on the walls. Through the overhead grating, daylight could at least be utilized until sunset (#114).

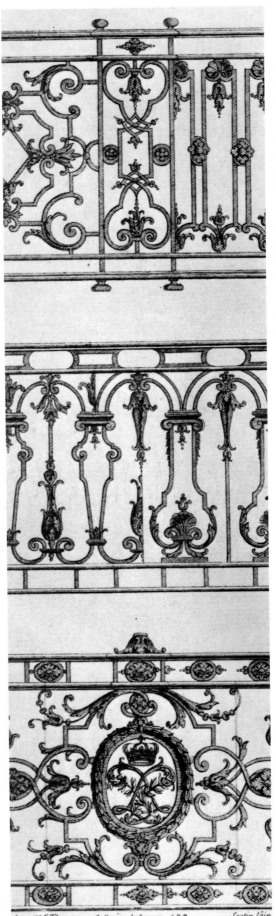

chez M.ʳ Thuret aux Galleries du Louvre C.P.R. Scotin l'ain.

Openings to the street and the world outside which invited more light and air also led to the invention of the balcony in Baroque times.

In the Middle Ages, when narrow streets crowded fortified towns, balconies were not possible; one lived withdrawn, as cut off from the outside in one's dwelling. The lots were usually deep, and the numbers of windows opening on the market place or the main street were determined by law. The inner cities, which were largely passed over by the industrialization of the eighteenth and nineteenth centuries, show this clearly to this day. Inner courtyards gave the rooms in the rear part of the building complex light and air. The arcaded courtyards of the cities on the Inn and Salzach rivers, for instance, built after Italian models, had to be sufficient for getting outdoors. At the front, there was at best a gable with a "spy window" breaking the smooth facade, but never a balcony. The balconies of the city halls, used for making announcements, were the exception, but their parapets and balcony railings were usually made of stone in Gothic times.

Only in later times, in the Baroque and Rococo periods, was a door in an upper story also supposed to open onto the outdoors. The facade was designed in a way that accented the center of it, and this was often done by means of a balcony. Man, his house and his home town had broken out of the medieval narrowness, and the streets were made wider. The way this was done in the Engadine are especially charming. At La Punt (#127) and Samedan, the old houses with the small windows were decorated bewitchingly by adding graceful little gratings of wrought iron to their small windows, extending out over the lower walls that supported them. Scrolls, leaves, shells and rosettes cast their shadows on the white walls, and a richness of colorful flowers blossomed forth from the balconies in the summer months, as from the basket gratings of the windows. The stricter, straight-lined balconies in the cities were different, for they looked comparatively dignified despite all the Baroque ornamentation and completed the curve of the footplate with only a slight bend. Scrolls, rocailles, ribbons, shells and flowers were included in these balcony gratings, setting themselves off from the castle facades light, playful, merry appearance, generally on the front and garden sides. A castle intended for joy and summer vacations is always inclined to open on the garden side.

The balconies, though, were always dependent on the climate. The practical bourgeois might ask why great balconies were built on dwelling houses where the weather was rough or an inland climate with strong temperature extremes prevailed, extremes from which one did better to withdraw inside the protective stone walls.

The customs were different in France. The high, narrow "French window" required security, and with these high windows there developed low parapets. There are two types: those that are almost one with the wall, not allowing anyone to step outside, but only protecting the opening and forming a small defensive parapet, and those that are really narrow balconies, onto which one can step out beyond the facade, but that usually do not stick out far enough to invite one to come out for a long time and sit outside the house. A French grating was never made as crudely, nor looked so transparent, as the one on the New Castle at Bayreuth (#97-99). The shape and the outline, like the interior design, are formed of comparatively severe lines, with moderate decoration. Overwhelming fantasy is not to be found here. The classically restrained form was never fully abandoned in France, not even in the heyday of the Baroque style under Louis XIV. The gratings were originally practical, "close-meshed", giving an impression of stability and security. Thus these balconies and window gratings are sometimes difficult to identify in time, for a grating on the Rohan Palace in Strasbourg (#233), for example, scarcely differs from a nineteenth-century grating on the Champs Elysées in Paris (#159). The balconies project ahead of the wall, and the side pieces continue the ornamentation of the front panel.

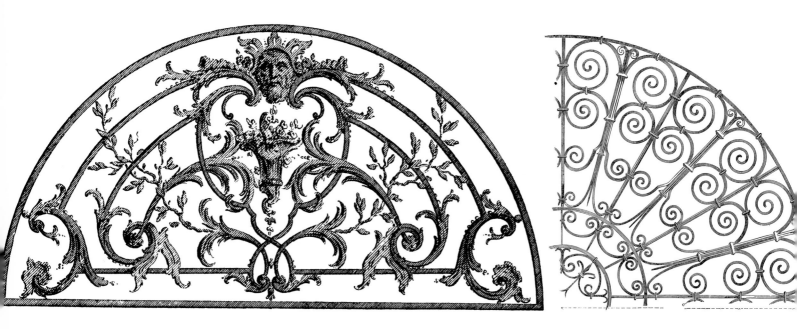

Stairs and Stairwells

In the Baroque period, there also began the age of great stairways, whether open or enclosed. This too can be seen as a result of the circumstances of the time, change in the overall sense of life.

In Gothic times, the stairways of churches were made in modest style, protecting the steps to the pulpit or the sacrament house, as two beautiful examples from Hall in Tyrol (#84) and in Rothenburg on the Tauber (#85) show to this day. The stairs were also protected in the churches, as seen particularly in the two doors to the stairway in the church in Hall, with their nicely flowing scrolls, the so-called "branched Gothic" style that is shown at its best there (#82, 83).

In the Gothic bourgeois house, the stairs are narrow and hard to get to, for in those days they had to be easy to defend if plundering robber knights tried to get into the upper stories. They were generally only passable for a small number of people, and usually had only one handrail for use in finding one's way and keeping one's balance. In the early days, the church, like the house, was designed for defense.

Then in the seventeenth century the outlook on life changed, and a house could no longer be stormed or defended with halberds and cudgels, for other means of warfare had been invented. The stairway was now made open, and developed to their greatest glory in the German grand staircases in Würzburg, in Brühl Castle, in Pommersfelden, reaching their artistic zenith particularly in the eighteenth century.

In Britain and France, the wrought-iron stair railings of the seventeenth century were still restrained designs. The individual pieces were lined up at short, regular intervals. They formed the shape of a lyre or a vase. Between them were pillars decorated with scrolls and large rosettes. This remained so in the eighteenth century. The individual parts changed very little in the styles of the times.

Between 1737 and 1749, the Radcliffe Camera, the renowned library in Oxford, was built to plans by James Gibbs. The railing of the staircase (#138) that leads to the upper floors, probably was also designed by James Gibbs. It can be considered typical of the time and of Britain. A broad and a narrow rectangular field alternate in even rhythm. The individual fields are separated by vertical rods with inset ovals. The wider fields are filled with a circle of leaves and rosettes, the narrower ones with appropriate floral motifs. Aside from the architecture of this staircase, the German stairways of the first half of the eighteenth century also differ in other essentials from this staircase in Oxford.

Individual parts, even though of greater dimensions, are combined in the Hôtel Brion in Paris (#141). The fields are connected or separated by vertical bars. The fillings, many-curved scrolls, look like ornaments drawn with a pen. Not many staircases of wrought iron have survived in France. Perhaps the French were more inclined to build grand stairways of marble, or perhaps much was lost on the French Revolution, melted down to make weapons and ammunition.

24. *Parts of stairway railings and balconies by François*
Cuvilliés, from Livre de serrurerie.

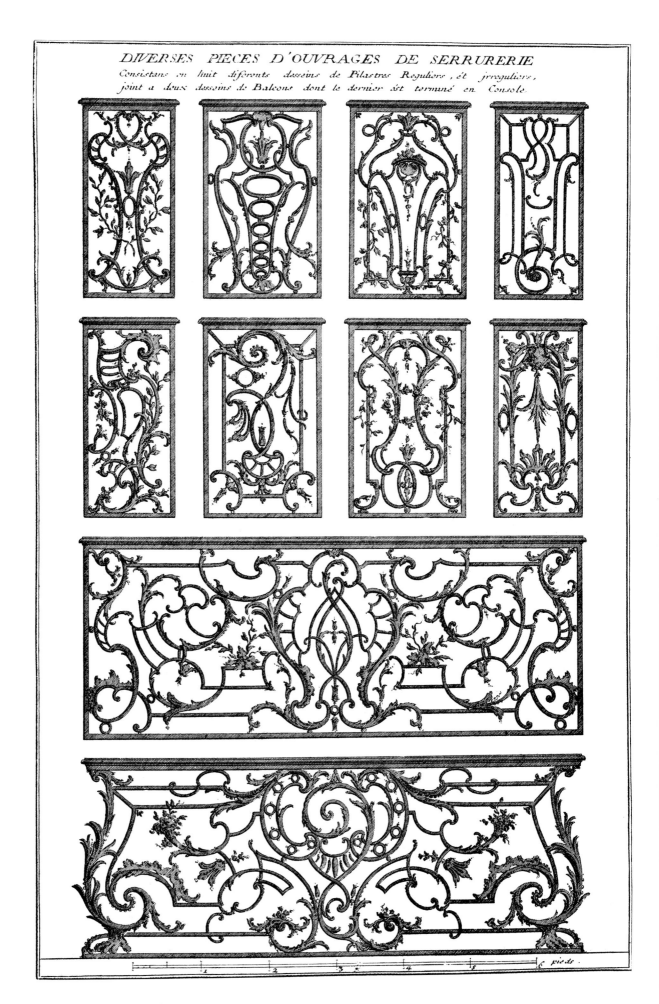

23

Such staircases can scarcely be found in Italy. Apparently stone marble with a rail of iron was preferred in the hot climate.

German gratings of the eighteenth century were enlivened by the imaginations of smiths, designers and customers. The stairways show a completely different spirit and overflow with shells, rocailles and ribbons. Flowers, leaves, and tendrils of foliage swing from stair to stair, the steadying vertical bar is ornamented whenever possible, and the framework is made indistinct. Sometimes there are no pauses, no fields in which motifs are inset in regular order.

In the bishops' residence in Eichstätt (#139), all the fluid grace creates a relatively calm effect, for the ornamentation is limited to a few motifs.

The staircase in Brühl Castle on the Rhine is one of the most beautiful and artistic staircases that was created in Europe (see *Geschmiedetes Eisen*, pp. 68-69, and elsewhere). The stair rail is of positively courtly grace, swinging up the double stairway, blending completely into the decor of the house. Probably the influence of the architect Balthasar Neumann can be found here too.

The large staircases in Pommersfelden, Würzburg, Schleissheim, and a number of other castles use stone balusters instead of the more graceful wrought iron. Smaller castles competed in the elegance of their staircases, whether single or double, with the buildings of the higher nobility. The staircase at the castle of Meersburg on Lake Constance (#157) includes a transparent grating, in which scrolls of flat bars swing from pillar to pillar.

Similarly geometrical patterns, without added vegetation, were used in the stair rails at the monastery of St. Blasien (#155). Within these gratings there are no divisions into fields; the design runs from one stone pillar to the next.

Toward the end of the eighteenth century, the gratings became lighter, imagination was

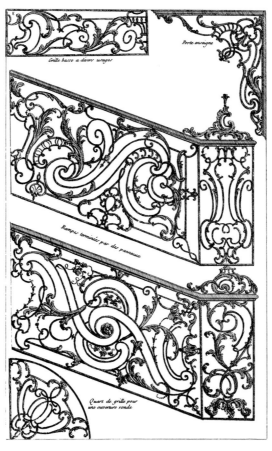

now limited, and the clarity of the Romantic spirit seems to have moved into German staircases and their railings with the beginning of Classicism. Previously, though (as in the staircase of the former electoral pleasure palace in Trier (#156), the gratings of which were made in the studio of Master Unterseher) the world of Rococo lived with its rocailles, shellwork and acanthus tendrils. Just as rich in Rococo motifs is the grating of a stairway in the Church of Strachow in Prague (#140) which, as opposed to the French gratings, is like those of German and Austrian staircases.

Even when a British staircase, such as that in Lincoln's Inn Field (#153), shows a more lavishly ornamented style with ample

acanthus tendrils, strings of pearls, masks, snails and a monogram, they are found only on the stair risers. The grid on the railing consists of stylized balusters with the construction clear to see despite all the ornamentation.

But when the railing shows its vertical lines in individual bars, then the bar that supports the grid and the handrail does not become clear. The post becomes a trellis with leaves and spirals in which flowers are plaited. Roses are interwoven as on a trellis, and between them, as from behind a curtain, step small human figures and half-figures. The master who made a light, transparent grating for the entire staircase of the prelate's steps at Stams Cloister in the Inn Valley of Tyrol was presumably the cloister locksmith Bernhard Bachnetzer. He inscribed the year on the gate of the upper stairwell (#147). It is no longer known whether strict guildlike rules prevailed in the cloistered community as well, or whether a cloister painter made the grating so lively and colorful.

Here, in any case, the colorful quality of the late Baroque gratings has been retained or recaptured in its entirety. Color absolutely had to be applied to this very thin ironwork. Whether the heavier gratings, that are only black and gold today, sparkled in such happy colors when they were first made is possible, but can no longer be proved. One can imagine their colorful quality to have been like that of the three-dimensional works in the churches. Until the first third of the eighteenth century, the figures were painted in colors; the closer one came to the age of Classicism, the more the single color was preferred, whether white, black or even green.

For Stams Monastery and its particularly rich grating decoration, one can presume a painter's sense of color, for to this day, no smith paints the grating that he makes. The existing documents and accounts of Maximilian's tomb in Innsbruck may be taken as an example for other colorfully painted gratings. Only for such a significant work as this was the "court painter" called in.

Open Stairways

The simple examples of open stairways shown here, from Grisons, stand apart from the style-setting works. They have rows of simple bars with little ornamentation to carry the handrails and give rigidity to the structure. They are nearly undatable and combine scrolls, diamonds and spirals, the omnipresent basic ornaments, refraining from any "fashionable" features. They are timelessly beautiful (#90-92). These open stairways are defined by either the railings, the hanging position, or the arrangement of the house. The living quarters are upstairs. The way to the barn and the shed, the route to the stables, must be downstairs. The basement contains the agricultural section. The open stairways exist, elsewhere as well, in farming or other agricultural buildings, from the necessities of life.

The open stairways in castles and palaces from this period exist for completely different reasons. The inhabitants of such buildings wanted either to go directly from their upper rooms, called the "Beletage", into the garden, or to be able to present themselves, as on the grand stairways inside. The open stairway, like the enclosed staircase, allowed plenty of space for retinues and visitors to move.

The wrought-iron gratings at Versailles have not, for the most part, survived to this day in their original condition. The main castle is, thanks to various bits of information, reconstructible in its original form (#31). The gratings in its large parks and grounds have remained, but not the individual details of them.

As for the details of the open stairways and their ironwork in the Grand Trianon (#94) and the smaller castle of Petit Trianon (#93) in the park of Versailles, we do not know so definitely.

In any case, the fence of one side wing of the Grand Trianon (#95) is completely in the style of Louis XIV, who also had the castle built. With its luxuriant acanthus tendrils, it is reminiscent of the work of Jean Marot from the latter half of the seventeenth century, as seen in the ornamentation on the gate of Maisons-sur-Seine. Whether Louis XV, to whom the grating of the forecourt is attributed, did indeed commission it, or whether it was worked on in later times, it has been made superbly in the style of Louis XIV. It is a splendid grating in gleaming gold, but it is not a grating in order to display great opulence. It only opens — though with considerable elegance — a suite of rooms dominating a descending terrain. The castle has only one story, and a colossal stairway would have been superfluous.

The situation is different at the Petit Trianon (#93). The open stairway with its large landing was made for theater and ceremony. The times had changed; Marie Antoinette, with a sense of taste and art, had had a railing made here with individual imitated balusters. Here the strict discipline was relaxed, grace and gentility had preeminence, and nothing more was to be seen of the ponderous pomp of Louis XIV.

Like the interior stairways, the railings of the open stairways became lighter as the eighteenth century rolled on. The railing of the open stairway at the Buhl House in Trier (#158) is already marked by the style of Classicism. It consists of vertical four-angled bars and a handrail from which hang garlands of leaves, as if part of a party decoration.

In the nineteenth century the villa appeared, the city house with a garden. The location of the house and the layout of the ground floor (where the company rooms were located, the kitchen, the laundry and ironing rooms) determined where the open stairway was positioned. In the nineteenth and twentieth centuries, on the one hand, people looked back to bygone days, while on the other, they invented completely new styles.

The open stairway on Möhl Street in Munich (#163-164) seems to be based, in terms of its clear lines, on French models of the late eighteenth century (#159). Such stairways are normally found inside dwelling houses.

The stair railing in the Casa Mila at Barcelona (#165), by the Spaniard Antoni Gaudi, took a completely new course. Only hints can be seen of the basic forms of the smith's art, scrolls and spirals which are handled very unusually and distinctively. Grooved and bent flat iron bars are made into compressed circles and ovals, with ribbons swinging in between.

The staircase in the vestibule of the Guimard House (1909-1911) in Paris (#167), designed by the owner himself, features designs in the elegant French Art Nouveau style. The handrail swings upward in delicate rods, the railing looks weightless, almost fragile, supported by only a few thin braces with the most ornate leaf decor.

Tombs and Fountains

Only a quick look at the potential of wrought iron in the realm of tombs will be given here. From the renowned tomb of Emperor Maximilian in the Court Church at Innsbruck to the Art Nouveau tomb in the South Cemetery of Munich, just a few important milestones will be presented here. The subject could be covered in a publication of its own.

A grating always affords protection, as we said at the start; protection of a special kind is afforded by the fences around graves and fountains. A raised grave was reserved for the nobility. The heavy sarcophagus itself offered sufficient protection for the rest of the dead, unless it was opened forcibly for the purpose of looting. But sometimes even such a tomb was surrounded by grating.

The best-known tomb grating in German-speaking lands is undoubtedly the tomb of Maximilian in the Court Church at Innsbruck, which we have already mentioned more than once. It must be regarded as an outstanding example of a royal tomb.

During his lifetime, Emperor Maximilian ordered his tomb to be built to keep his memory alive forever. It was a gigantic tomb with an extensive layout which was never completely finished. A guard of honor, including all of his Habsburg ancestors, was to encircle the tomb. Bronze figures of ladies and gentlemen holding candles, in all the iron splendor of their costumes, jewelry and armor, were gathered as escorts around the cenotaph which never held the remains of the emperor (shown in many books). To protect his tomb, the Emperor ordered, in 1573, an iron grating to be built that showed all the motifs that were possible in the Renaissance. Elements of Gothic style, which never completely disappeared in the Alpine area, are also apparent (*Geschmiedetes Eisen*, pp. 48-49).

The symbol of infinity, based on the number 8, is the dominant motif and takes up half of each field. Tendrils, spirals, leaves, and spindle flowers fill the rest of the fields. With all this richness of imagination, great order nevertheless prevails. Alternating with it are various paintings on sheet iron with erotic figures, while beautiful cross and spindle flowers blossom on the crowns (#168).

The grating was designed by Paul Trabel, Innsbruck's city painter, and was made and gilded by him along with Christoph Perkhammer and Conrad Leitgeb. The grating itself was made in Prague over a five year period, 1568-1573, by Jörg Schmidhammer, Emperor Maximilian's wrought-iron maker and gunsmith. The princely tomb in St. Vitus' Cathedral in Prague seems to have been made by him as well. It is possible that Paul Trabel was familiar with this grating and may even have been sent to Prague by his client to study it.

Some old graveyards still contain the gravestones and monuments of past centuries; usually they are cemeteries in smaller towns or out-of-the-way places that still preserve the graveyard culture of times gone by. Cemeteries and city churches are usually left

open nowadays, with the important old grave markers being moved to the outer walls of the church, concealed inside the church, or even placed in museums. For the most part, they are the tombstones of people honored in the material or spiritual sense, including well-to-do patricians.

Prosperous bourgeois families used to strive for a burial place by the wall of the cemetery, have it walled in, and closed off with wrought-iron gratings.

The graves in St. Peter's Cemetery in Salzburg are particularly well-kept. Simple gratings with purely geometrical motifs from the seventeenth century alternate with tenderhearted styles of the eighteenth, taking a little of the deadly seriousness away from the house of the dead. Separation is guaranteed to some of the dead by a memorial tablet or a sculpture in their memory tucked away inside in the shadows.

Other graves have enclosures of low gratings that can offer only symbolic protection and have been erected mainly for the sake of beauty. Few grave fences from the eighteenth century have survived unless they are preserved in private collections or museums because of their particular artistic features. In open cemeteries, most grave sites have turned into places of rest and recovery with the tombstones fallen down, the fences rusted away, or they are gently covered by ivy. If the families have died out, and if the stones are historically important, they may be maintained at public expense. A new cemetery regulation in Germany forbids the enclosing of graves; rather the grave shall be covered with grass with only one tombstone allowed.

Wrought iron grave crosses prevail, or used to prevail, the most wherever iron smelting and working were practiced for centuries. Here one found fields of graves with wrought-iron crosses, and sometimes there was even a grave marker made completely of wrought iron. Perhaps the desire, conscious or unconscious, to see the surrounding country through the grave marker was

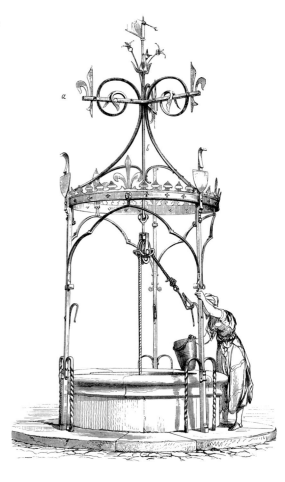

decisive. Seeing through it into the distance, or to the next grave, could become part of one's thoughts, seeing the neighborhood that one knew; such may have been people's thoughts at one time, though it may be just romantic ideas about a feeling of togetherness that we want to feel today. The idea extended from a simple iron cross of two bars to the gridwork of the grave crosses shown here (#176-178). For some time now the crosses once thrown on the trash heap by the cemetery wall have been collected, restored and erected again as memorials.

In the old "South Cemetery" in Munich (#179), there is an Art Nouveau style grave marker of unusual individuality and beauty. On the stone a tree of life with naturalistic roots, trunk and branches is portrayed which rises up from a low enclosure.

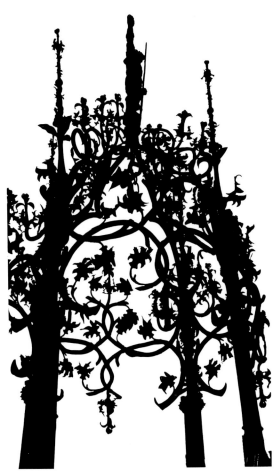

After a time in which the stonemason's handiwork dominated cemetary markers, it appears that lighter grave crosses that can be looked through found acceptance in cemeteries, or "fields of God". *Requiescat in pace* was the meaning of the enclosures, "may he rest in peace," even though his peace, in a mundane sense, could scarcely be disturbed.

On the other hand, the fences around fountains served a practical purpose in more ways than one. They protected the purity of the water, preventing animals from drinking out of it, as well as preventing people from falling into the depths.

In the beginning, there was the simple well for drawing water. The public well used to supply the community with water. A simple raising apparatus made of iron bars fashioned into scrolls, combining art and technical necessity, can be seen in the well at Vezelay in Burgundy (#185). When no water was being taken out, the well was covered with a wooden or sheet-iron cover. In Gothic times, the water-drawing apparatus was already developed into a canopy on four pillars, decorated with tracery and leaves, as seen in the example of the well at Spontin, France (#183). A similar renowned example is the 1470 well in Antwerp (#27), perhaps the last Gothic well to be covered with an iron helmet.

The well covering at the Landhaus in Graz, Styria, is also covered by a canopy. A protective grating is unnecessary here, probably because the well is not at a place accessible to the public. The well is not made of wrought iron, but was cast in bronze by Thomas Auer and Marx Wening in 1589-90. It is possible that most wells of this type have disappeared, since bronze was easier to melt down. One can assume that there were many such wells made of forged iron.

The seventeenth century was the greatest period of well coverings in Austria and the former Danube monarchy. In no other land has such a quantity of lovely well designs survived. The mechanism has changed; water buckets are no longer raised by hand, for as the need for water rose in a growing community, water had to be made available more easily and quickly. The crank winch was developed. One of the most outstanding creations is the well cover at Bruck an der Mur, in Styria (#186). According to the inscription on the stone socket, the stone cross was built in 1626, the covering, the canopy itself is probably somewhat older. The wrought-iron grating around the well was added only in 1693. Spirals and flattened leaves form the main elements of the enclosure, while there are still Gothic traces in the canopy and all kinds of animals made of cut sheet iron. To be sure, on the four sides of the canopy there are scrolls with extending leaves up to the crowning cross-flower, but the arrangement itself is reminiscent of crabs that are seen on Gothic pinnacles.

The well covering at Bruck an der Mur has an almost cross-shaped ground plan, while the well in the cloister courtyard at St. Florian in Upper Austria is in a rectangular housing against the wall. The housing is completely closed here; a balance wheel raises the water. The well was built in 1603 and is thus a very early example of this type. Renaissance ornaments, tightly arranged, give the impression of extreme closeness.

Years later, at Vordernberg near Leoben in Styria, another enclosed well was built. Here Baroque style had already become fairly prevalent. The well stands on a square foundation in the middle of the market place. The features of Renaissance art have disappeared; many arrangements of scrolls, spirals and the infinite number 8 (individually set on round iron plates) are the only decorative elements. They provide a charming play of ornaments with their cuttings and piercings. The purely geometrical pattern becomes a beautiful, airy work resembling lace. On the flat arch segments of the canopy, the hood, scrolls ascend to the crowning flower. The well is dated 1668 (#180). The individual pieces of the ornaments are held together by bands.

Styria possessed large deposits of iron ore, so it is not surprising that the smith's art was developed to such artistic heights there. Exceptional designs were made not only for interior use but, most of all, on outside windows, balconies, stairs, churches and graves.

In the seventeenth and eighteenth centuries, Silesia belonged to Austria, which explains the double eagle on the well covering in Neisse. Artistic work here documents rich traditions of the former Austrian Empire. In the manner of Greek statues (such as in the dedication inscription on the Nikandre from the 7th century B.C.) one can read on the Neisse well cover's circular stone foundation the following: "Anno 1686, for the pleasure of a praiseworthy magistrate, made by Wilhelm Helleweg, Weaponsmith". At Neisse, the flat bar is also extensively used,

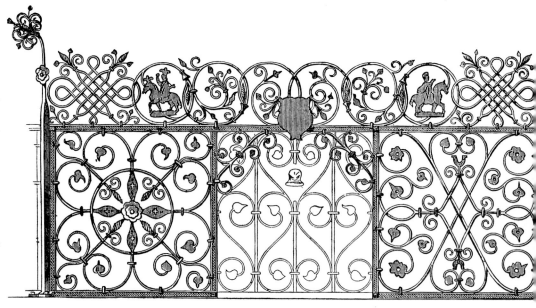

28. Grating on St. Florian's Fountain near the archbishop's apothecary shop in Salzburg, 1583. Drawing from Wilhelm Lübke, Kultur der deutschen Renaissance, Stuttgart, 1882.

and decorated with carved or etched ornamentation. The inscription is on the central band around the cylinder. The cylinder, like the cupola roof, is covered very thickly with wrought iron decorations of spirals, leafage, and opposed scrolls as the main ornaments (#192). Twenty years earlier, the well in Vordernberg was built exclusively of round bars with uniform ornamentation.

Besides wells with low gratings and canopies, or with closed housings, there have been, since the sixteenth century, wells with only a protective grating, in the middle of which an architectural superstructure or three-dimensional decoration was built.

The most famous example is probably the "Beautiful Fountain" in Nuremberg (#187-191). Its history can be characteristic of other fountains as well, so a closer look is in order.

The original grating was made in Nuremberg in 1587. The well itself goes back to the fourteenth century and was surrounded by a simple grating of pierced square bars. The well deteriorated in the following centuries, until rebuilding began in 1587. The Gothic substructure with square bars was retained, with only some rings, leaves and diamonds added, ornaments that form vital links between Gothic and Renaissance styles. Onto this basically Gothic foundation there was set a high crown in a style approaching that of the Renaissance, with spirals, leaves, imaginative ornaments and large cross-flowers. The master was the Augsburg locksmith Andreas Kuhn, whose job included providing the lavish gilding. The master also added a movable ring, a playful touch popular in larger works, which still adds pleasure to the work today.

In the nineteenth century, the grating was thought to be too heavy. It concealed the pillar, and in addition it was regarded as not matching the style of the fountain. In 1823, Locksmith Pickel installed the present crown,

which does indeed give a better view of the Gothic fountain pillar, the original of which, though, has been in the Germanic National Museum for a long time. A copperplate engraving, also at the Germanic National Museum in Nuremberg, shows the original high crown (Brüning-Rhode, #30), and today it is no longer possible to see why the original grating had to be removed. Presently, the grating on the fountain, as was customary in Historicism style, shows an overabundance of ornaments with round and flat bars, slim and extended spindle- and cross-flowers, coats of arms cut out of sheet iron, and winged allegories. Along with them is the Virgin's Eagle, a symbol of Nuremberg, in half-relief on chased sheet iron. The grating, once richly gilded, was covered with black paint. The sixteenth century Beautiful Fountain in Nuremberg started a long series of fountains with a stone structure in the center. The protective gratings were made lower from the start, so that the view would not be obstructed.

Toward the end of the sixteenth century, circa 1583, the citizens of Salzburg erected a fountain under the direction of their prince-bishop on one of the loveliest squares in the old city, near the prince-bishop's court pharmacy; it bore a statue of St. Florian (#28). One could almost say that the fountain and the square in which it stands make a visit to Salzburg worthwhile. The Renaissance ornaments are arranged in delicate form and pure style. Round bars form scrolls with ends hammered into leaves or forming spindle-flowers. Fields resembling net fillet have been formed with plates of sheet iron between them bearing portrayals of saints on horseback (such as St. George) and of animals, including some mythical ones like the unicorn. The only ornament that is still reminiscent of Gothic decorative elements is the cross-flower, but this was utilized throughout the Renaissance; in fact, it enjoyed its greatest popularity then. Of course, the state of preservation of the monument must always be kept in mind.

In the seventeenth century, there also appeared the famous Dragon Fountain at Klagenfurt in Carinthia. The locksmith Georg Tillitz forged the grating on the rim of its graceful basin in 1634. In beautiful colors, it surrounds a gigantic dragon and a club-wielding giant. This Dragon Fountain has become the symbol of Klagenfurt.

As early as the sixteenth century, it was no longer necessary to raise water from the Beautiful Fountain in Nuremberg, as the water could be made to flow by using pumps. Just like the St. Florian Fountain in Salzburg, water could be taken from four pipes simultaneously. The Baroque fountains in the cities no longer existed solely to supply the population with water; by now they were mainly decorative. It had become feasible to pipe water into the houses.

The Neptune Fountain, the so-called "Fork-Man Fountain" on the square at St. Michael's in Bamberg, was built, as far as the three-dimensional figure with the trident is concerned, in 1698. The protective grating was added only in the middle of the eighteenth century. All the typical Renaissance ornaments are no longer to be seen. Instead of cross-flowers, there are now small obelisks on the supporting pillars, and a new ornament, typical of the eighteenth century and presumably originating in France like so many seventeenth- and eighteenth-century ornaments, appears here in the crown. A cartouche is now placed on iron plates set in diamond shapes, with decorative rosettes forged at the crossings. The cartouche is an ornament that splendidly characterizes the decorative art of the middle third of the eighteenth century and ranks among the particularly popular developments of the time. The diamonds set with rosettes were already used in the Gothic period (#195), but now they have broken outlines (#343) and look considerably more playful, graceful, or capricious than they did with heavier frames in the fourteenth century. With the completion of water supply systems for the cities and market places in the nineteenth century, drinking water could be piped into the houses, with central public facilities supplying the water. Public fountains and wells became less and less necessary and turned into purely decorative elements in the streets and squares, and people no longer met at the public well as they used to.

There are "still fountains" that were surrounded by gratings. One is the fountain in Munich with the lovely green-painted Art Nouveau grating (#197, 199). Ordered in 1908, it was made to a design by Friedrich Delcroix. More and more fountains are being built for decoration and for cooling, and because the sound of the splashing water has a calming effect. This type is known as the "still fountain." Other fountains have moving parts and are used in children's playgrounds or even at adult meeting-places when the architecture of the place provides many seats. They are also used by young and old as places to cool off during the hottest days of summer.

Gates and Park Fences

Books about objects of art and commercial art are generally organized chronologically and deal with main epochs of style. Here the attempt is made to classify work not according to its date of origin, but rather according to its use.

Another question that comes up is why and at what time different functions were applied. The basic forms of ornamentation were continued while their applications in different times and places varied; they appeared in the foreground, became dominant, withdrew into the background, and stepped forward again with a changed nature for a new function.

Large gratings at their original sites have survived only since the fourteenth century. They can be found and are carefully maintained in northern Italy where they last better in the hot, mostly dry climate than in the damp, snowy areas north of the Alps. Large gratings can still serve their original purpose, that of protecting a consecrated area, when the gates are usually closed. For example, the fence around the baptistry in Bergamo and those around the Scaliger tombs in Verona can be regarded as structurally typical of their time period and country of origin. At Verona, quatrefoils are placed in rows at regular intervals and are overlapping. The quatrefoils with the stretched lily- or cross-shaped ornaments, which look like small spears, are similar to each other. At Bergamo, the interior of the quatrefoil remains empty at Bergamo, making a cross shape. At the Scaliger tombs in Verona, the space is filled with the symbol of the Scaliger family, the ladder. Thus in contrast to the more severe gratings in Bergamo, they look like lace curtains hanging in front of the tombs (#201-202).

Nothing similar has survived farther north. The great days of grating gates really began there only in the Renaissance, and Germany plays a leading role in this area. Among the outstanding creations are, as already noted, the fountain gratings, but the great church gates can also be cited as noteworthy achievements. Once again, it can be mentioned that France cannot be judged here, for here again, the French Revolution must be held responsible for losses that cannot be replaced.

Austrian ironwork is included here under the heading of Germany because culturally Austria is a mainly German-speaking area. It has also been shown that an active exchange of master smiths took place across the border. For example, Tyrolean Johann Georg Oegg, who was called to Würzburg.

The gate of St. Lorenz in Nuremberg (#205) might at first be classified as Gothic after a quick glance. The cross-flower flourishes in its crown, and the middle section is enclosed in a donkey arch. But the elements of the new style, the spirals with the added fantastic forms that appear to have been taken from both the plant and the animal kingdoms, are also to be seen. At this time and for this application, inspiration surely came from the ornament makers and small-work masters such as Aldegrever, Behaim, Peter Flötner, etc.

The round bar, which has been mentioned already, allows a greater variety of shapes and is more decorative than the square bar, and its flexibility could be utilized particularly in the larger gratings. In Germany, the Renaissance seems to have brought back the vegetation patterns of the Romanesque era (#45), though without copies having been made of them; rather the bundle of scrolls that project out of the bundles like bouquets of flowers were imagined and developed in new ways.

The ends of the scrolls were hammered out, widened into flowers, stars, rosettes and fantastic figures, like those on the Bride's Door at Urach (#209, 211). Elsewhere, lance-shaped flowers were inserted, combining with the scrolls to form lily ornaments like those on the grave of St. Francis in Assisi (#212). Spears were retained in the crowns, even though their hostile effect is moderated by swinging scrolls, as on the portal of the Church of Chiesa di Santa Chiara in Assisi (#210).

In the two great German church portals of the seventeenth century, the cloisters of the cathedral in Eichstätt (#208) and that of the archbishop's palace in Aix, France (#29), the difference of terrain may become clear. Both gates are built into a prescribed type of architecture. The grating at Eichstätt fits into the lines of the pointed arch and fills the surfaces with luxuriant, curvaceous decor. A completely different approach is shown by the grating in Aix. Here a grating was built into a stone frame, with "pillars" on its sides, vertical square bars, while the horizontal bar that affords rigidity is visibly set off. In the lower part there are two fields that appear to have been created to imitate door fillings. To the clear lines of the four-angled bars, a few rosettes, acanthus leaves and masks have been added.

Between the two gates there is a time differential of some fifty years, but in principle, the national particulars differ through the centuries, even when produced at the same time.

Even when the portal fillings almost overflow with vegetable patterns and three-dimensional griffin heads or scrolls of acanthus tendrils unfold and rosettes add their three-dimensional forms, the supporting and load-bearing parts still remain clear as to their function. The strict order of symmetry is never omitted.

The portal of the castle of Maisons-sur-Seine (#215-216), built for René de Lonqueil by François Mansart in 1642-1651, has scarcely anything in common with the gate of the dedicatory hall in Lenggries (#218) in terms of size and grandeur. Yet the differences between the German and French concepts of

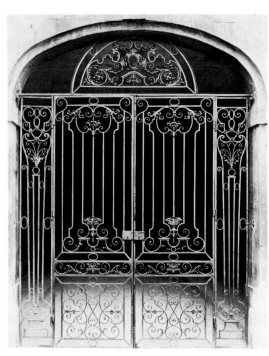

wrought iron can be seen clearly.

At about the same time, in the middle of the seventeenth century, the cemetery gate at Lenggries in Upper Bavaria was built (#217). The two Lenggries gates share the round arches of the scrolls and the symmetry of arrangement, but they both lack structural framework, a means of stability and that characteristic remains the same in Germany through the centuries. The spindle-flower here is held firmly in the branches of the scrolls. In France, this lack of structural support had long since died out, along with the cut and painted sheet iron, in the sixteenth century.

The same comparison can be made with British ironwork in the seventeenth century where the tendency was toward clear construction of the grating with inscribed ornaments, cool, matter-of-fact, and without the naturalistic life of the German grating. The same tendency for structural design applies to Italy, as shown by an eight-section grating at the Victoria and Albert Museum (#224).

In the second half of the seventeenth century, the era of gates of honor began, "grilles d'honneur", as they are called in court language. Much has been destroyed, and particularly in France, where these gates came

into style and were most widespread. They could be found not only at royal castles, but in great numbers at the country estates of the nobility as well. The French Revolution caused many changes here too, though it was not everywhere that, as happened at Versailles, the bars became used as lances to impale the heads of the palace guard.

It is not possible to evaluate these large gates only by art-historical, stylistic criteria. The social conditions played a decisive role in their existence.

In earlier times, the castle stood off on some lonely hilltop, or, if there were no hills around, it was separated from the community by bastions, walls and moats, protected from enemy encroachment in flat terrain as a moated castle. In order to enter the heart of the castle, one first had to conquer its entrance, the approach to which was limited by moat and drawbridge. Heavy iron-studded gates were reinforced by a portcullis with large blades. Extensive as they were, the castles guaranteed refuge to peasants and handworkers in time of war, thus protecting the community and the lower classes. The underlings, though, were simultaneously called upon to defend the property of their feudal lord. Master and servant lived close together.

New times, with their new means of warfare and the invention of gunpowder, made bastions, walls and moats superfluous. The lord of the castle moved into the city, or built his community into a larger city, and became the lord of the manor. He also built a summer retreat not far away from his urban residence.

Modest at first, even in the Renaissance, and also isolated from the world outside, the buildings and inner courtyards formed groups in which the court, the nobility or the wealthy patricians conducted their private lives. Stately accommodations were also within the inner structures. The rich burghers, like the nobility, entered through a wide gate in the front wall of the manor to reach the first inner courtyard, the gates closed quickly behind them, and high society was invisible to anyone who passed by.

In the Baroque era, with its emphasis on splendor, whoever could afford to made a display of his relative opulence. The people put themselves on display; they wanted to be seen. Rulers and nobles wanted an audience for their theater and well-conceived appearance. As far as new buildings were concerned, the elegant staircase, of which we have already spoken, was added, and the inner courtyard was moved outside. Thus the court of honor was created, and it was made as large and opulent as possible. Open stairways, as noted, led to the courtyard, so that the lord, escorted by his retinue, could walk up and down the courtyard, so as to surround his own arrival or the comings and goings of his guests with worthy ceremony. He wanted and had to be seen, though the common people should not be allowed to come too close. An audience of joyful, excited, and admiring people was wanted, and if those of ill will should be found among them, then the protective grating was there to ward off hostilities and protect the dignitaries.

The grating of the court of honor at Versailles (#231), which accents the castle so beautifully (#232) with its gilded decorations, has a checkered past. It is the only reproduced grating in the entire palace complex, and only engravings by Silvestre, Regaud and Lepautre can give an impression of the extent of the wrought-ironwork around this castle. Versailles became a model for other royal courts and inspired many imitations, in more or less lavish form, depending on how much money could be spent. Here the gateways of the Cour de Marbre and the Cour Royale have disappeared, and only that of the Cour de Ministres or Avant Cour remains, though not in its original form.

The original stone pillars with vases on top have been replaced by wrought-iron "pillars". Stylized inscribed lyres are crowned alternatingly with crowns and suns, the latter being the symbol of Louis XIV.

The original grating was damaged in the French Revolution; the spears were used as weapons, and only in the First Empire, under the direction of the architect Dufour, did restoration begin, with the changes already noted.

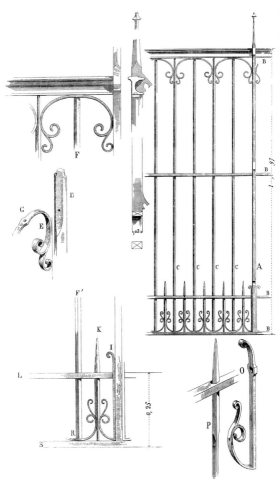

Thus the present grating cannot be regarded as an example of wrought-iron art under Louis XIV at Versailles, as far as details go. According to an engraving made in the eighteenth century before the French Revolution (#31), the composition of the original can be determined. The gratings could be seen through very easily, for the royal pageantry was to be concealed as little as possible. Vertical bars were attached by horizontal bands of ornaments.

Of all the splendid wrought-iron creations that were found not only in the park at Versailles, but also at the country seats of the nobility, practically nothing has survived.

Not only did castles have courts of honor, but the entries of hospitals also were closed with gratings, for their architecture, usually a three-wing layout, was similar to castle architecture. The large hospitals which were built on the Pilgrims' Way from France to Santiago de Compostela were obligations of the princes, particularly the rich dukes of Burgundy. The most beautiful hospitals were built in Burgundy, the Jura, and along the Rhone.

The Hospital of St. Jacques in Besançon was founded under the auspices of King Louis XIV and granted lavish privileges. The monumental gate (#228), dominated by the high section with gilded decorations, coats of arms and inscriptions, was built at that time. Here too, the architecture is stressed in its supporting and load-bearing parts, with only a small frieze closing off the gridwork of the bars at the top. The grating was completed in 1703 by *maître serrurier* Nicolas Chapuis. The park around the building was finished in 1674, in the style of Louis XIV. A similar grating with a splendid gate is also found, for example, at the Hôtel-Dieu de Troyes; it was created in 1760 by Pierre Delphin, *maître serrurier* from Paris. Specimens of this genre also include the gates of the Palace of Justice and the Ecole Militaire in Paris (#36).

The open stairways of the Grand Trianon in the park at Versailles (#94-96) and the smaller Petit Trianon (#93) have been mentioned. A small court-of-honor grating, in comparison with that of the Grand Château, can still be seen at the entrance to the Grand Trianon (#234). It is no longer possible to determine exactly when it was built, unless information should still be found in the documents of the castle. To be sure, Louis XIV had the castle built — so the story goes — for himself and his friends, in order to be able to spend time far away from the ceremonial strictness of the court, but his successors built onto it, and so it can probably be assumed that the gratings in their present form were added only in the middle of the eighteenth century. They are more decorative, more elegant, and the "thorn plait" that prevents climbing the wall by the moat is, in terms of its lightness and grace, more probably ascribable to the time of Louis XV. The colors of white and gold, which are presumably original, corroborate this.

A completely different picture is presented by the great eighteenth-century park gates and gratings of Germany and Austria. For Germany, the high point began, understandably, only long after the Thirty Years War. Only then could the masters become more numerous, when prosperity had once again developed to the point where large-scale contracts could be given. How much imagination was included in the vertical bars, and how light and airy the crowns are in contrast to those from the France of Louis XIV! Even though the sovereigns in principle wanted to imitate the *Roi Soleil*, they did not do it slavishly, but translated the model into their own style.

In Vienna, the Upper Belvedere, the pleasure-house at the summer residence of Prince Eugen, was built by Lukas von Hildebrandt in 1721-1723. At the entrance to the court of honor are three wrought-iron gates (#239) whose crowns, so light and easy to see through as if they were drawn in the skies, rise up over the simple bars of the wing doors. The severity of the lower structure, with its vertical bars, is mitigated only by borders, and all the richness was devoted to the crowns. The massive crowns of the French park doors are not to be found here.

The gate at the court of honor of the Palais Potocki (#237, 238) in Warsaw reflects the same spirit, even though in more modest proportions. The crowns are light, airy and decorative, with shells, ribbons, rocailles, flowers and leaves swinging into the bars of the gates.

The gratings of France, and also of Britain, are always two-dimensional, flattened, as a grating has to be for physical reasons. In Germany, though, the crowns are sometimes also the lower structure, multi-leveled, three-dimensional, plastic, reaching out on both sides.

An outstanding representative of this trend, who was not the only one, is Johann Georg Oegg of Tyrol whose chief works are in and around Würzburg. The master was born at

Sils in Tyrol, learned the craft from his father, and continued his training as a journeyman, which was customary then. Finally he reached the court ironworking shop of Prince Eugen in Vienna, from which he was invited by Prince-Bishop Karl Friedrich von Schönborn to his court in Würzburg, where he died on October 8, 1780. The Prince-Bishop named him court locksmith. The Schönborns were all bitten by the "building bug", and a prince-bishop's court was scarcely inferior to that of a secular ruling prince in terms of splendor and expense. This prince of the church presumably had an advantage over a secular prince, in that he did not have the obligation of supporting a family.

A splendid castle was built in Würzburg, with a court of honor and a large park. Large fence gratings were essential for it, and presumably Lukas von Hildebrandt, who built the Belvedere, had recommended Johann Georg Oegg to the Prince-Bishop.

The large grating that closed off the court of honor has disappeared; presumably it was melted down. If it were sold anywhere, it probably would have been recognized because of the uniqueness of Oegg's work. Contemporary copperplate prints provide an approximate picture of the extent and arrangement of the grating. A few gratings at the court garden have survived (#241-245), at the Castle Square, the Raceway, and the Court Garden Promenade. They show the great ability of Oegg, for there is nothing in Rococo Germany that can equal them.

The gridwork on the reception desk at St. Julius' Hospital in Würzburg may also be included as an example of Oegg's art. The crown, which is the Prince-Bishop's coat of arms, seems to float on a swirl of waves, with rocailles, shells and ribbons, leaves and flowers intertwined to make a multi-layered picture of considerable depth. The structure completely conceals its real purpose, that of a support on which druggists' equipment can be hung (#240).

For thirty-three years, from 1734 to 1767, Oegg and his assistants worked on the castle in Würzburg. Over this long period of time, a change from lively, bouncy Rococo to the more restrained Empire style took place. Simple garlands then hung from simple, clearly formed closing arches, where intertwined scrolls, broken pieces of bars, support the swirling figures of the framework. The gridwork, studded with rosettes, a favorite ornament of Rococo times, disappeared again, the supporting scrolls became visible and could be seen through, and above it there swung only restrained, slim shellwork.

Equal to the gratings of Würzburg are those of Nancy, though for different reasons. In Nancy (#230), the grating forms an area of space in which the grating itself is an essential part of the architecture, whereas the front grating merely closed off the court of honor in Würzburg.

In Würzburg, Balthasar Neumann, the builder of the castle, probably contributed to the designs for the gratings. Whether, and to what extent, Emmanuel Hérés, the architect of the square, had influence on the design of the gratings is not known.

Jean Lamour (1698-1771) was the court locksmith to Stanislas Leszcynski, the former king of Poland, who had settled in Nancy and Luneville after his abdication and promoted the arts there very much. Jean Lamour, like Oegg, learned his handiwork from his father, the city locksmith in Nancy. He too became a journeyman, worked in Metz, and then went to Paris for further study. His greatest times were spent under the patronage of Stanislas Leszcynski, who had been recompensed with the Duchy of Lorraine, and who promoted him to court locksmith from the position of city locksmith in Nancy, an office which he had inherited when his father died. There are still numerous works of his in existence in and around Nancy but many have also disappeared, though they are illustrated in his book *Recueil des ouvrages en serrurerie*.

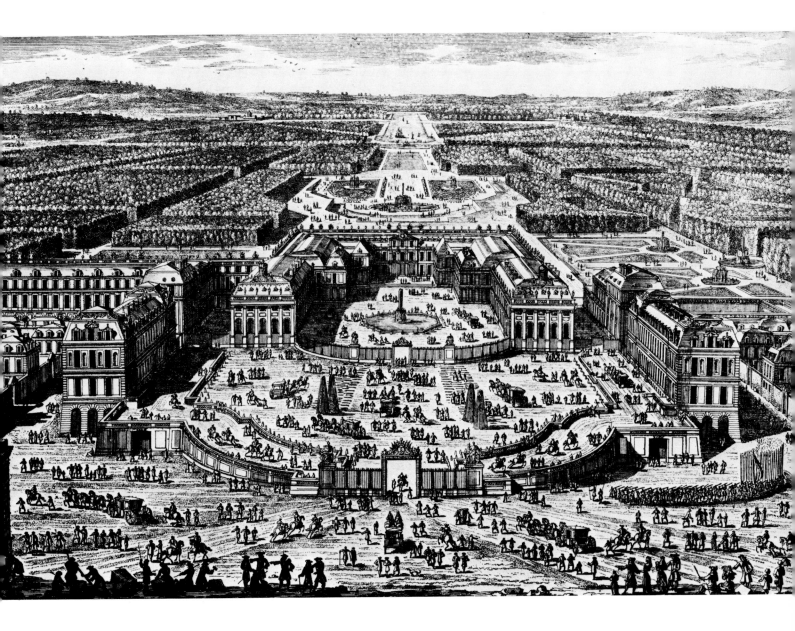

31. The great palace of Versailles with gratings before the courtyards, copperplate, pre-1722.

The designing and making of the wrought-iron works can probably be attributed exclusively to Jean Lamour. The work of Hérés, *Plans et Elevations de la Place de Nancy* of 1755, indicates this. The wrought-iron works are not included, for they were still being made and were probably finished only around 1760, at a time when the Würzburg gratings were gradually being erected.

The square is rectangular. The south side is completely taken up by the city hall, while various buildings stand on the other three sides. At the corners, and at the streets that go off from the short sides, there are six openings in the square area, which are closed optically with gratings and large gates. Opposite the Hôtel de Ville, two monumental structures, their black color enlivened by gilded decorations, fill the corners. The ornamentation is said to have been done in two-tone gold originally. The other four square openings are closed off by structures similar to portals, which are still decorated with particularly lovely lanterns. The two big structures, resembling triumphal arches, enclose fountains with statues of Poseidon on one and Amphitrite on the other, each accompanied by a retinue of water spirits and cupids. The figures, cast in lead, were made by Berthelémy Guibal. Typical of French taste, the ornaments are not lavish, and the structure is most important. The crowns are massive here, as in Versailles and Besançon, with rows of coats of arms, insignia, acanthus tendrils, medallions, rocailles, crowns, profiled heads and such in relief. The whole atmosphere, in contrast to that of Würzburg, expresses noble restraint with all its pomp, which becomes visible in size, arrangement and pattern. The elegant overall decor, with the fountain and its more than life-size statues, does not find expression in Würzburg, but here the greater artistic skill and delicacy, the playful fantasy, is all the clearer.

The crown was rebuilt in simpler style in 1879.

On the grating in Nancy, the framework with its vertical bars and load-bearing horizontal members is noticed first, an architecture that is overplayed by small ornaments. These are hanging between the bars, though the larger ones actually break the vertical bars, which continue above them as if the ornaments were just hung on them, an extremely artistic design.

In Würzburg, the vertical square bars carry an abundance of ornaments, rocailles, shells, flowers, leaves, architrave pieces, fields of grids in lively, flowing frames. The supporting bars swing out in scrolls, which in turn are overlapped by acanthus leaves and shell designs.

Würzburg is the high point of the smith's art in the eighteenth century; the square in Nancy unites architecture, iron forging, sculpture, water and buildings into complete harmony.

The works of Jean Lamour have almost all been lost, whether they were destroyed or sold in times when the owners no longer had any appreciation for the styles of the past.

Johann Georg Oegg made other gratings in the same style as those in Würzburg, even though in more moderate versions, for smaller country estates such as Werneck Castle in the vicinity of Würzburg. His style is unmistakable, as the aforementioned grating in the apothecaries' shop of the St. Julius Hospital in Würzburg shows.

Park gates of former or existing noble residences, or even religious properties, can still be found in great numbers from south to north. In the south, in Austria, a large number have survived, and that may be because the iron mines and the art of ironworking were developed to a higher degree there. Naturally, more and greater masters also developed there. Another reason may be that the south communicates more readily than the north, that its people are more open to the fleeting play of light and shadow than people who prefer plain brick buildings to more decorated styles.

The gates resemble each other, have the same elements of style in terms of form and decoration in the middle of the eighteenth century, and yet they are not the same. In their simple form, they end in a rounded arch at the top, with the crown consisting of soft Rococo ornaments that hold a lantern, a coat of arms, or a monogram between them. The vertical bars are more strongly functional with the advancing centuries, and thus in terms of appearance. The grating is also easier to see through, aided by the flat bar which came back into use again (#246-248).

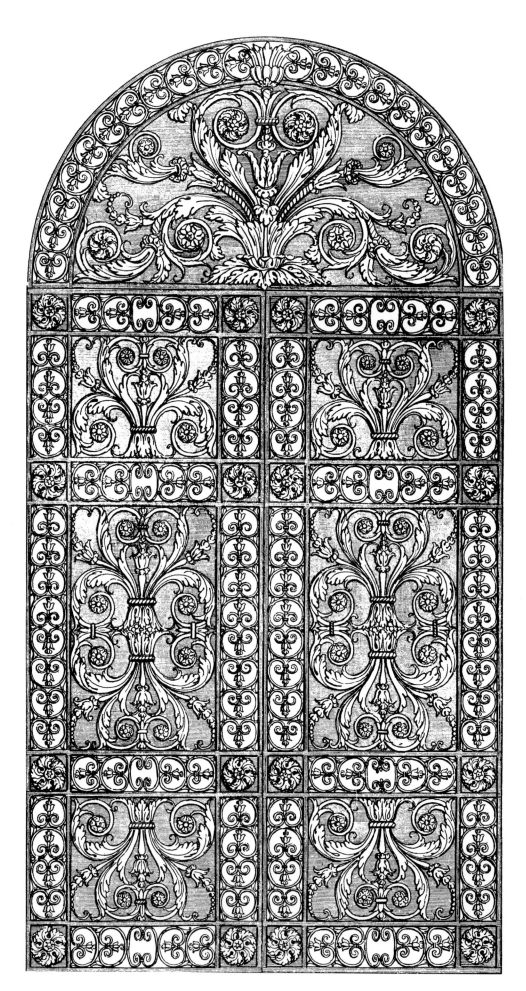

A difference in terms of landscape can scarcely be seen. In Switzerland and Austria, round-arched gates alternate with those with a straight closing and a particularly lavish crown. Garlands hang on them, scrolls roll up, broken diamonds, shell and ribbon motifs appear, according to the customer's wishes and the master's ability. It may be that the Swiss grating gates show richer decoration, a heavier interior design than gates in other areas of Austria and Germany. Perhaps the grating was not supposed to provide a good view of the interior of the place, according to the Swiss nature, or perhaps it was just to show greater wealth. Ornaments are piled on more closely, but they are the same ones that we find on other gates and gratings.

This simultaneous appearance of motifs, designs, and ornaments in different places has definite reasons. First of all, one must remember that the guild system insisted on having its members travel after they finished their apprenticeship, so that before they could settle down, they first had to spend several years "on the road". Thus they gave and received inspirations on their wanderings from place to place. But perhaps that was not the main reason for the resemblance of many works.

The main reason for such similarities can be found in the great numbers of pattern books that gave the smaller smiths models to imitate and be inspired by. One adopted — and this applies to the greater masters as well — the ideas of others without trepidation, felt not at all like a despicable plagiarist, and there was no legal copyright to hang over anyone.

The pattern books first appeared in the seventeenth century but reached their greatest distribution in the eighteenth. Many masters had their works duplicated in copperplate, dedicated them to their sovereign, and proudly showed their creations to their fellow men; thus they gained the greatest distribution, for long trips were possible only by the wealthiest of them. Single pages were also distributed, and with them the copperplate dealers moved from town to town, so that even the smaller wrought-iron masters could obtain the patterns of the great ones.

France already began to attract attention with its pattern books in the seventeenth century. One of the great master smiths was Jean Marot, who published a large book of copperplates showing his works. Numerous engravings of Jean Marot have survived, and his works attracted the greatest admiration, but he found no real successors and did not found a school. His acanthus tendrils, imaginary animals, coats of arms, insignia, and serpents are masterpieces from the beginning of the reign of Louis XIV, but they look more like cast objects than pieces forged by hand. His contemporaries did not follow him; perhaps a greater degree of creative art was called for than most metalworkers possessed (#32).

A far greater influence on wrought-iron work was that of Jean Bérain, one of the most brilliant creators in the realm of wrought iron (#35). He above all gained, with his ornamental work, the greatest influence on the work of Germany and Austria. His effect extended over half a century, far beyond his death, for his designs spread ever farther thanks to various engravers, were included in the work of later smiths and in their pattern books.

Since all of Europe, except Spain and England, turned to France for interior decoration and commercial art in general, it was, above all, copperplates of French models that became known far and wide.

One of the most important metalwork books of the Rococo era was published around 1740 (#25) by Gabriel Huquier (1695-1772). His works also became very widespread, and through them he was able to gain enduring influence. Gratings had become very thin and elegant. Acanthus tendrils lost the fleshy fullness of Louis XIV style and had become very tender shoots.

Shellwork, which was very popular among the Germans, was utilized only very sparingly. In simple, general terms it could be said: The lighter, softer, more transparent the grating, the more French influence was at work.

Since, as was stated, no copyrights prevented anyone from taking and using any of another's designs that pleased him, it is often hard to determine which works were made by whom. Works by Huquier, for example, also show similarities to those by Meissonier and Oppenord. Meissonier ranks among the most fruitful creators of Rococo commercial art, but it is not always easy to determine which were his original works.

There were also special instruction books, such as the collection of designs for balconies and stair railings published by Moreau in 1762. Not all of these pattern books, the literature of this branch of commercial art, that came out in France can be listed here. Naturally, the Germans published them too. In Germany there appeared what was judged one of the best pattern books of the time, *Newly Invented Metalwork Pattern Book drawn by Franz Leopold Schmittner, Journeyman Locksmith*. He was born in Vienna in 1703 and presumably died there too, drew very good leaves and ribbons, and also a very nice perspective grating.

Between 1742 and 1745 there appeared *Nouvellement Inventé par François de Cuvilliés, Conseiller et Architecte de sa Majesté*. Cuvilliés was responsible for the most charming creations of the Rococo era.

The "leaf- and ribbon-work", as the German engravers and master smiths called Bérain's style, found wide distribution thanks to the German engravers, and they were responsible for the knowledge of his works, for scarcely anything of his work has survived. Augsburg was the center of publication for pattern books and individual sheets of copperplates.

Johann Georg Hertel published the metalwork book of Johann Georg Rummel; he and Martin Engelbrecht were the main publishers. Johann Samuel Birkenfeld, Emanuel Eichel, Josef Baumann, Philipp Jakob Kessel, Franz Xaver Habermann, Johann Auer, Johann Andreas Graffenberger and others were the more or less widespread authors of pattern books. J. C. Weigel published a *Neues Bändel-Werck Büchlein von Schlosser aufgezeichnet.* It was a high point of the smith's handicraft, which would never be equaled before or after.

Spain went its own way; its doors and windows have been noted already. Britain also adopted more austere forms in the eighteenth century, unless one called in a French master smith or used a French pattern book for a grating. Here Jean Tijou and his works were influential; his patterns set the tone. Around 1700, the smith's art reached a new high point in Britain too, inspired by William III (1688-1702) of the House of Orange. Presumably

he brought a preference for the material and its use over from the continent.

It can be assumed that Christopher Wren, the "creator of modern London," invited Jean Tijou to design various works for the court. His main works were created in the years around 1700, thus in a time when the style of Louis XIV was still at its zenith. The drawings in his metalwork book, and the drawings for his work that have been preserved at Hampton Court, still clearly show the French influence on his work. In 1693 he published his own *New Pattern Book with Many Kinds of Ironwork, such as Gates, Crowns, Stair Rails, Fillings, etc., of which the greatest part have been made for the royal palace of Hampton Court and the houses of numerous persons of rank in this monarchy. All for the use of those who want to work iron with skill and art* (#37, cited by Brüning-Rhore, p. 77). It was published anew in 1890 by Starkie Gardener of London.

Some of Tijou's works are intricate and

overloaded. The acanthus tendrils are still closely related to the works of Jean Marot and can be compared to the doors at Maisons-sur-Seine in their broad, flabby structure. The posts, like those at Versailles, have inscribed lyres, heads look out of crowns, and animals climb through the thin tendrils.

The bibliography in the appendix includes a list of the most significant pattern books, so that here we need note only the few that were particularly influential in setting styles or became particularly widespread.

The Spanish grating stands by itself, and will be dealt with particularly in the chapter on church gratings. The gratings are severe and defensive, the vertical line is stressed; where the grating stands free and thus crowns are necessary, the crown becomes a sharp barrier, very reminiscent of the drawings that Violett-le-Duc made of Gothic gratings. The slender comumns, inspired by balustrades and looking as if turned on a lathe, are a Spanish specialty that scarcely appears elsewhere in Europe.

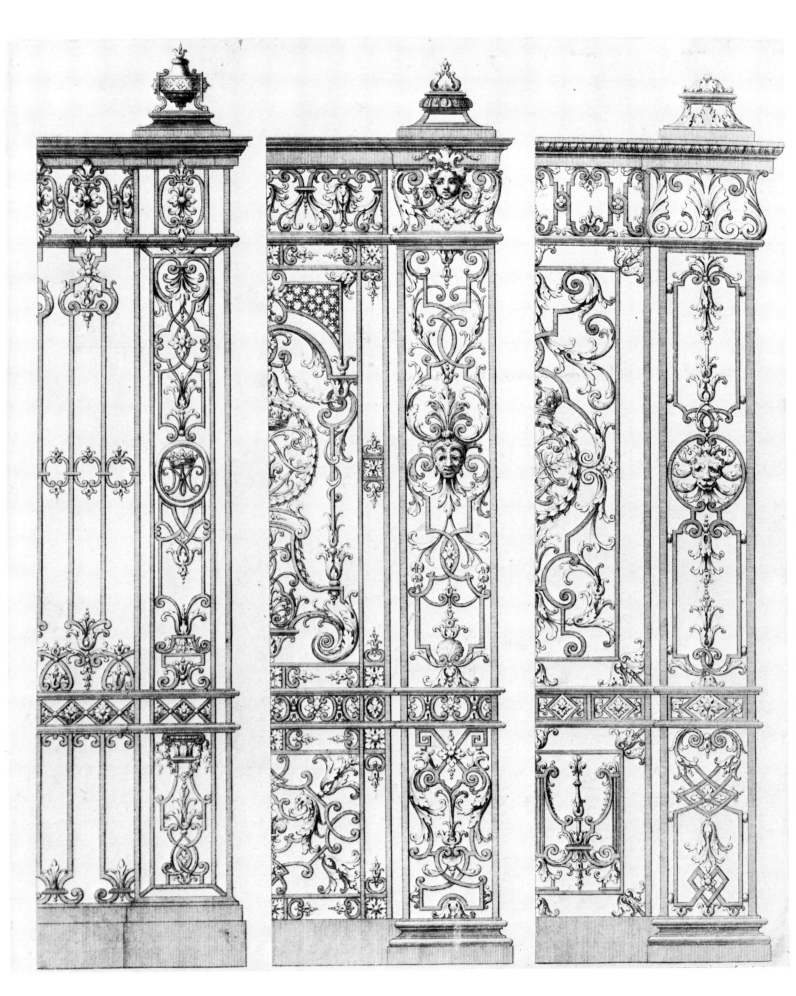

With the end of the eighteenth century, the forms became subdued in Classicistic style, and acanthus tendrils and shell patterns disappeared. The decorations that became more and more moderate in England, aside from those of the Frenchman Tijou, were now completely limited to circles, diamonds and lances (#268). Scrolls still appeared in the last quarter of the eighteenth century on the cathedral doors at Salzburg (#269), but they were combined there into severe bands that seem to have been drawn with a sharp pencil between the massive verticals, with a very transparent effect.

The Empire inspired lovely designs with tender garlands of leaves, hung on the door of the former cemetery by the cathedral in Brizen around 1800 (#270) and looking like party decorations. The ribbonwork in the right angle has now been curved into a meander.

The nineteenth century again brought forth luxuriant flowers, such as the framework of the equestrian statue of Joseph Piniatowski in Warsaw, presumably made in 1822 after a design by Thorvaldsen, the sculptor of the statue. In Britain, tight rows of Tudor roses were placed over a nucleus of quatrefoils cut into the sheet metal on the Houses of Parliament (#271) in the nineteenth century. Turned bars leave the view unhindered, and a crown of lance-shaped leaves secures the premises, as was done on the Scaliger tombs in the thirteenth century.

The Neo-Gothic style adopted the chief motif of the Gothic style, the quatrefoil, as its particular ornament on an international basis. At Mecheln in Flanders (#272), the grating of a Moorish pavilion is completely filled with quatrefoils, with iron bars strongly defining the contours of the architecture.

The Neo-Baroque style once again created grandiose gratings in Britain, particularly in London. The great gratings at Buckingham Palace, which were finished in 1911, exude royal grandeur. They reflect the wealth, splendor and dignity of the Victorian Age in their extent, decoration and gilding. Numerous coats of arms in ornate frames, surrounded by rays of gold, may be regarded as a symbol of Britain's importance in the world, the significance of its ruling house and its worthiest representatives. The grid, the foundation itself, is severe and straight-lined; only in the crown do the French gratings of Louis XIV appear to be reborn.

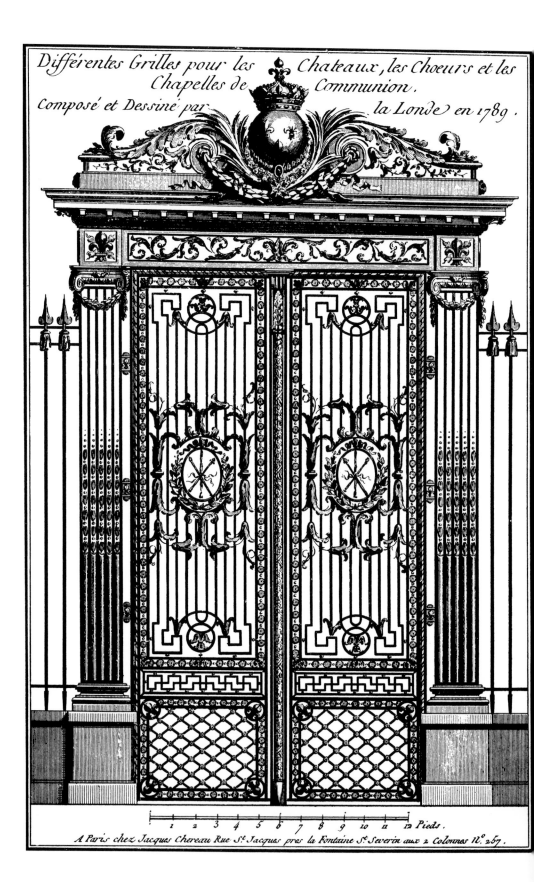

Différentes Grilles pour les Chateaux, les Choeurs et les Chapelles de Communion. Composé et Dessiné par la Londe en 1789.

A Paris chez Jacques Chereau Rue St. Jacques pres la Fontaine St. Severin aux 2 Colonnes Nͦ. 257.

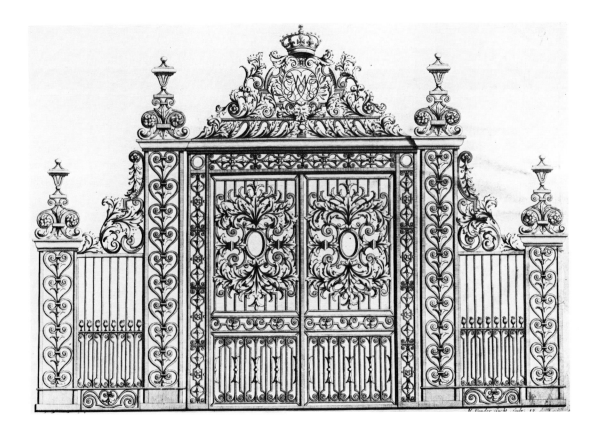

The Canada-Gate to the park (#273-275) was finished in 1906, under King Edward VII, in memory of Queen Victoria, and only the stone pillars with their crowns were already built in 1850 (information from Dr. Howard Colvin, St. John's College, Oxford). The design for the gate was made by Walter Gilbert, with the help of Louis Weingartner. It was constructed by the Bromsgrove Guild. An old English tradition is involved in the decoration. The ornaments that are attached to the wrought-iron frames are made of cast bronze.

Incomparable, and without any example on the continent, are the fence gratings of the big park in London, of which only the Alexandra Gate in Kensington Park will be illustrated here, although cast rather than forged iron was used there. The Industrial Age had come, and with it came the possibility of producing cast iron in large quantities, using the same dies many times. The park fences in Britain and the Metro stations in Paris, for example, are typical cast iron creations (#276-279).

Wrought iron has survived into the twentieth century in reduced circumstances. A castle garden or cathedral receives a new grating, the castle in Vienna gets a new sky-light grating, St. Emmeram in Regensburg gets a new portal, the cathedral in Freising a new entryway grating, all in Neo-Baroque style.

Not until the Art Nouveau style became popular did anything new arrive. Its stylized plant ornaments decorate the enclosure of a monument or enliven garden and park fences. No longer is the prince the best customer, but rather the nobleman or the well-to-do burgher. The suburbs with their villas come into being. The house is set back from the street; to some extent, the regulations require it, in part one does not want to be too close to the street with (at that time) its dust. Thus private property is fenced in, the front lawn or the park is fitted with fences and gates. Since there were building codes in many cities which forbade high walls that afforded no look into the garden, wrought iron was used in simple but decorative forms, with some charming and elegant details at times (#293-298).

Today, in the new residential districts with one-family houses, one again finds the wrought-iron gate more often, even though the fence itself is made out of some other material. A low wall is pierced, and even a wire fence — often hidden with flowers — is closed with a handmade wrought-iron gate.

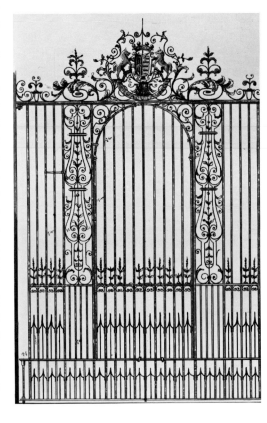

Church Gratings for Choir, Entry and Chapel

The history and concept of Gothic choir and chapel gratings begins in Spain where the most numerous gratings, the most artistic works, and the greatest richness have survived.

Only one religious work of art from the Alpine area can be presented, and that is the grating in front of the Waldauf Chapel in the Pfarrkirche at Hall in Tyrol. Created around 1500 by an unknown Tyrolean master smith, it is an incomparable creation based on knowledge of the objects. The substructure is comparatively simple, with bars piercing diamond shapes and only a few tracery ornaments. All the richness is gathered in the crown. Tracery set with crabs is arched upward in donkey arches and falls back down to the base of the crown. Helmets, coats of arms, and trophies, some in chased work, some forged with a stamp, are set between the tracery arches. Coats of arms were cut out of sheet iron and painted, a decoration particularly popular in Gothic times. Holders of the coats of arms, in the form of fully three-dimensional helmets and griffins, are added, pinnacles rise up and are crowned by cross-flowers, a great richness of design which was originally supposed to form nothing but a protective structure.

The chapel's patron was Florian Waldauf who wanted to protect his large collection of reliquaries at the same time. The richness in artistic design of this grating remain unparalleled in Germany.

Comparable in terms of basic forms — that is the donkey arch or Moorish arch — is primarily a chapel grating in the Cathedral of Santiago de Compostela, which was ordered by Canon Mondragon in 1522 and presumably was built by Guillen de Bousse. Only the crown of donkey's backs in their late Gothic form — here, to be sure, we can speak of the peateresque style — shows a certain relationship, but the spirit is a completely different one.

Peace and regularity, order and symmetry are shown by the Spanish grating. There is nothing to be seen of the overflowing fantasy of the Tyrolean grating. And another thing is clearly apparent: the bars of the substructure, whether bent out into hearts or curved into segment arches, let the horizontals and verticals be clearly recognizable; there is no network, there are no spirals, the bar dominates, be it round or square, and is set with leaves or thickened into buttons so that overall it appears to have been turned on a lathe. A more or less slender frieze with tendrils overlays the bars, followed in turn by a perforated frieze with scrolls, rosettes, coats of arms and figures made of cut sheet iron. The Spanish gratings of the sixteenth century differ considerably in nature from the gratings in the rest of Europe. The fact that a special richness of large, very decorative and artistic gratings has been preserved in Spain can be attributed to the particular nature of religious services in the large Spanish churches, and in the seating order of the priesthood. The chorus, with seats for the clergy, was a closed-off space projecting into the middle of the nave. Since the clergy had to be visible, and their singing had to be heard by the people, large gratings were required to enabel their visibility through the area. The clergymen, for their part, had to have an unimpeded view of the high altar, the *capilla major*, and so those especially intricate, splendid high gratings were created to let the events of the mass be seen clearly. The medieval idea of a separation between clergy and laity continues here, and is practiced in the Renaissance with the highest art of the metalsmith (#302, 304, 305, 307).

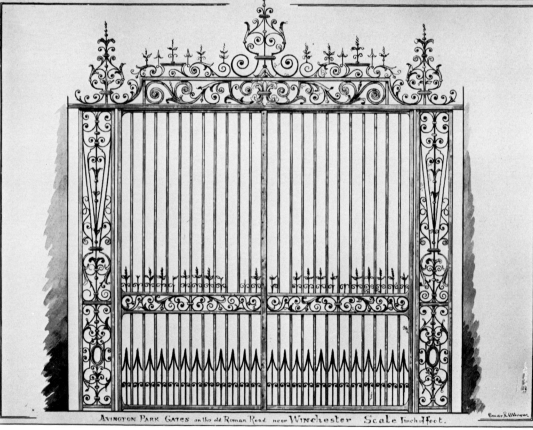

AVINGTON PARK GATES on the old Roman Road near Winchester Scale 1 inch 1 foot.

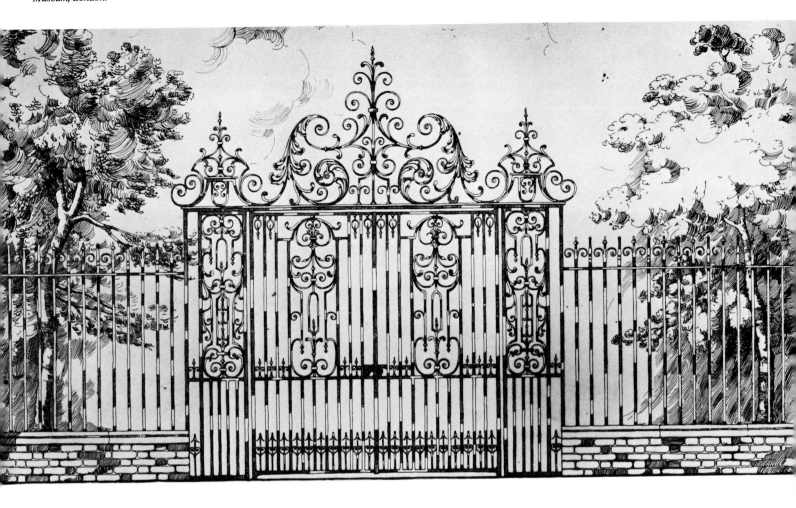

In France, as in other countries, wooden screens were removed during the Renaissance. At the height of the Gothic era, with the choir passage, which was also accessible to the laity at certain times, and the chapel circle in the cathedrals, choir cabinets had also become necessary. The high altar acquired its own housing, in which the choir seats for the priesthood were set up. In the late Gothic era, though, the choir cabinets and wooden screens were already regarded as no longer in harmony with the spirit of the times. The cabinets concealed much of the holy rituals from the eyes of the laity. The renowned choir cabinets in Bamberg Cathedral (1220-1230), Hildesheim (1186), and the Church of the Virgin in Halberstadt (ca. 1200) may be cited for clarification. They remained in existence because the crypt underneath required the elevation of the high altar.

In Baroque times, the choir passage and its lateral security, and thereby the entire choir cabinets, disappeared from reliogious architecture. The new mendicant orders rejected choir passages and choir cabinets in principle. A closer relationship to the people

in the preaching churches was the goal of these orders.

In the fifteenth century, choir cabinets became easier to see through, with gratings erected in place of walls. A few gratings from the early days are still in existence in northern Germany.

The chorus cabinets in the Franciscan Church in Salzburg still afford a good picture of the gratings around the high altar. The gratings were made only in the eighteenth century, in the days when the high altar in the high Gothic choir had been rebuilt. To the long Romanseque main aisle, the master builder Stetheimer added a high Gothic choir with passage and chapel circle. Fischer von Erlach erected a Baroque high altar by the central pillar, took from the old altar the late Gothic Madonna by Michael Pacher, installed it in the new altar, and had the choir area surrounded by a wrought-iron enclosure in which, according to the taste of the times, all the late Baroque decorations are found: acanthus tendrils, flowers and rosettes, coats of arms, heads, helmet ornaments and small angels (#346).

The high point of choir gratings began with

the Counter-Reformation movement. As opposed to the medieval custom, the Baroque splendor of the mass was revealed to the faithful flock, and royal ceremonies could take place in a larger space. The costly habiliments of the priests became visible — the opulent altar utensils, the chalice, the monstrance, the shimmering golden tabernacle, the silver incense vessels — to the faithful, and their souls should be elevated by beauty, splendor and mysterious glitter. The people should take part, though at a proper distance and only with their eyes, not actually in bodily juxtaposition. Therefore, the choir gratings emerged, which were separations and connections all in one. They hang a lace curtain before the holy happenings and guarantee respectful distance.

The height of artistry for choir gratings appeared only in the seventeenth century, perhaps because the smith's art, after lying fallow for a long time during the Thirty Years War, had to come back to life again, or because the orders came from a changed Catholic cult and inspired artistic powers with great new tasks. There were forerunners, such as the grating by Mattäus Andres, signed and dated 1561, in the City Church of Ingolstadt.

41

41. Drawing of a park fence, England, mid-18th century, Victoria & Albert Museum, London.

42. Drawing of a garden gate, England, Victoria & Albert Museum, London.

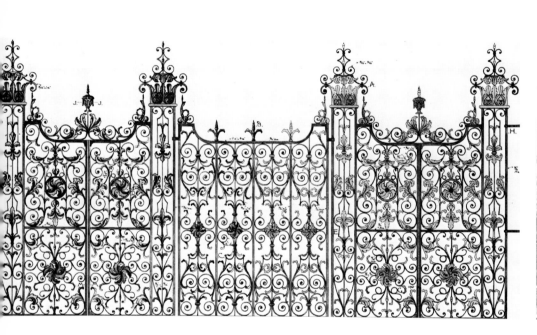

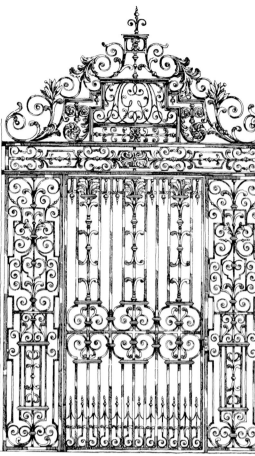

Late Baroque churches, which refrained from choir gratings from the start, guaranteed the faithful access as far as the communion grating, and protected the churches from heretical invasion of the church premises at times when no masses were being performed, with an entry grating. The faithful, though, could come in for a prayer and feel that they were in the church.

The extensive iron gratings, heavy in weight despite all their apparent lightness, necessarily had to have their supporting and load-bearing parts strengthened. They became clearly visible, whether horizontal, vertical, broken bar sections or edgings bent into flowing arch segments. For the internal designs, many patterns were used, and the same applies to them as to the castle gratings and their masters.

One particularity, especially in the south German area, remains to be observed. The gratings which appear to go back in perspective derive from an architectural drawing by Wendel Dieterlin in his *Architectura Tedesca*. They can be found particularly in the Lake Constance area in southwest Germany and in a few cases in Bohemia. Wendel Dieterlin worked mainly as a painter and master builder (1550-1599), and his ornamental

engraving works were used very often as models for many works, and are highly valued as such, especially in the early Baroque era, for as already noted, copyright laws were not existing then as now to protect the originator.

The perspective painting that Dieterlin, and Holbein before him, had used on facades as well is here translated into forged iron. At first, all the lines were drawn to one focal point.

One of the earliest perspective gratings is at the Court Church in Lucerne, built by Johann Reifell of Constance in 1641-1644.

In the lower portion, the illusion of an area paved with flagstones is created. Arranged one behind another, the columns seem to stretch into the depths, which in turn appear to bear a self-shortening superstructure (*Reallexikon zur Deutschen Kunstgeschichte*, Vol. III, p. 562, #5). This type of grating always achieves a remarkable surprise effect. Whether laid out as one door or three, they have a close relationship in terms of conception with the earlier wooden screens in the medieval churches.

All gratings, whether the big entry or choir types or the chapel gratings, correspond to the style of the time in their ornamentation. Spirals, scrolls, diamonds, acanthus tendrils,

shellwork, medallions, cartouches with gridwork and rosettes fill the spaces between the purely structural parts, sometimes overwhelming them. Sheet iron, cut into many shapes and tenderly painted, comes alive in the crowns. Imaginary creatures, animals, coats of arms, angels and even saints set accents, almost continuing the paintings on the ceilings, or extend the painted areas farther into the gratings. There is scarcely a difference between the church ironwork in Germany and Austria. One must understand that this is limited to the Catholic area, just as in Switzerland only the Catholic areas became carriers of the wrought-iron art. Thus only those lands can be represented here, since most of the gratings in France, as noted before, were destroyed during the Revolution, with only a few pieces in one province or another surviving.

The three-gate grating in the Cloister Church at Einsiedeln is, as illustrated, very simple and linear; only the crown carries all the ornaments, as airy and elegant as the effect of bent round bars can be. The view is scarcely blocked (#326). The work is ascribed to the cloister brother Vinzenz Nussbaumer. The grid was created between 1675 and 1685.

The grating in the Cloister Church at Weingarten, which was presumably constructed at a Constance workshop in 1730, has a completely different appearance. Here the idea of the wooden screen seems to come through considerably more clearly. The grating is compact, forms a conclusion, and expresses much more distance. All the Baroque techniques provide an illusion of spatial depth. Flat, square and round bars are utilized to create displaced pilasters and corkscrew pillars, which in turn support rounded arches and, by being ranked in an appearance of depth, give a three-dimensional illusion. In the process, the concealed "overcut flagstones" add significantly to the optical illusion.

The Benedictine Abbey in Muri had a very charming perspective grating (#327), probably a high point of this type, made for its church by J. J. Hoffner in Constance in 1744-1746. Flowing arches, which are strangely reminiscent of donkey's-back arches, become shorter in their depth, and the bottom, a Rococo grating, seems to stretch far into the distance, its fields filled with the most delicate leaf- and shell-work.

The gratings in the church at Mittelzell (#330), on the other hand, are simple. They were made at the same time, 1746, as the Muri grating, but possibly were influenced by the more restrained Romanesque architecture of the main aisle.

Around the middle of the eighteenth century, it appears that the perspective gratings, the special form of the Lake Constance area — in the furthest sense — were no longer produced. It has been noted already that this concept is also to be found in Prague, but the gratings are no longer made to create the same sort of illusion as those shown here. There too, the illusionism of the Baroque era was now rejected, the designs became clearer, and a new direction of style began to make itself known.

It is easy to explain how connections existed between Prague and Austria, for they were both part of the former Dual Monarchy.

This relationship was already noted in reference to the tomb of Maximilian in Innsbruck.

Along with the perspective gratings that create an architectural illusion, there are gratings with a simple substructure and the most lavish crowns. An outstanding example of this type are the entry grating in the Church of St. Mary at St. Florian's Abbey in Upper Austria (#333) and a chapel grating in the entry of the church at the Cistercian monastery at Stams in Tyrol (#336). On vertical round bars, sometimes turned, and thickened in the center, there rests a very lavish crown formed of flower and fruit wreaths. Flower vases surmount pillars, flowers and leaves swing from scrolls, heads and half-length figures of angels look downward. The central crown is topped by an imperial eagle, for at times the abbey housed the emperor and his retinue, and the imperial building was constructed for him.

Even though the bars are thickened with knobs here and might recall the Spanish gratings of the sixteenth century, the gratings are yet very different in terms of their crowns. Never does one find in Spain such luxurious, three-dimensional, transparent crowns. This grating was made by Hans Messner in 1698.

Enclosed in the round arches of the architecture is the so-called rose grating, the already mentioned grating in the entry of the church at the Cistercian monastery in Stams, Tyrol (#336). On a substructure of broken diamonds painted in black and gold, the branch of roses, in delicate colors and glittering gold, rests on a simple bar. The remarkable feature of the roses is that they are made up of countless leaves and look remarkably true to life. Other than the prelate's steps in the connected cloister, something similarly artistic and naturalistic is scarcely to be found. According to the date inscribed on it, the grating was made in 1716. The master's name is given as Bernhard Bachnetzer.

A third group of church gratings can be observed, as seen in St. Gallen (#341) and

Amorbach (#342, 343). They are of some length and also have much in common in terms of decoration. Ribbons, medallions with gridwork, garlands and crowns of lanterns, coats of arms and cherubs are found in both of them.

The choir grating in the Abbey Church of the former Benedictine Abbey of St. Gallen (#341) follows the curves of the rotunda of the choir. There is no illusion and no rocaille here; the vertical bar becomes more visible, and the change to Classicism is already apparent here. The grating was designed by Anton Dirr and created by the court locksmith, Joseph Meyer of Bütschwil, in 1769-1771. The coat of arms of the Abbot Beda Angehrn is attached to the arch of the door with a crown and the decoration that is found in all lands and at all times.

In St. Gallen there is a continuous, lively grating. In the church at Amorbach, the gratings stretch from pillar to pillar right through the main aisle (#342, 343). The gratings were made by Markus Gattinger of Würzburg in 1749-1750; he was a contemporary of Georg Oegg (#241) but his works are less lavish yet of the same artistic quality and technical perfection. Once again, the Rococo ornaments come to life here, the gridwork in the cartouches and the shellwork and ribbons.

With the end of the eighteenth century, the great age of church gratings also was past. The Enlightenment rejected the extremes of the Rococo, limited the pictorial piety of Catholicism, and secularization had a destructive effect not only on religious treasures but also on the churches themselves. They became restrained, and thus many valuable church gratings were lost, for where there were no longer any treasures to preserve, one no longer needed a grating to protect them.

The new constructions of Classicism, as far as they came into being at all, could do without gratings. The present-day liturgy and the unadorned new styles had no use for gratings either. But the old gratings, like the bright, lively churches of the late Baroque themselves, are carefully preserved.

New Times, Old Forms, New Forms

The age of the great park gratings, just like that of the choir and entry gratings in the Baroque churches, is past, for no new ones are being built. Here only conservation, rebuilding and restoring are practiced.

Balcony and window gratings, as well as stairway railings, are still needed, and here there are still new products. Window gratings in particular are more and more in demand. Two possibilities become clear. One is the conservative grating, which is particularly popular in southern Germany, in the Alpine area. Here the scrolls still swing and roll, hearts still bend from vertical bars, rosettes and flowers are set into the scrolls, a bouquet of flowers in stylized form breaks through a grating with diamonds, diamond gratings still include a lovely crown of scrolls and entwined ribbons. Round or square bars are adorned with decorations.

According to the architecture of the house or the wishes of the customer, a strictly geometric modern grating in new style may also be made, or the builder may choose to add a nice detail, a decorative accessory to his restrained style.

The wooden doors of churches, though, must still be repaired, for the number of break-ins is increasing to a frightening degree. The simple rectangular grating pierced by square bars lends itself, in its timeless form, to a Gothic architecture with pointed arches. In its simplicity, the good work of the artisan shows itself in lovely form. Only in the slightly turned bar set close to the center without stressing the center, may the distinguishing mark of today's style be found. It is a modern feature, not a fashionable one that would become old-fashioned quickly. Once again, the basic forms of ornamentation are being revived. There are spirals, squares, scrolls, a somewhat strange C-shape, the broken diamond. The Gothic quatrefoil has also come back to life, here as before and always in strong lines, elsewhere in somewhat more transparent form. Linking bands are highlighted in gold now as they were in past centuries.

Here in the realm of wrought iron, one may say, as Goethe did, "What pleases, is allowed."

43. Grating study by Pierre Müller, Ferronnerie d'Art, 1943, Veytaux, Switzerland.

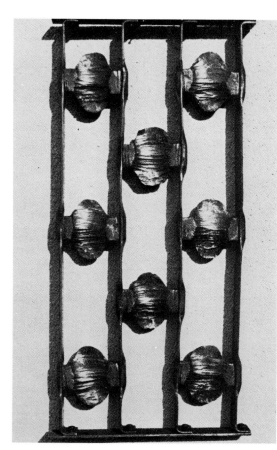

Windows, Doors, Stairs, Balconies,

44. Detail of a door grating in the Cathedral of Le Puy, France, 12th century.

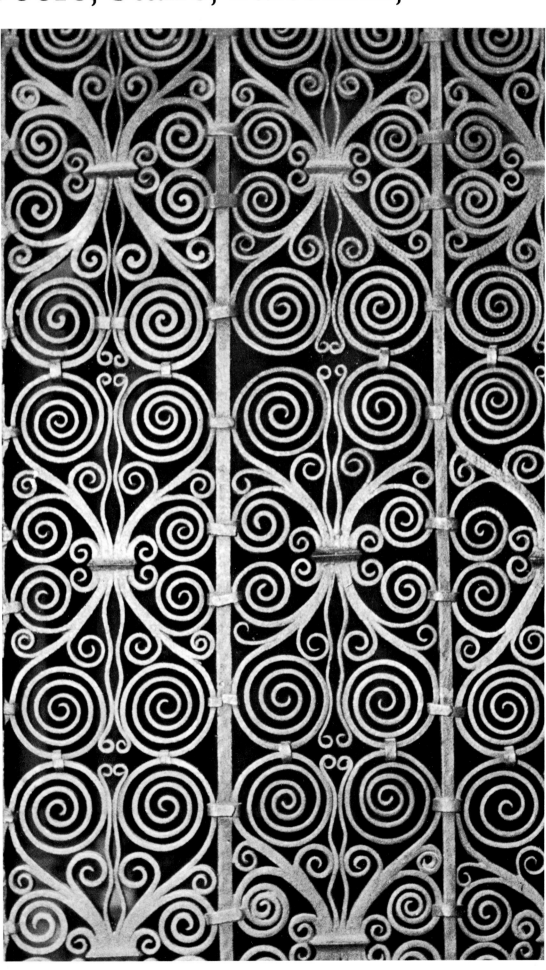

45. St. Swithin's Shrine, Winchester Cathedral, England,
12th century, Victoria & Albert Museum, London.

46. Shrine of St. Richard, Chichester Cathedral, England,
13th century, some parts missing, Victoria & Albert Museum, London.

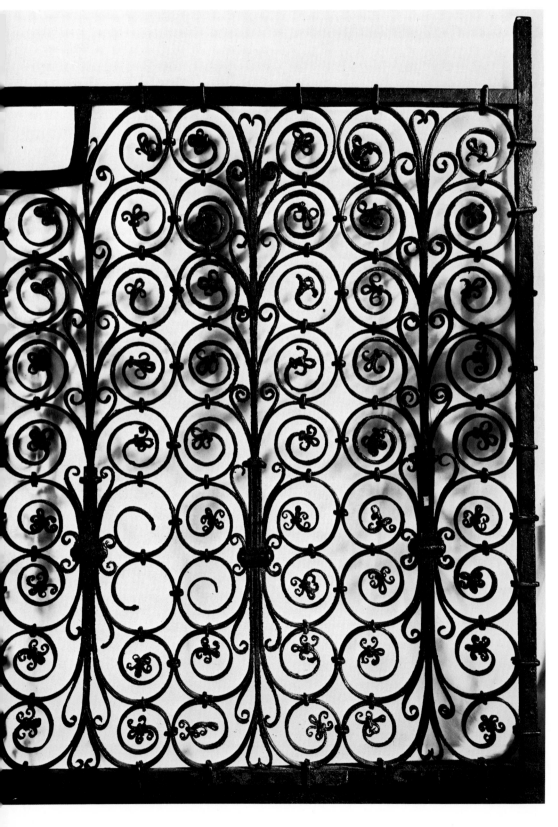

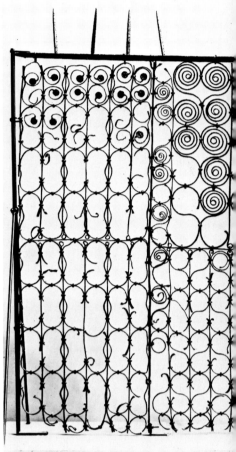

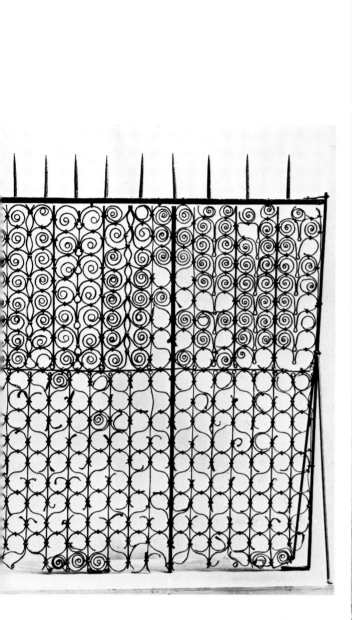

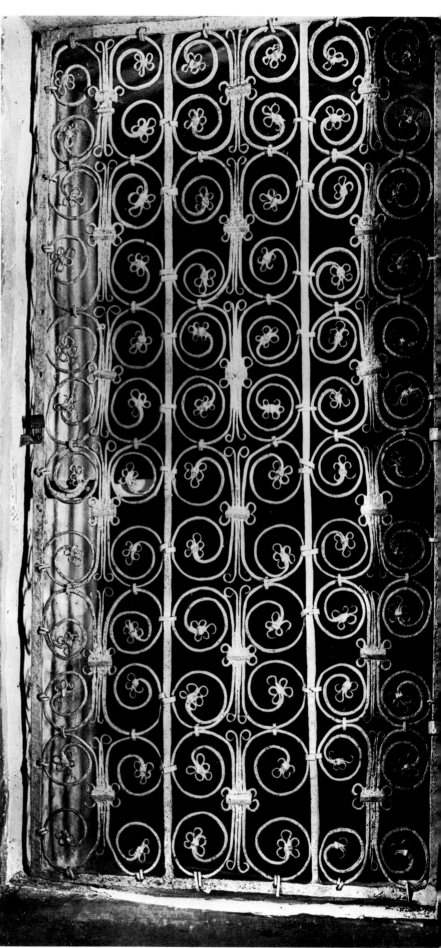

47. *Romanesque grating, Church of Santa Maria de Mellid (Coruña), probably late 12th century.*

48. Shrine of St. Elisabeth, St. Elisabeth's Church, Marburg, ca. 1350.

49. Sacrament house, German, 14th century, Victoria & Albert Museum, London.

50. Window grating near the cathedral, Barcelona, 14th century.

51. Window grating, Italian, late 14th century, Victoria & Albert Museum, London.

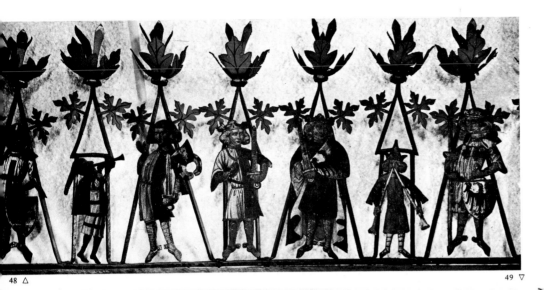

48 △ 49 ▽

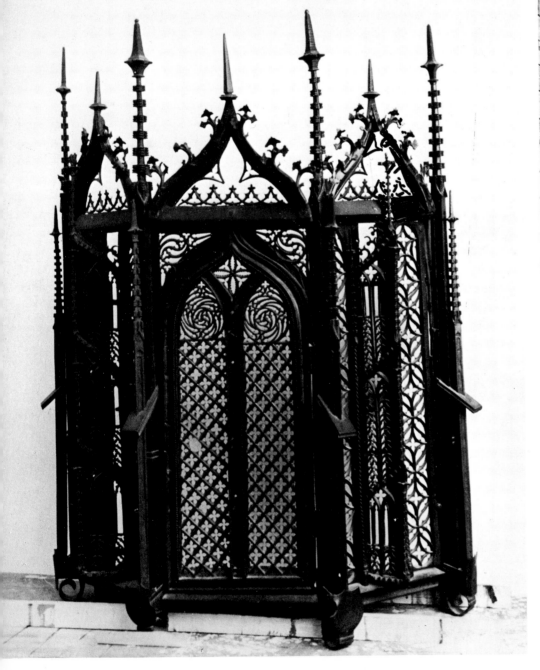

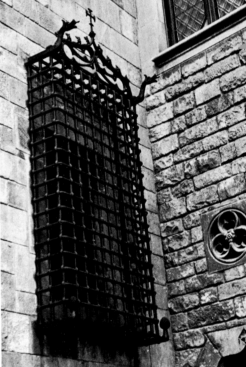

50 △ 51 ▽

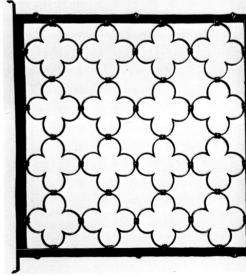

48

52. *Tabernacle grating, France, 15th century, late Gothic, Rouen, Musée le Secq de Tournelles.*

53. *Window grating, Venice, 16th century, Victoria & Albert Museum, London.*

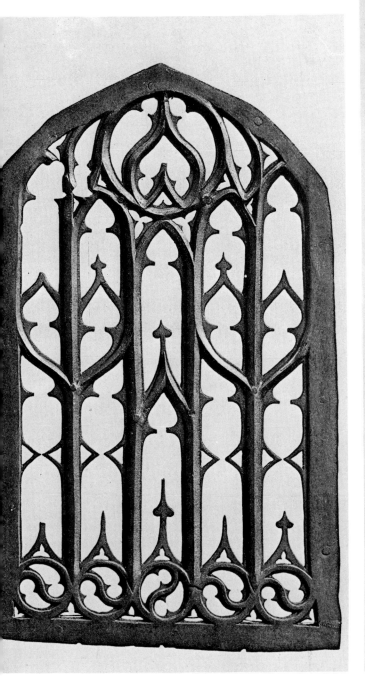

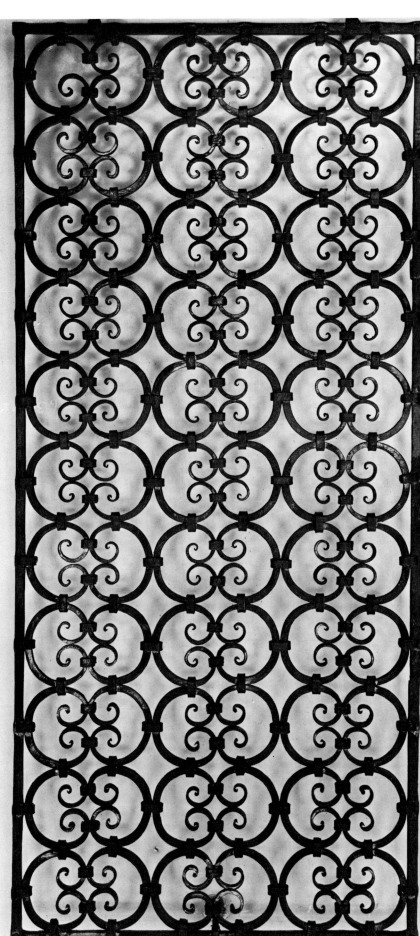

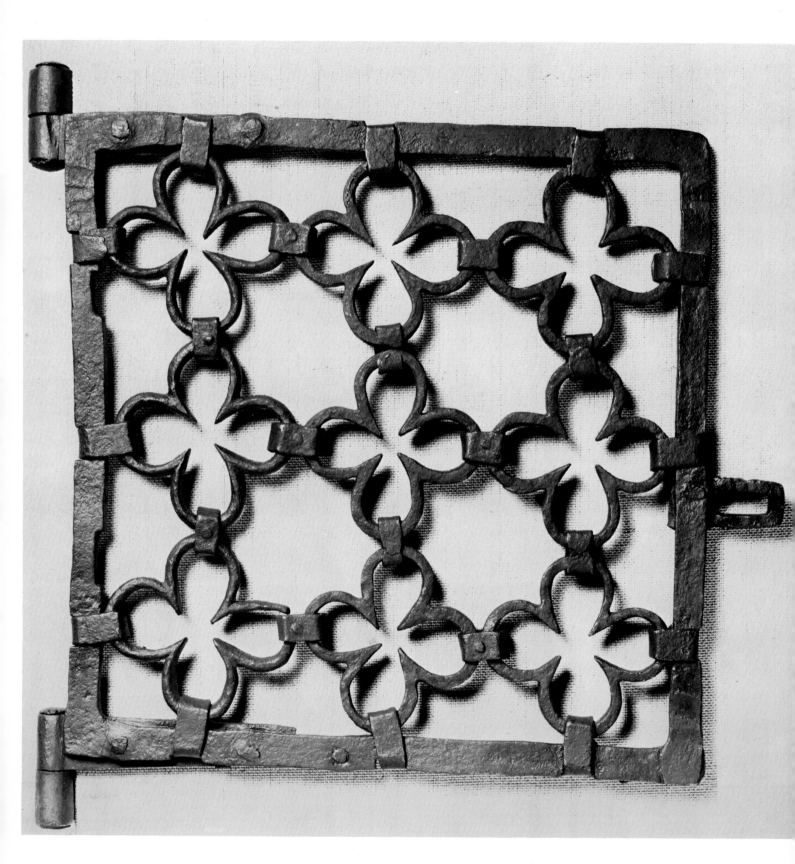

55, 56. *Sacrament house in the Pfarrkirche of Weissenbrunn near Kronach, Franconia, late 15th century, late Gothic.*

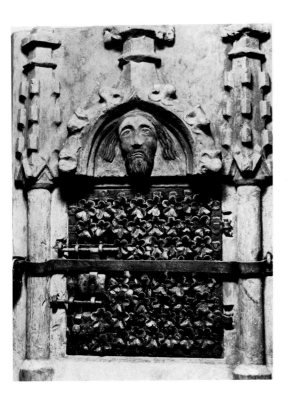

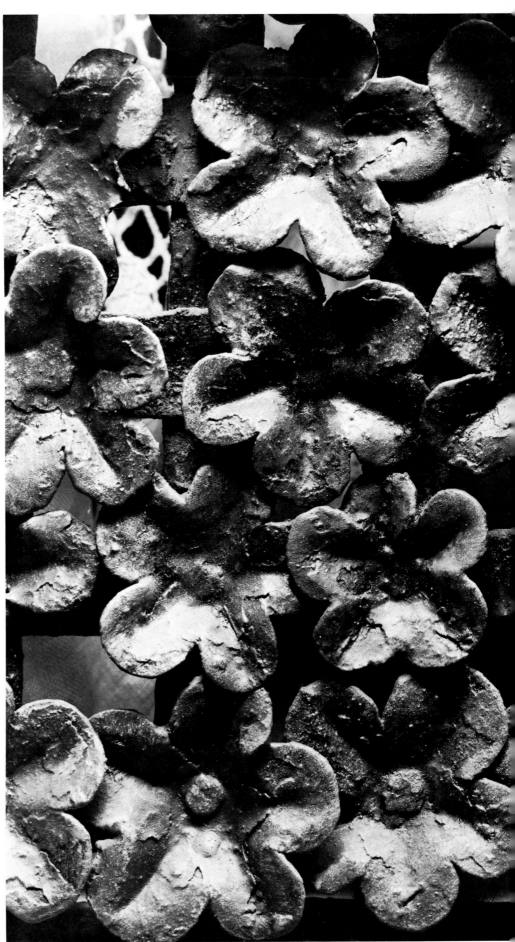

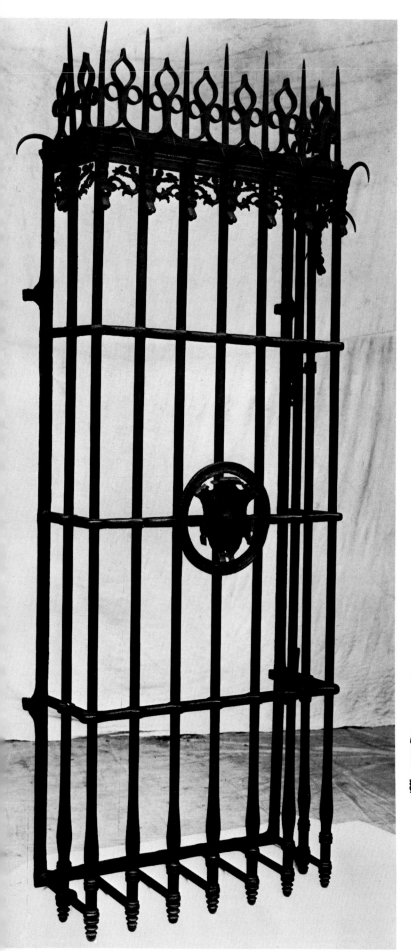

57. *Window grating, Ghent Cathedral, Flemish, ca. 1520, Victoria & Albert Museum, London.*

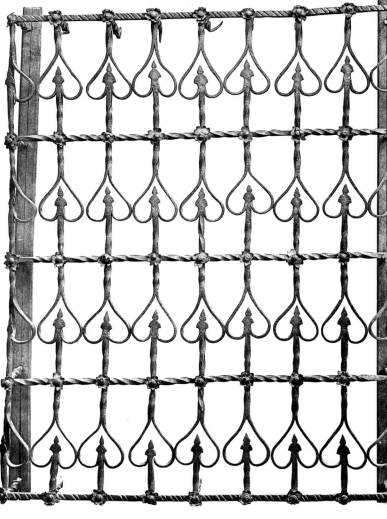

58. *Window grating with hearts and turned bars, from a house in Bourges, 15th century (?), flat and square bars, Rouen, Musée le Secq de Tournelles.*

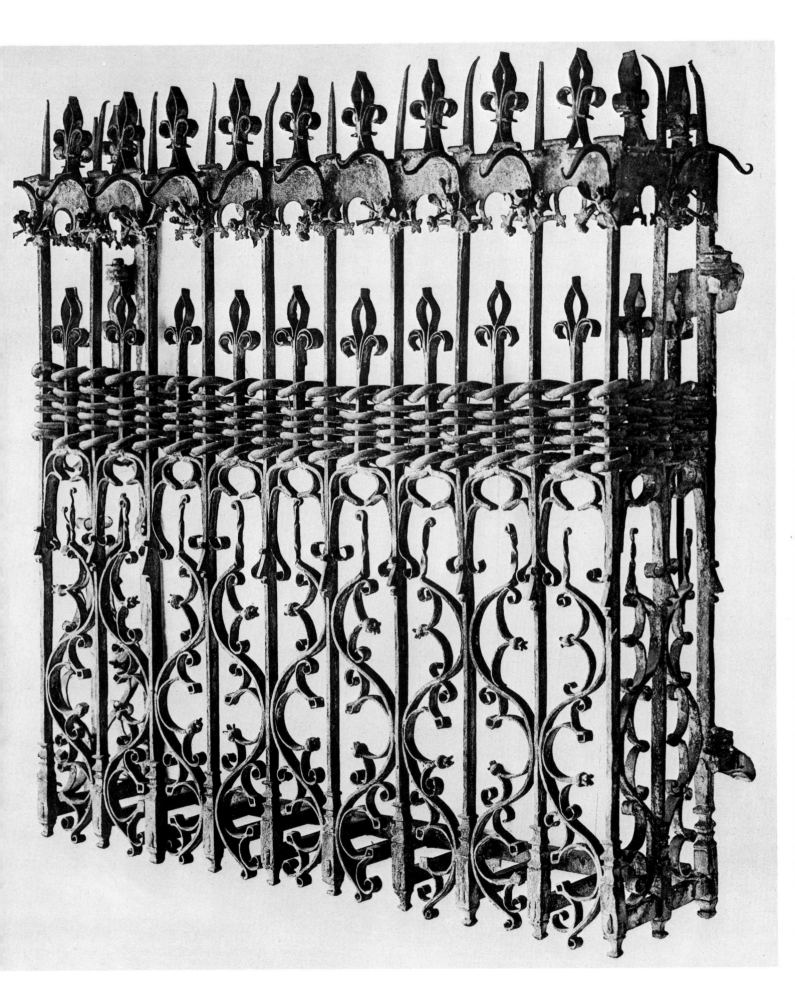

59. *Window grating with band resembling basket-weave,*
Flemish (?), late 16th century, flat and square bars, Rouen,
Musée le Secq de Tournelles.

53

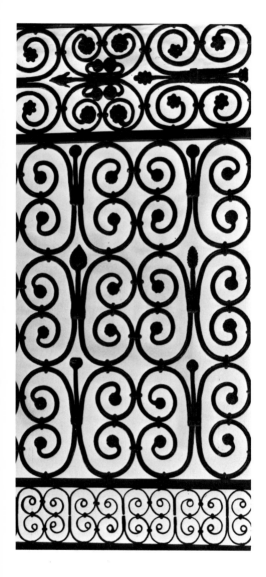

60. *Probably a 13th-century French window grating, Musée de Cluny, Paris.*

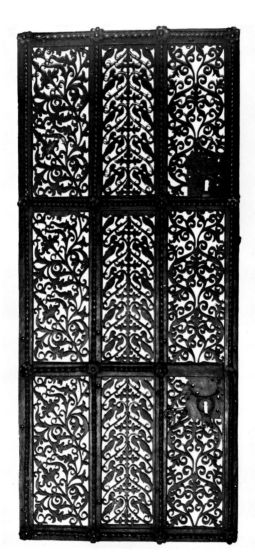

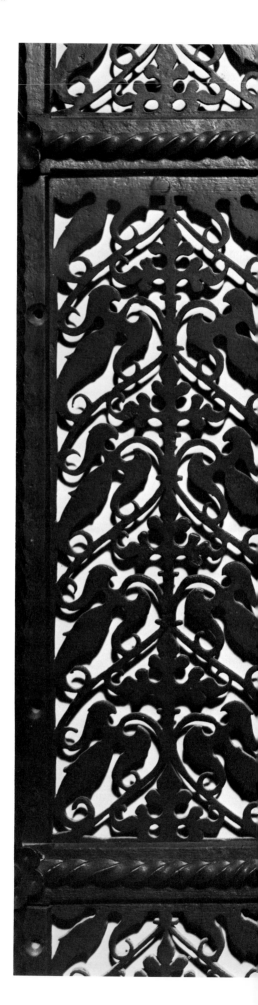

61, 62. *Tabernacle grating from the chapel of the castle of the Counts of Flanders, Ghent, Flemish, 16th century, Victoria & Albert Museum, London.*

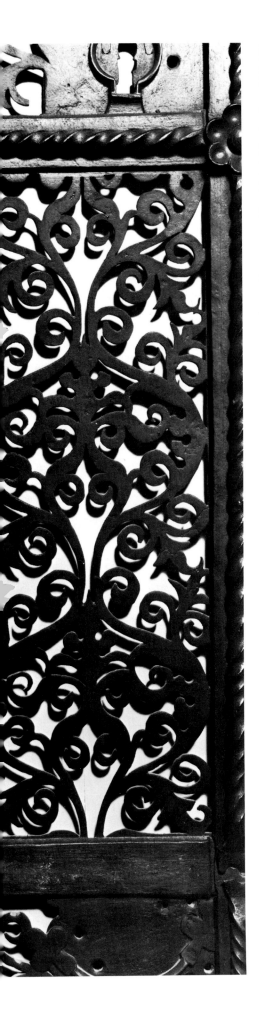

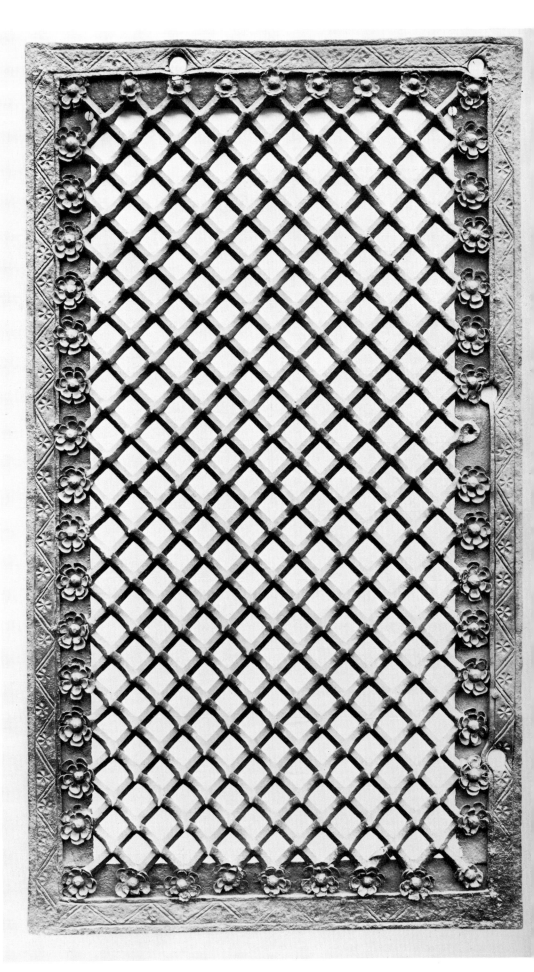

64. Half-moon transom, Salzburg, Kapitelplatz 1, 17th century.

65. Window grating on Kepler's house (died 1650), Regensburg.

66. Simple window grating on a farmhouse near Aranjuez, Spain.

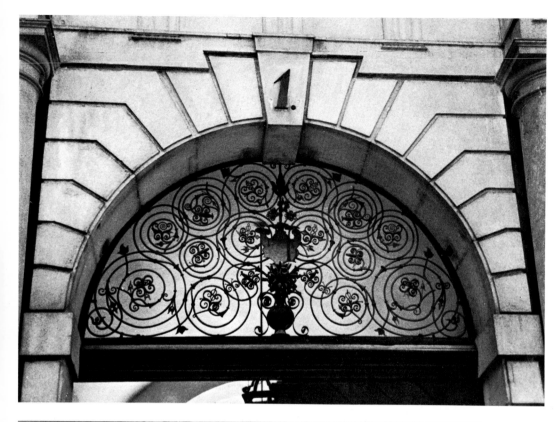

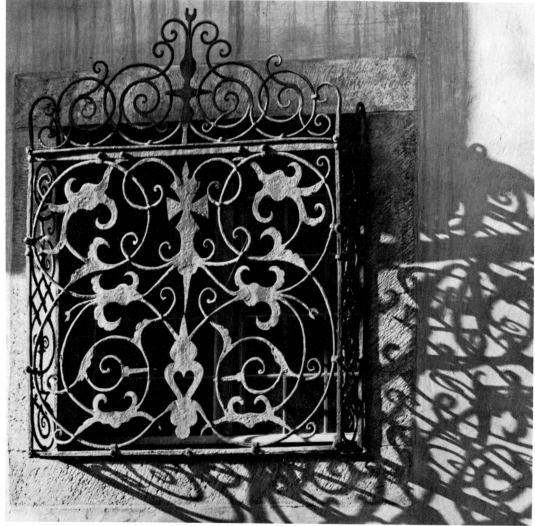

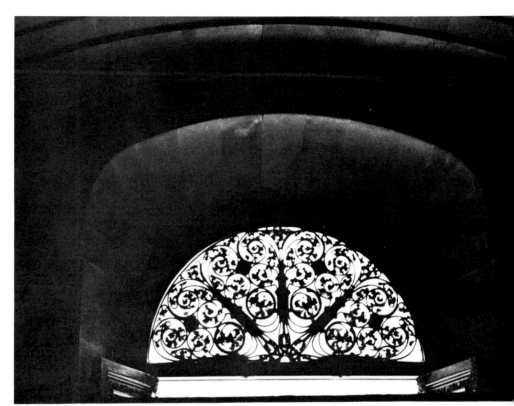

67 △ 68 ▽ 69 △ 70 ▽

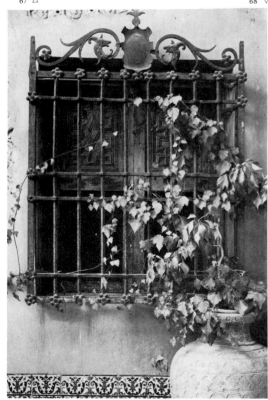

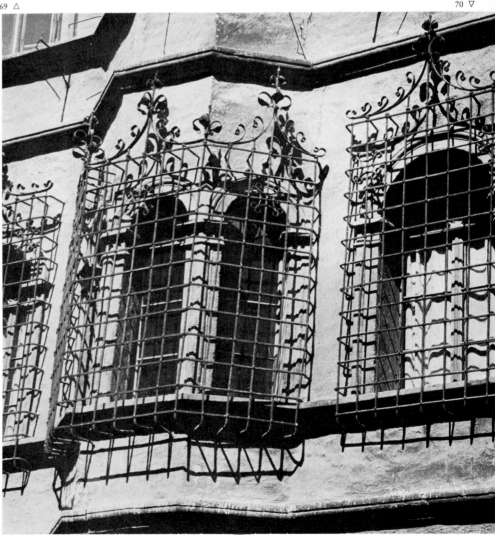

71. Window grating, Italy, 17th century, Victoria & Albert
Museum, London.

72. Window grating, Red House, Andeer, Grisons, dated
1694.

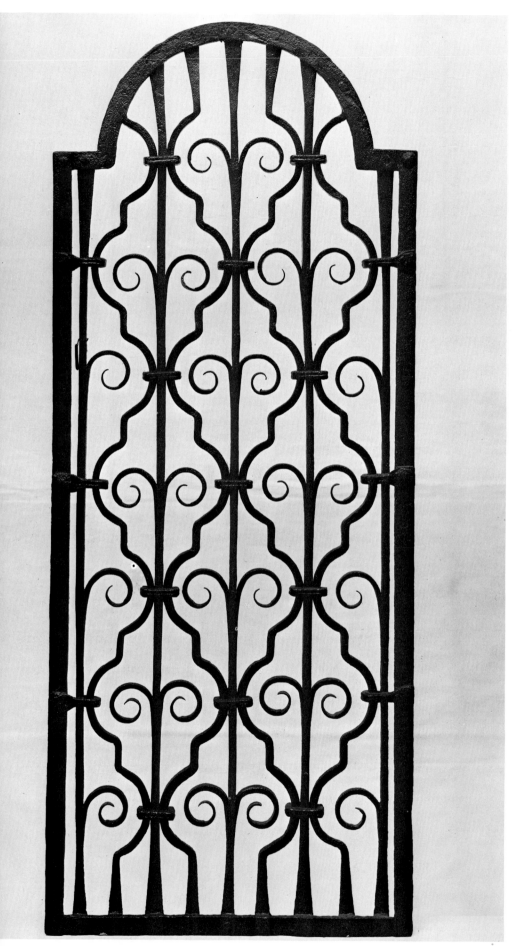

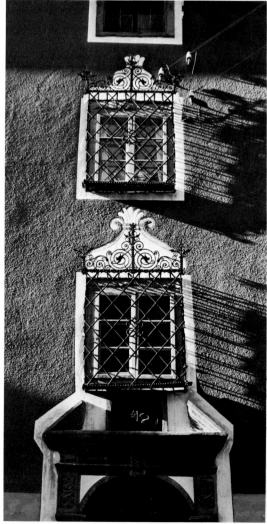

73. *Window grating with rosettes, Italian, 17th century, Rouen, Musée le Secq de Tournelles.*

74. *Window grating, probably Venetian, 17th century, Trogir, Dalmatia.*

75. *Part of a door, German, late 17th century, Victoria & Albert Museum, London.*

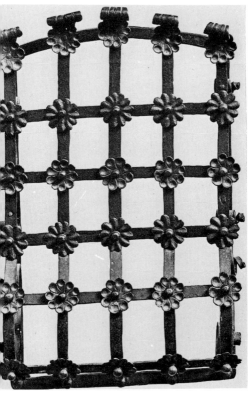

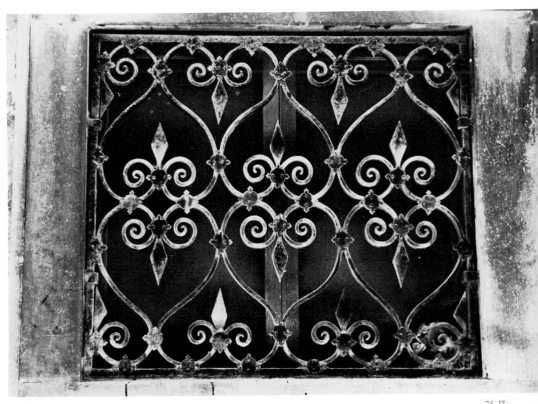

73 △ 74 △ 75 ▽

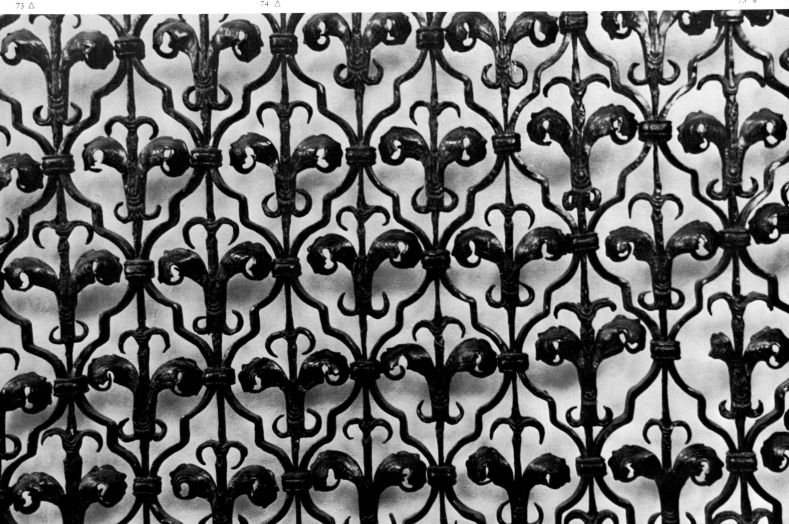

76. Large window grating with opening, PHarmacy of
Santa Cruz Abbey, Barcelona, 1696.

77. Window grating with monogram in center, French, late
17th century, Victoria & Albert Museum, London.

78. Detail of #76.

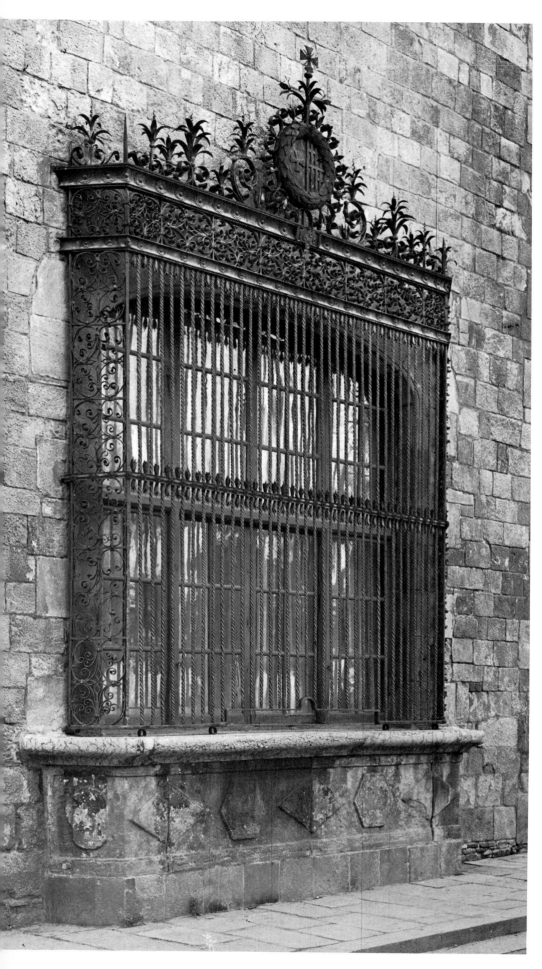

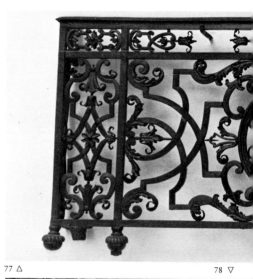

77 △

78 ▽

79. Window grating from Casas Novoa, 1714, Santiago de Compostela, Fassade de las Platerias.

80. Balcony grating, France, circa 1700, Victoria & Albert Museum, London.

81. Window grating, Birnau Cloister Church, Lake Constance, circa 1750.

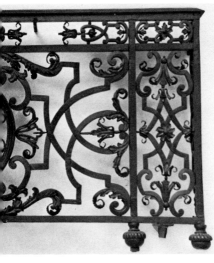

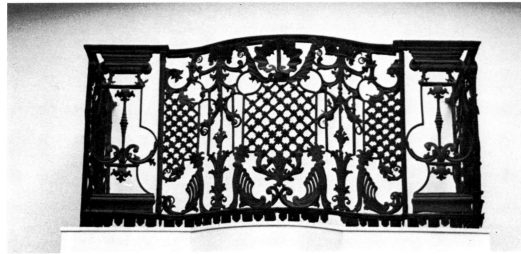

79 ▽ 80 △ 81 ▽

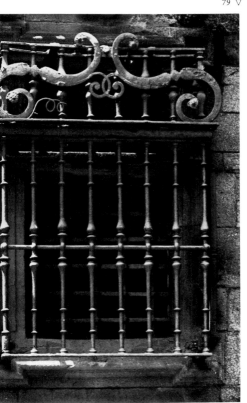

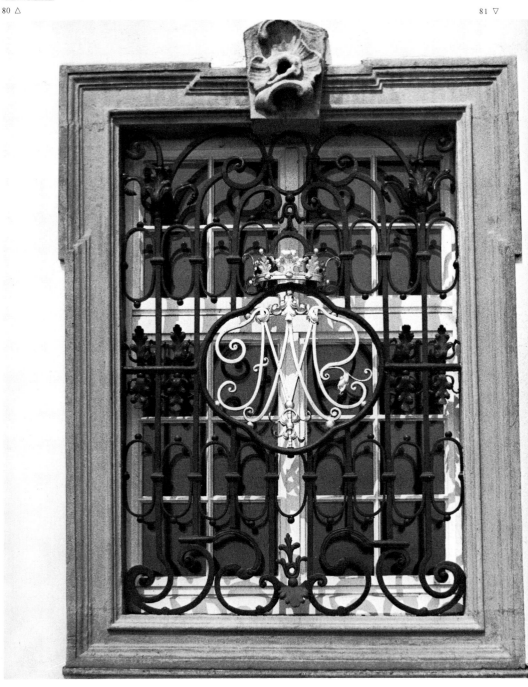

61

82, 83. Door gratings on stairs, Pfarrkirche, Hall in Tyrol, "branch Gothic", circa 1500.

84. Stair railing, Pfarrkirche, Hall in Tyrol, early 16th century.

85. Stairway, St. Wolfgang's Church, Rothenburg on the Tauber, late 16th century.

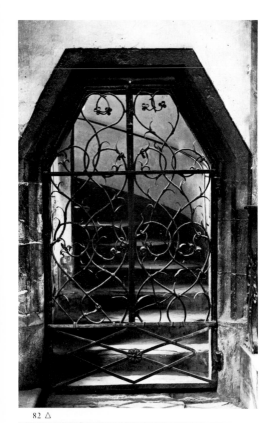

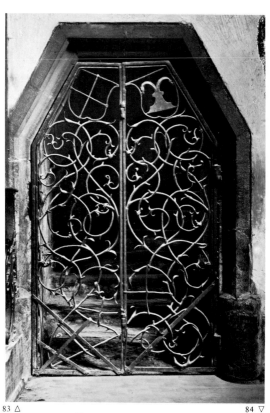

82 △

83 △

84 ▽

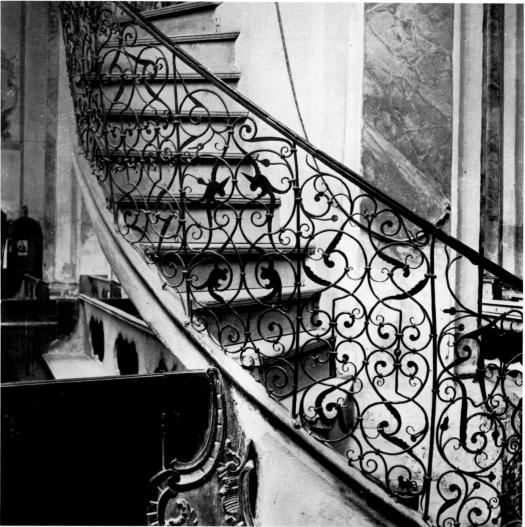

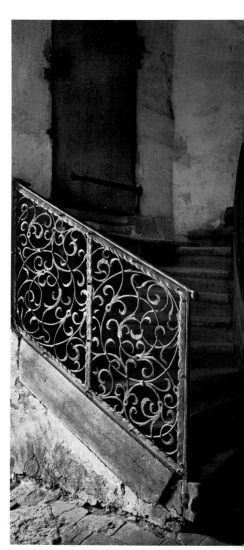

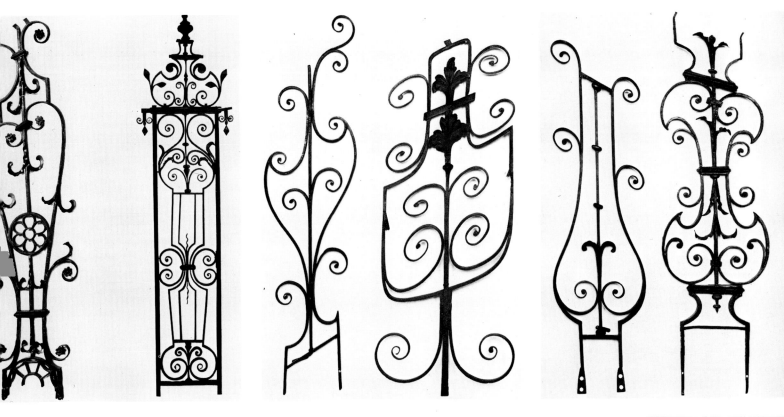

89. Stair railing from Siena, Italy, 17th century, Victoria & Albert Museum, London.

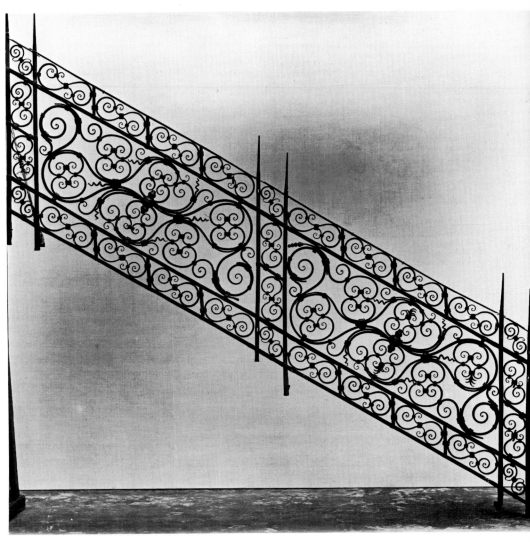

90-92. *Three open stairways, farmhouses in Engadine:*
90. *Engadine, mid-18th century.*
91. *Samedan, Engadine, mid-18th century.*
92. *Engadine, circa 1800.*

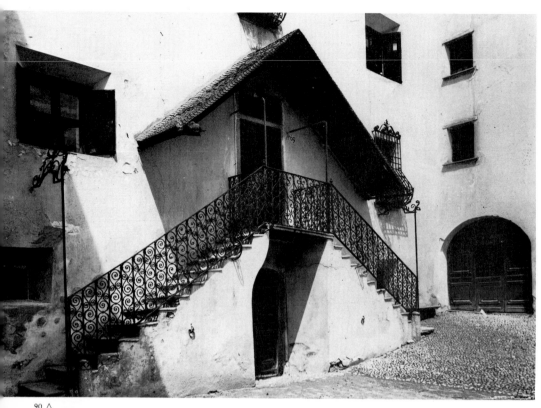

90 △

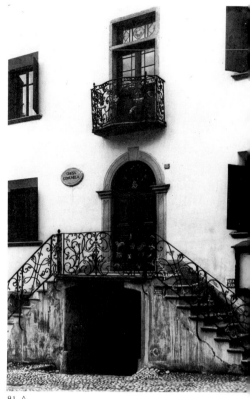

91 △

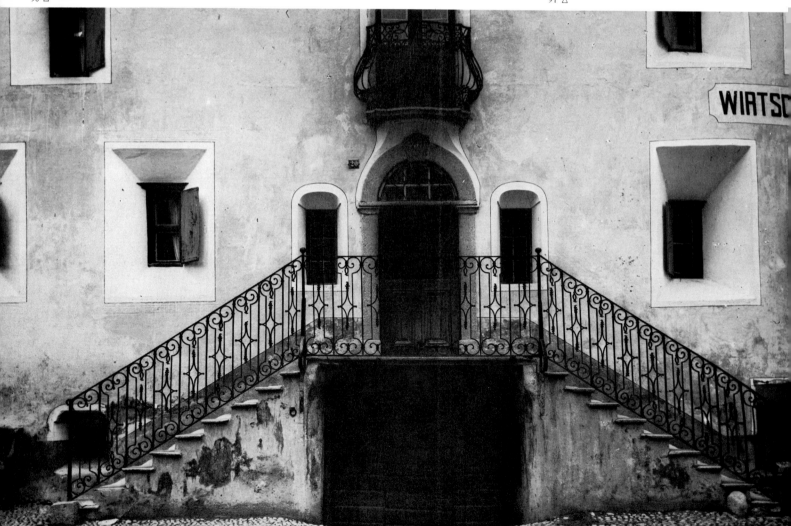

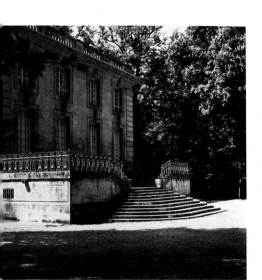

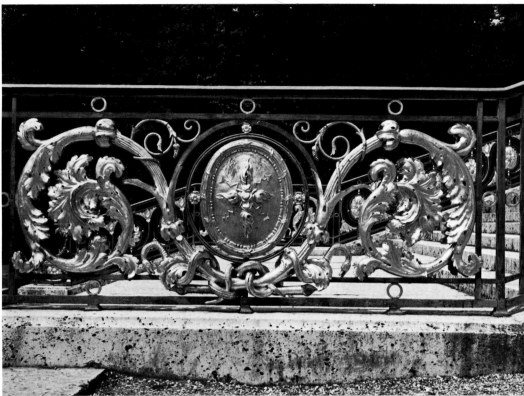

94 ▽

95 △

96 ▽

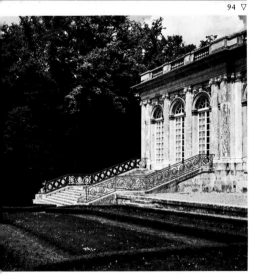

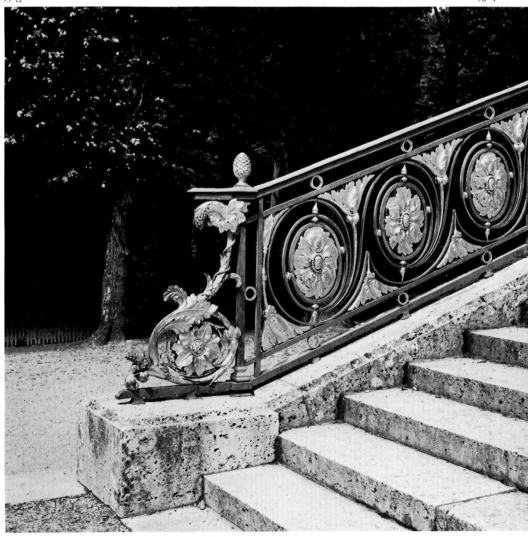

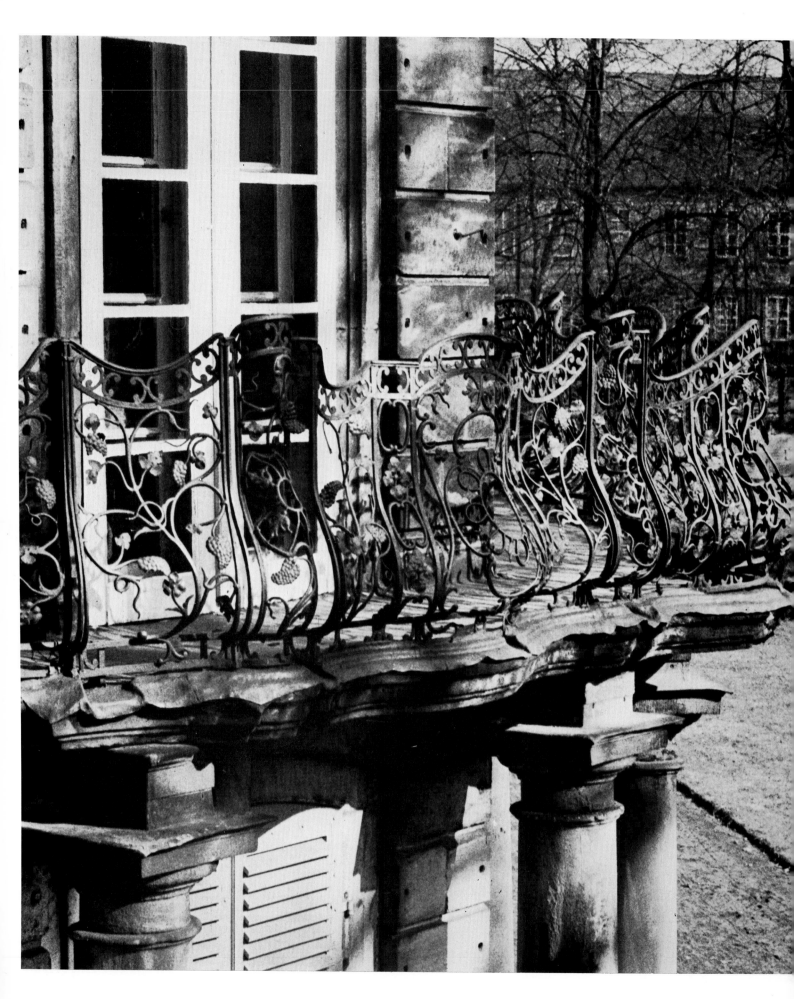

97. *Balcony of the music room, New Castle, Bayreuth, circa 1760.*

98, 99. Balcony, middle [risalit], New Castle, Bayreuth,
circa 1755.

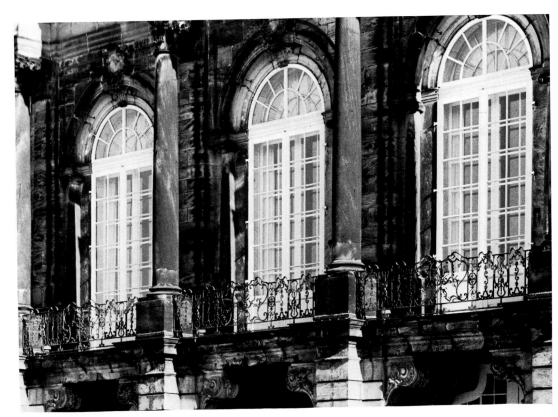

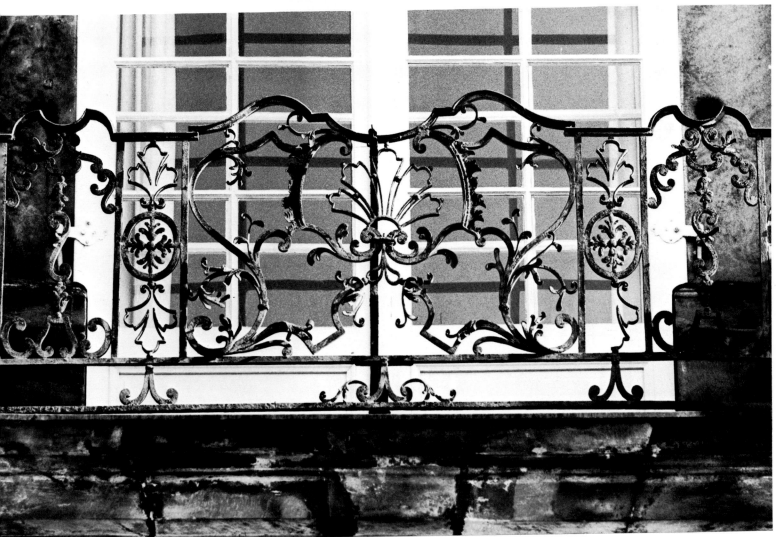

100. Window grating, pagoda in castle park,
Nymphenburg, Munich, mid-18th century.

101. Balcony grating, Schleissheim Castle, near Munich,
first half, 18th century.

102. *Balcony window grating, France, 18th century, Victoria & Albert Museum, London.*

103. *Grating by Sebastien Barthelmes, staircase of Bishops' Palace, Eichstätt, Franconia, 1767.*

104. *Balcony window grating, France, early 18th century, Victoria & Albert Museum, London.*

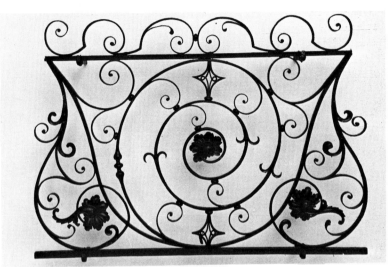

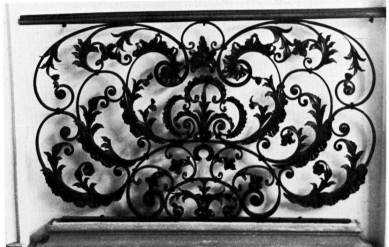

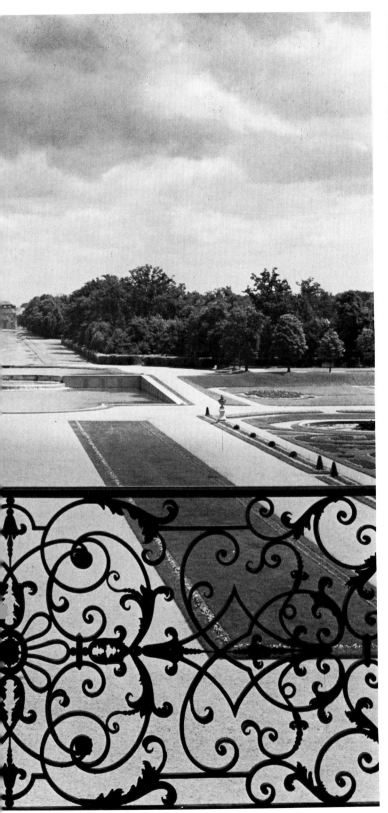

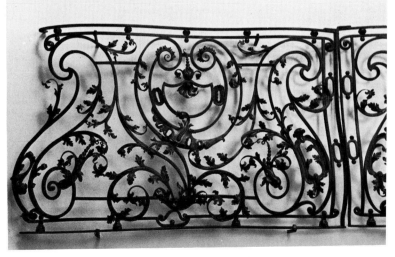

105. *Balcony grating over the Andromeda Fountain by Raphael Donner, Vienna, 1741.*

106. *Balcony grating, Archbishops' Palace, Munich, probably by François Cuvilliés, 1733-1737.*

107. *Grating on the cupola, Amalienburg, Nymphenburg Park, Munich (built 1734-1740), by locksmith Andreas Aignmann.*

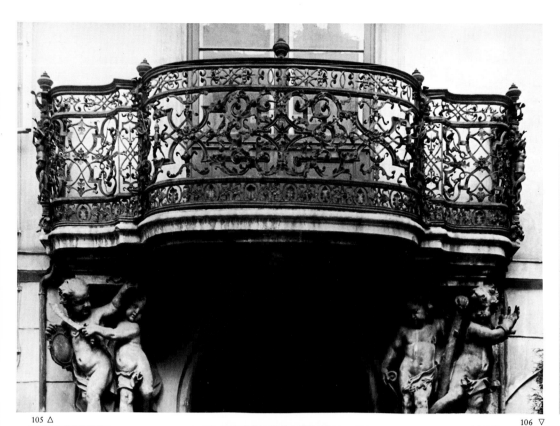

105 △

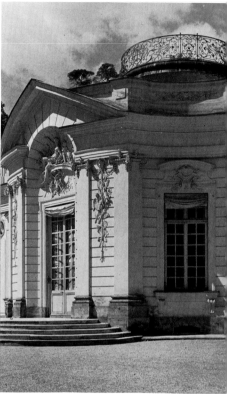

106 ▽

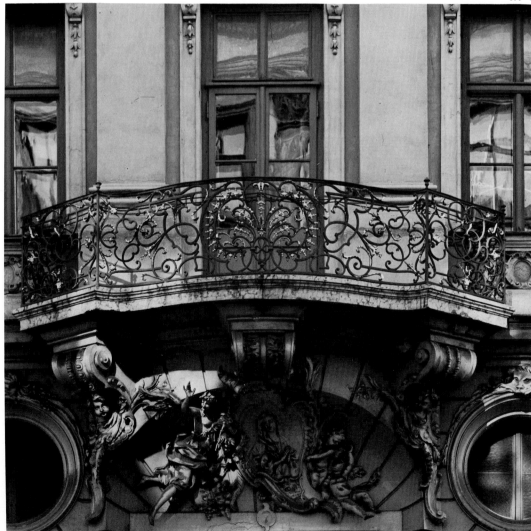

108. *Balcony grating, east wall, dance hall, Wilhelmsthal Castle, baluster columns, first half, 18th century.*

109. *Terrace grating of a villa in Monastero, Lake Como, Italy, 18th century.*

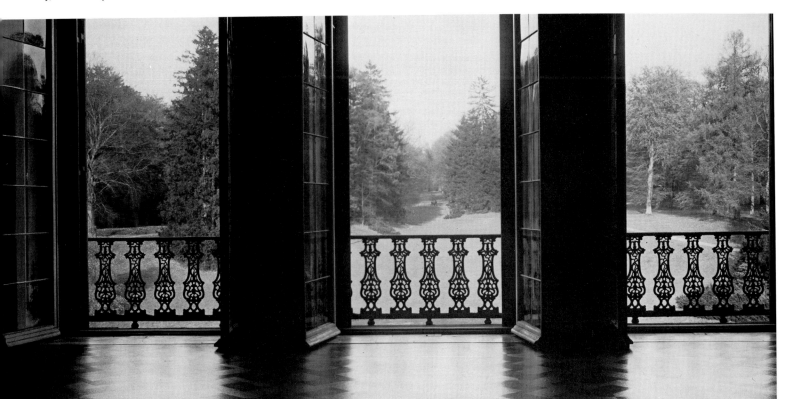

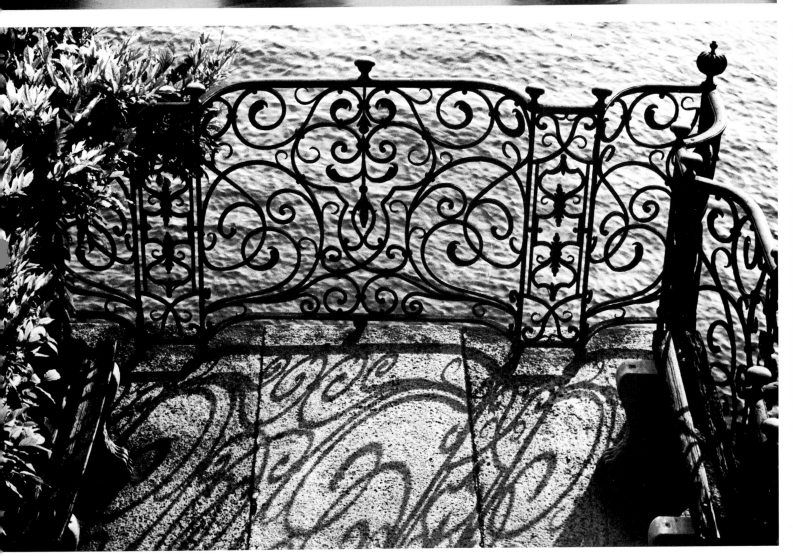

110. Protective grating, gallery of Niederaltaich Cloister
Church, Bavaria, over oval flat couplings in transepts,
first half, 18th century.

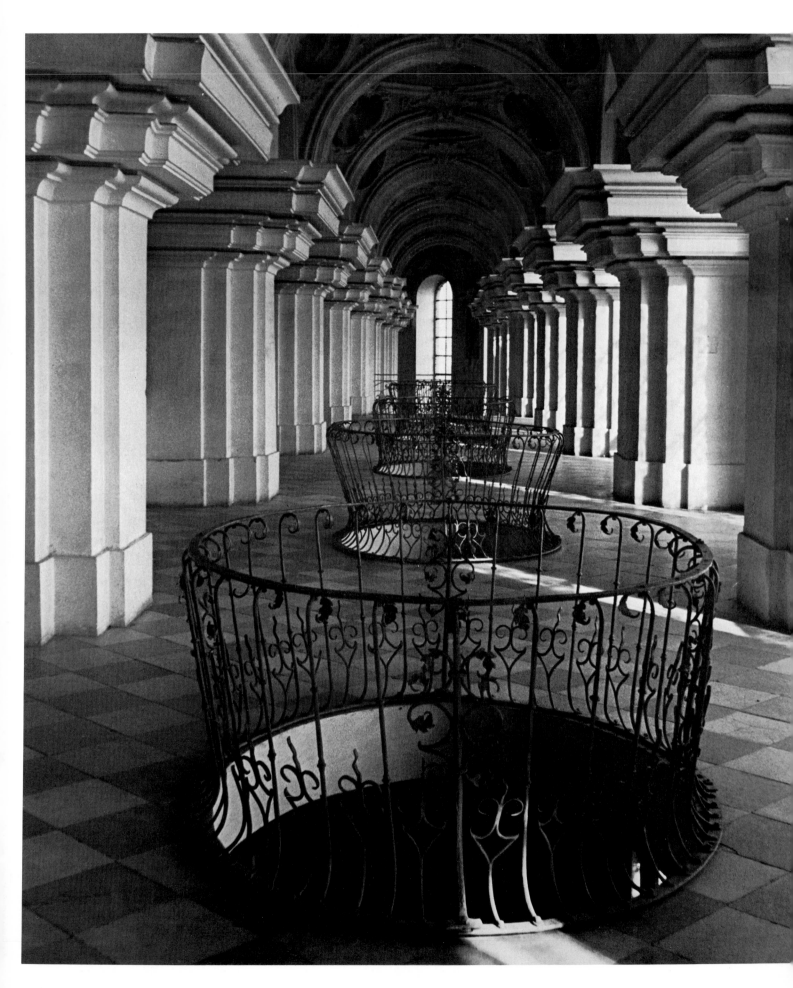

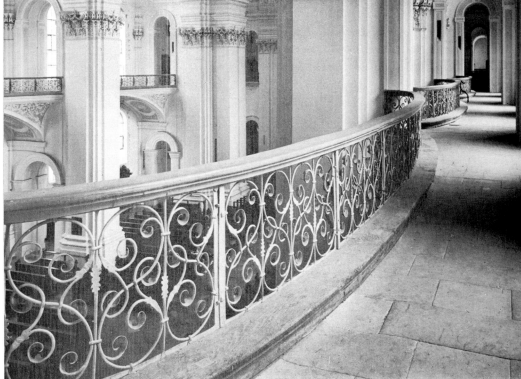

112 △

113 ▽

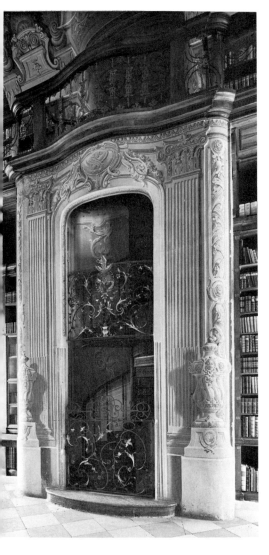

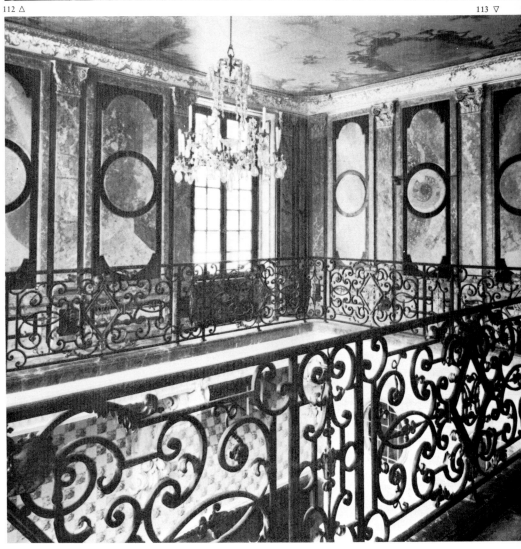

114. Half-moon transom, Salzburg, Kapitelplatz, 18th century.

115. Transom of the manse, Vierzehnheiligen, Franconia, mid-18th century.

116. Window grating, farmhouse, Bever, Upper Engadin.

117. Window grating, Rittergasse, Basel, mid-18th century.

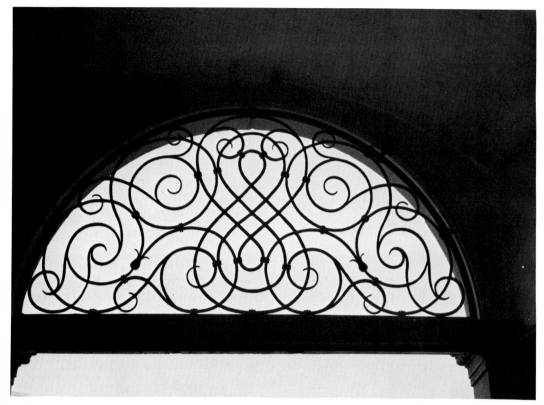

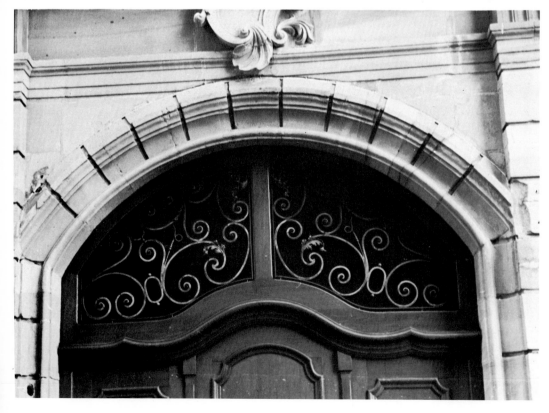

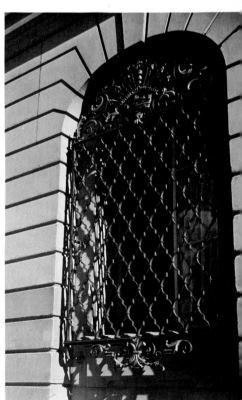

118. Grating, entry of Stams Abbey Church, Inn Valley, Tyrol, first half, 18th century.

119. Window grating, Haus zur Hohen Sonne, Rittergasse, Basel, 18th century.

120. Window grating, St. Mary's Chapel, west facade, Augustiner-Chorherrenstift, St. Florian, Upper Austria, first half, 18th century.

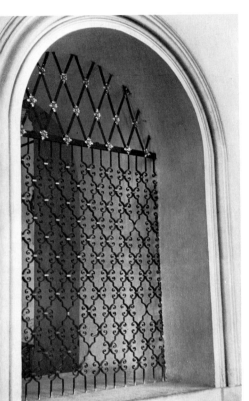

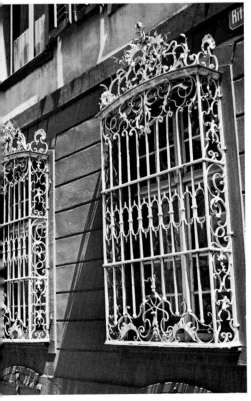

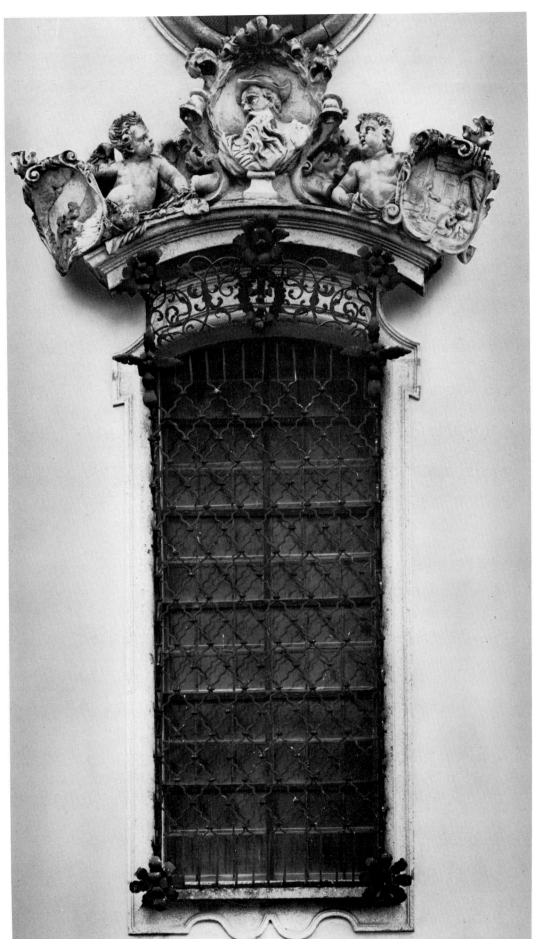

121, 122. Window gratings in Basel, 18th century.

123. Front of the house shown in #121.

124, 125. Window grating and detail, west façade, Banz Abbey, near Staffelstein, Franconia, early 18th century.

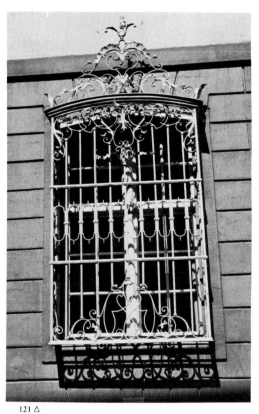

121 △

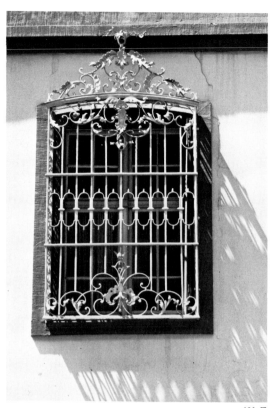

123 ▽

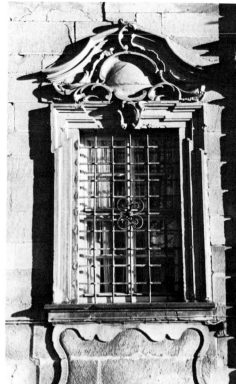

124 △

125 ▽

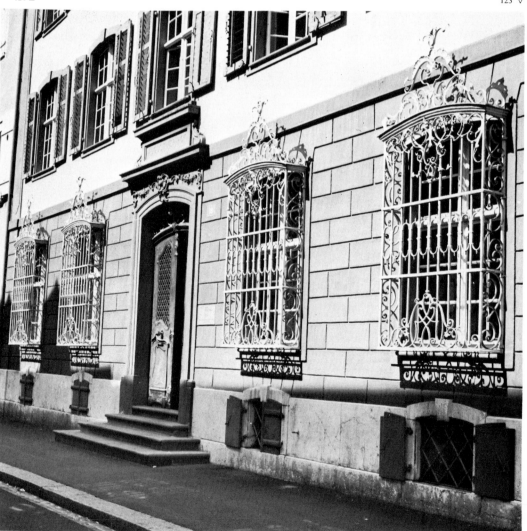

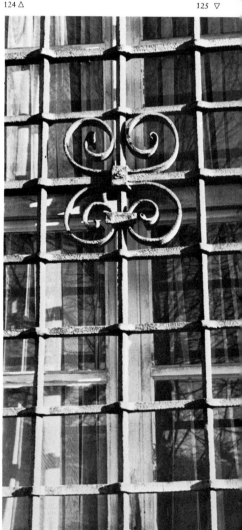

126. Window grating of a farmhouse, Grisons, Switzer-
land, 18th century.

127. Balcony grating, La Punt, Upper Engadin, Switzer-
land, 18th century.

128. Window grating of a farmhouse, Bergün, Albula Pass,
Switzerland, 18th century.

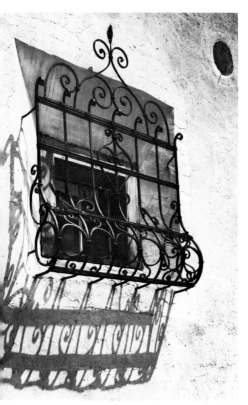

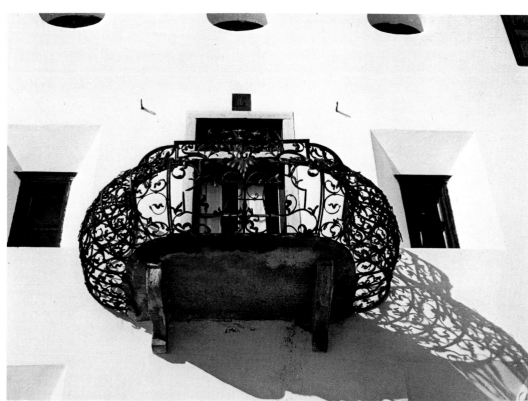

127 △

128 ▽

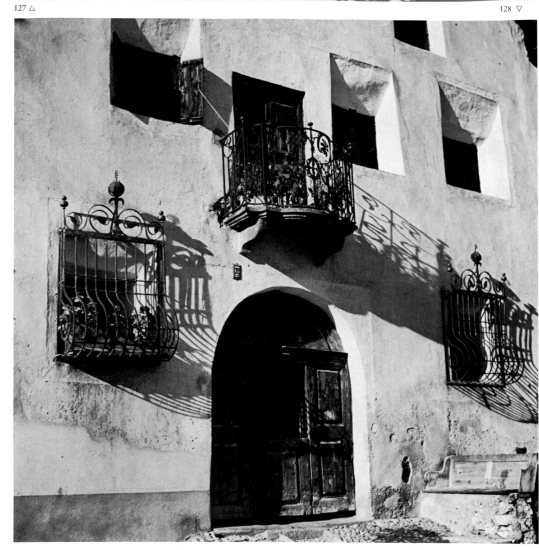

129. Richly decorated window grating with large basket,
Öhringen, Württemberg, mid-18th century.

130. Simple window grating, Mozart Square, Salzburg,
18th century.

131. Heavy window grating, Braun House, Bergün, Albula
Valley, Switzerland, early 18th century.

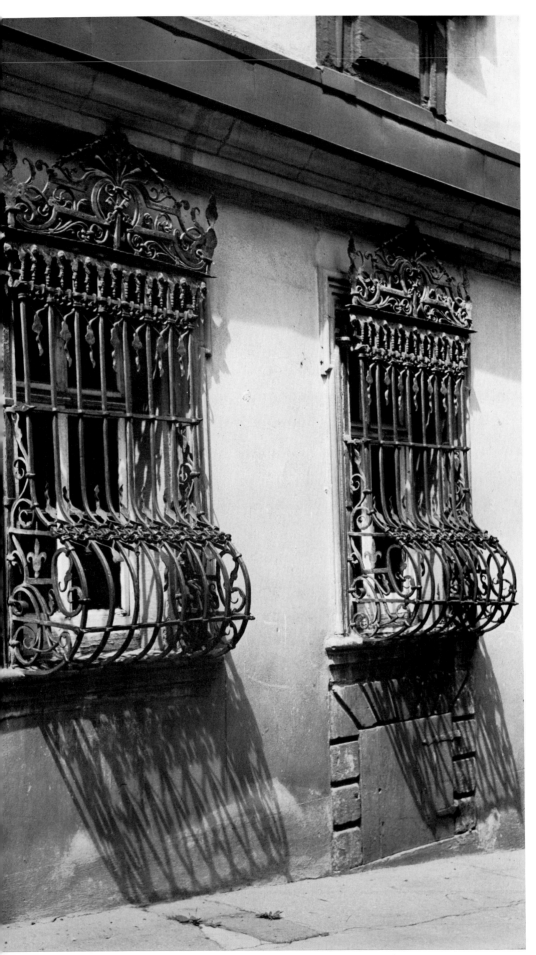

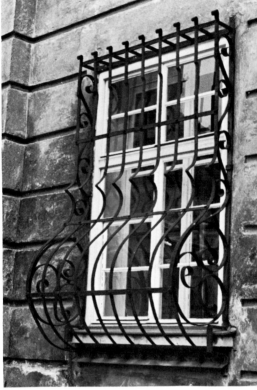

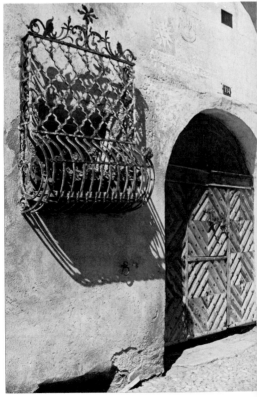

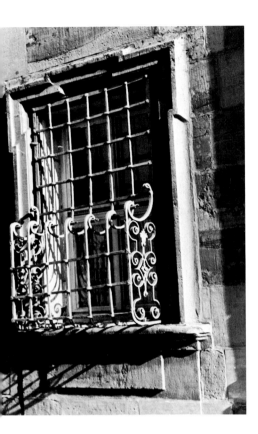

132. *Window grating of pierced square bars, manse of the Pilgrimage Church of Vierzehnheiligen, Franconia, mid-18th century.*

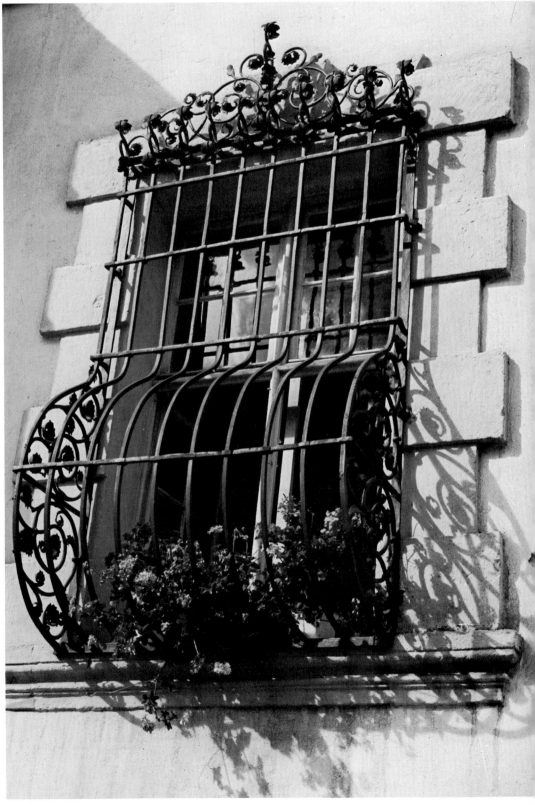

133. *Window grating of long rectangles with rich leaf decor, Ellingen Castle, Franconia, first half, 18th century.*

135. *Window gratings on ground floor and balcony with*
balusters, Palais Morass, Heidelberg, now Kurpfalz Mu-
seum, 1712.

136. *Balcony grating of a house on the Hauptgasse,*
Samedan, Upper Engadine, Switzerland, 18th century.

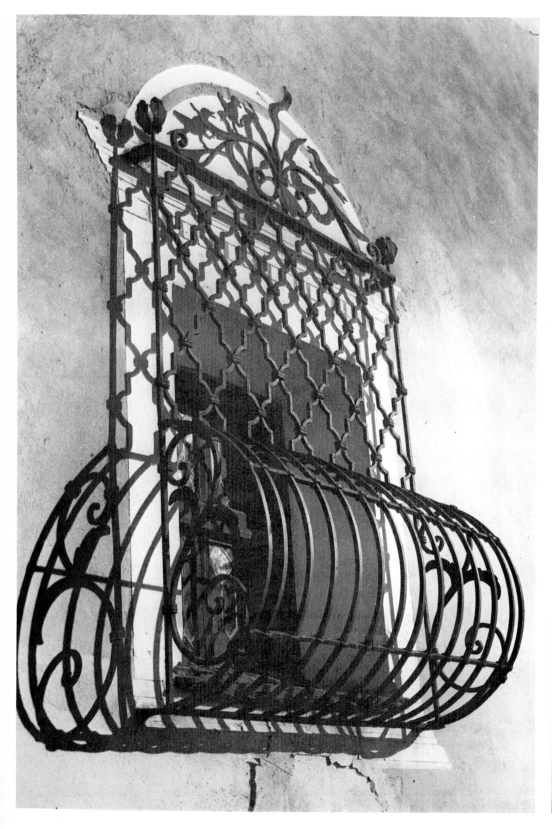

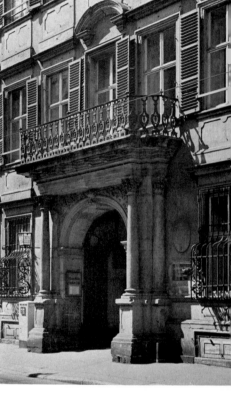

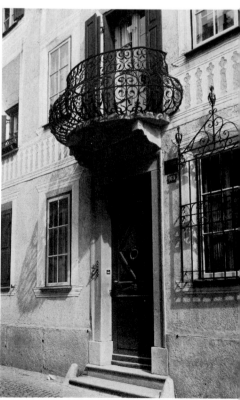

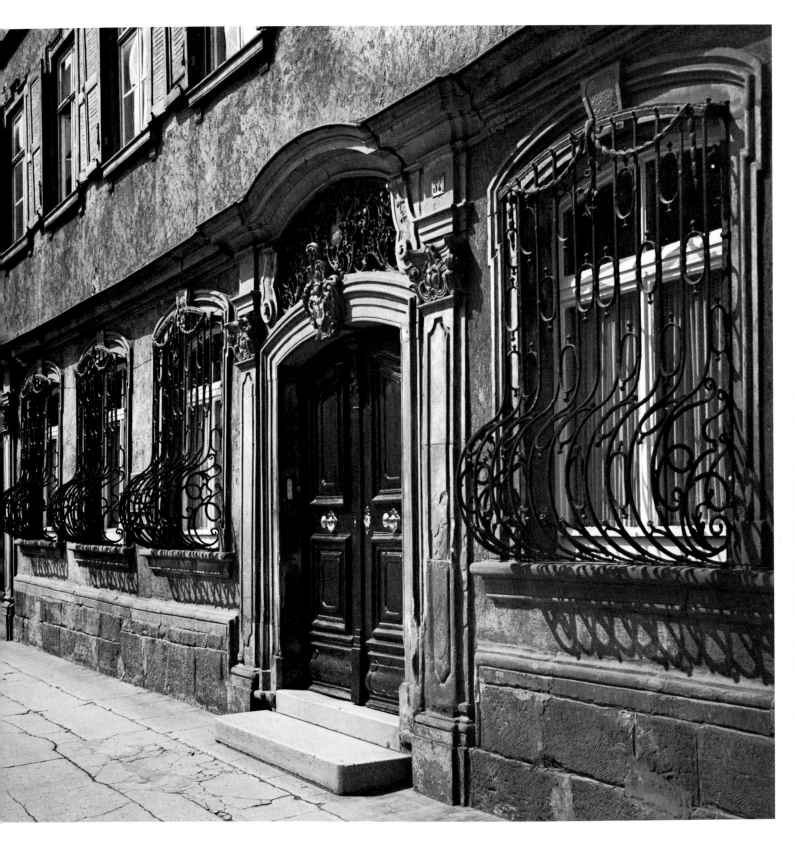

138. *Staircase of the Radcliffe Camera Library, Oxford, England, to plans by James Gibbs, 1737-1749.*

139. *Staircase, Bishops' Palace, Eichstätt, Franconia, built by Pedetti, 1767. Stair railing by Sebastian Barthlmes, probably designed by J. J. Berg, stucco artist.*

140. *Stair railing in Strachov Church, Prague, early 18th century.*

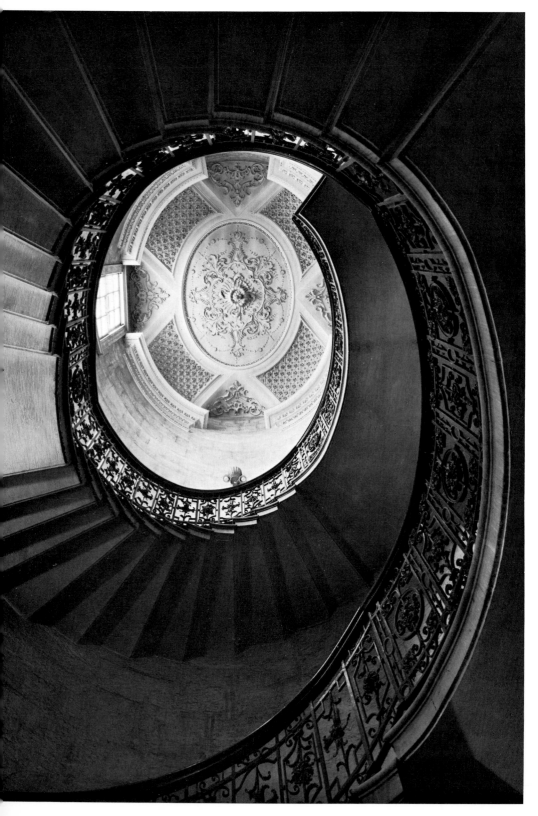

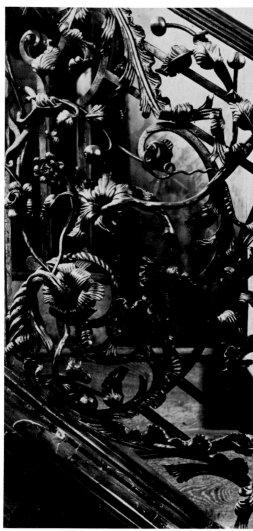

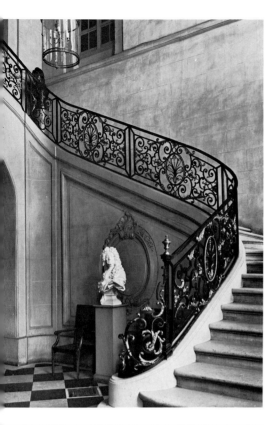

141. Stair railing, Hotel Brion, Paris, late 18th century.

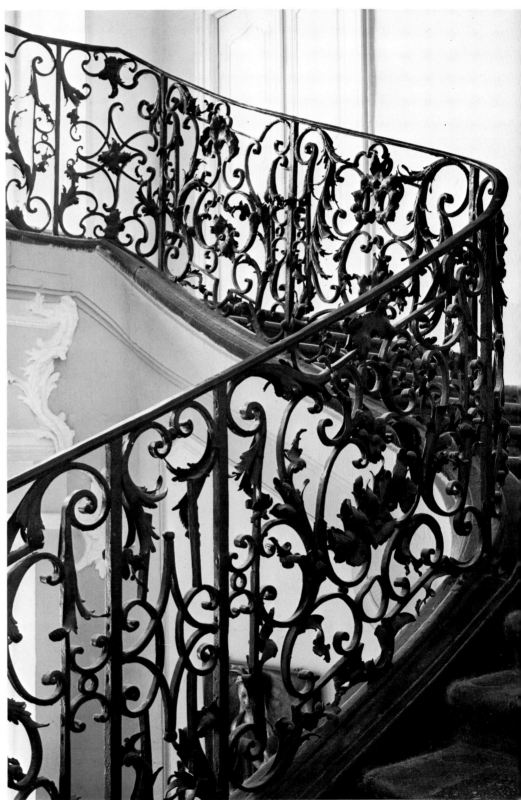

142. Staircase, Engers Castle, former pleasure palace of the Elector of Trier, Rheinland, built 1758-1762 by Johann Seiz for Archbishop Philipp von Waldersdorf, grating made at Master Unterseher's studio.

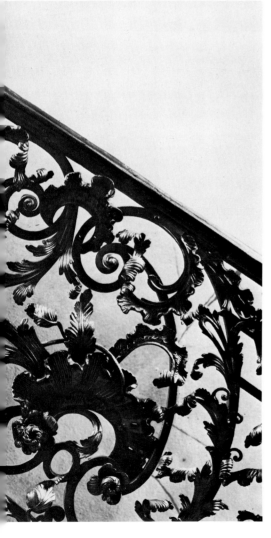

143-146. Prelates' stairway in Cistercian Cloister of Stams, Inn Valley, Tyrol, probably by monastery locksmith Bernhard Bachnetzer.

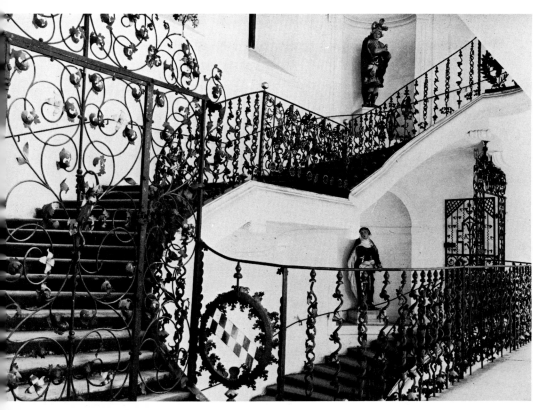

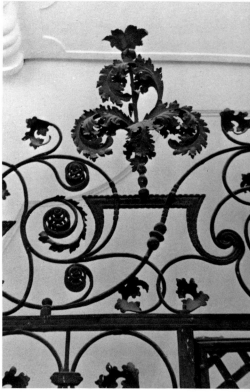

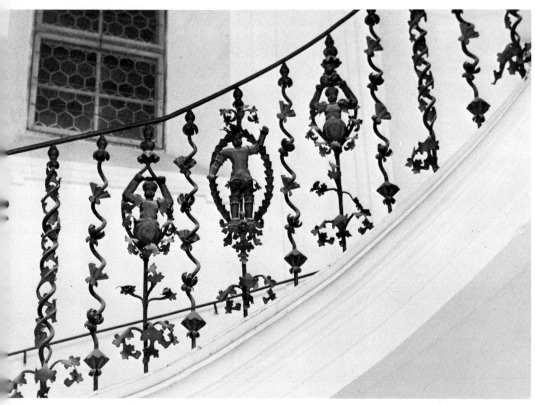

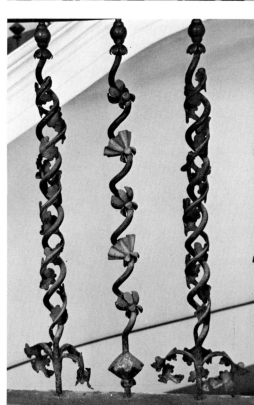

147-148. *Details of #143-146, door to upper hall dated 1727.*

149. *Door to staircase, former cloister of Schöntal on the Jagst, Württemberg, first half, 18th century.*

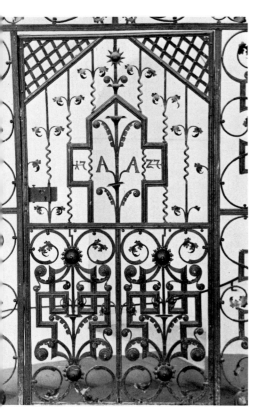

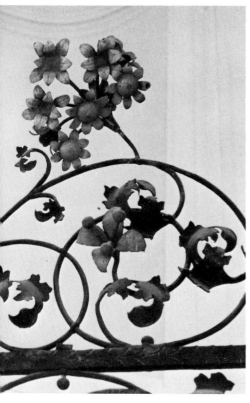

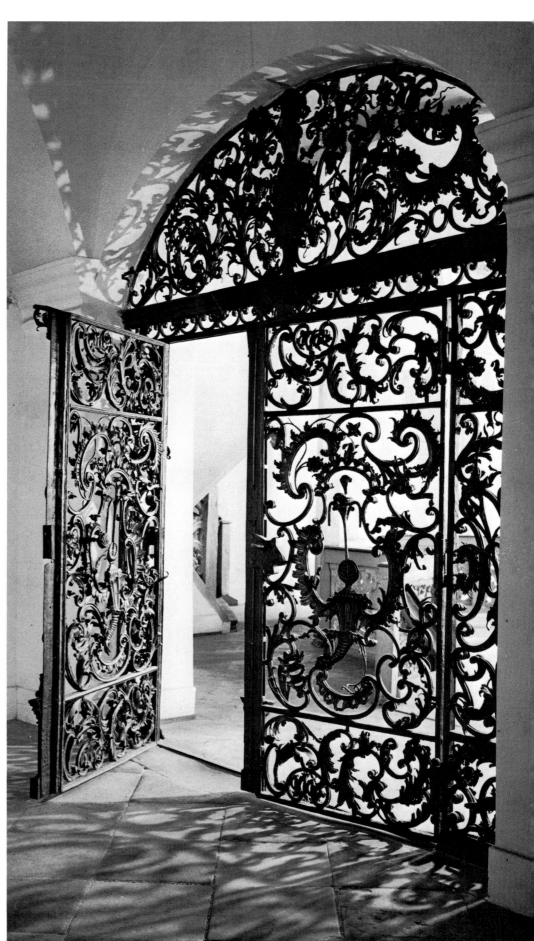

150. Stair railing, prelature of Einhards Abbey,
Seligenstadt on the Main, Hesse-Darmstadt, circa 1760.

151. Dog, detail of a window grating, Versailles, 1775-
1789, Victoria & Albert Museum, London.

152. Dove, detail of a stair railing, Gotteszell Church,
Bavarian Forest, late 18th century.

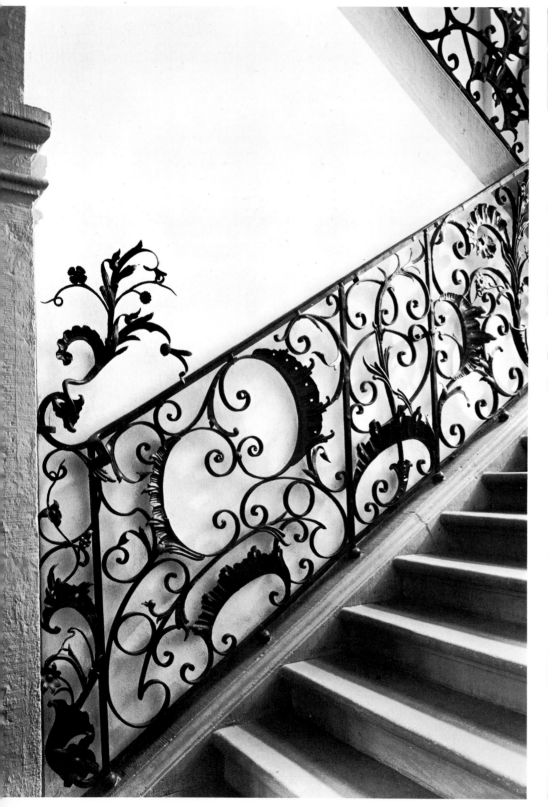

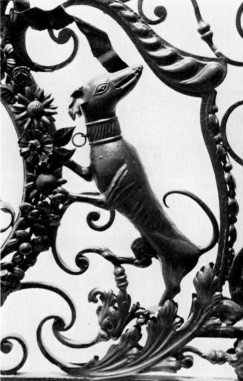

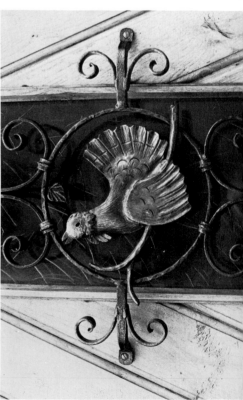

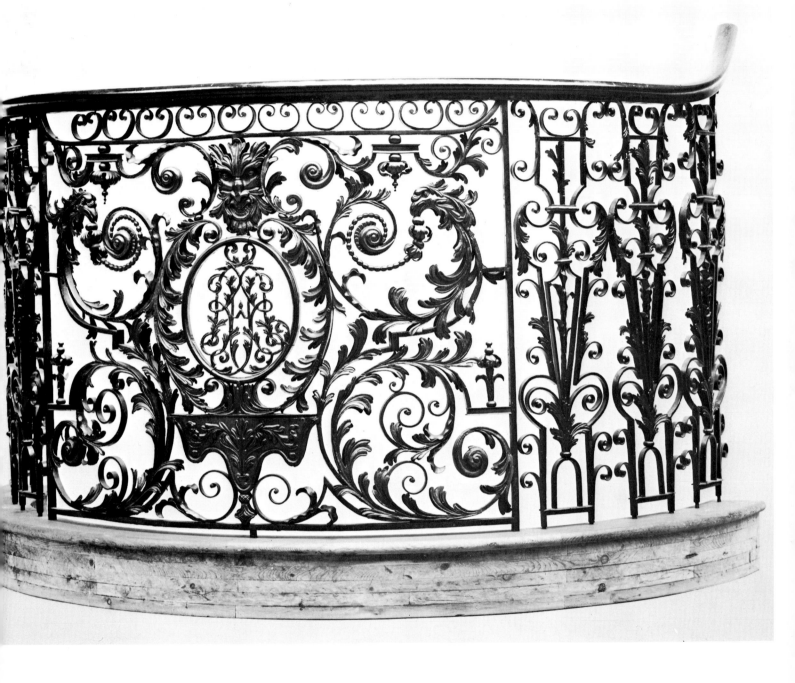

154. *Staircase, City Hall, Gengenbach, Baden, second half, 18th century.*

155. *Staircase, St. Blasien Abbey, Black Forest, second half, 18th century.*

156. *Staircase, Falkenlust Castle, Brühl, second half, 18th century.*

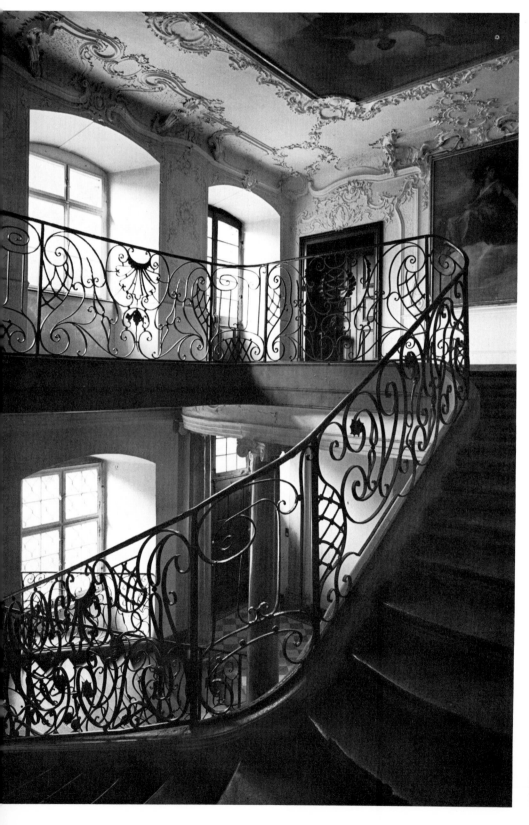

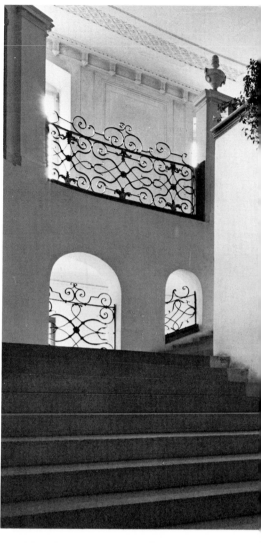

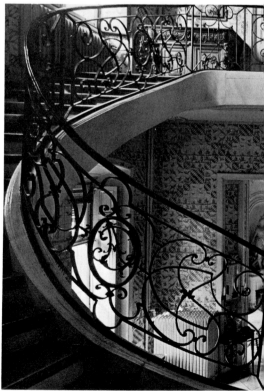

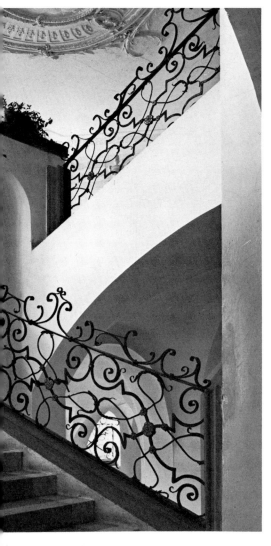

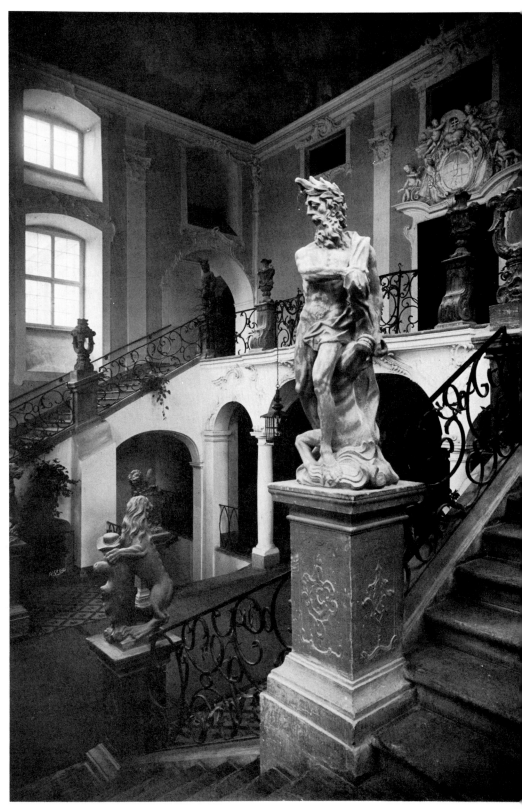

158. Open stairway, Buhl House, Heidelbarg, early 19th century.

159. Part of a house facade with balcony gratings, former palace of the Duke of Morny, Champs-Elysees, Paris, early 19th century.

160. Balcony grating at Sitges, Spain, late 19th century.

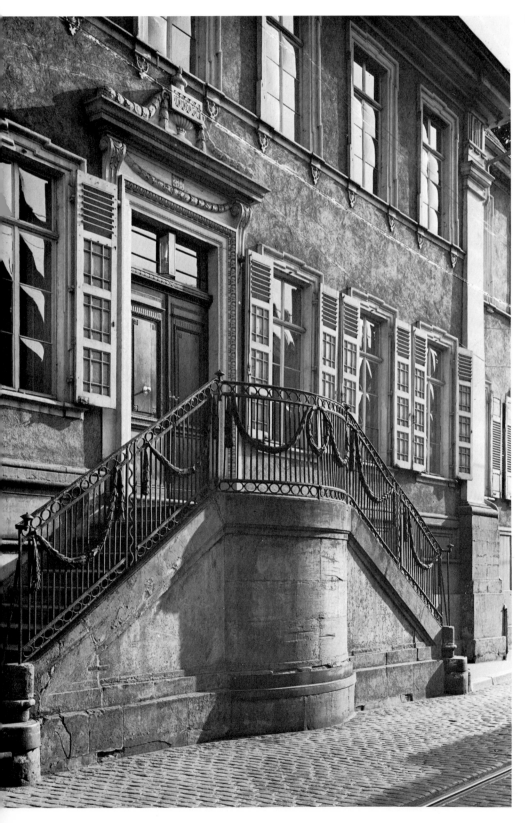

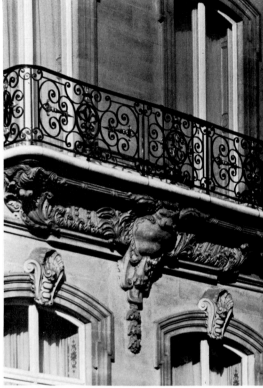

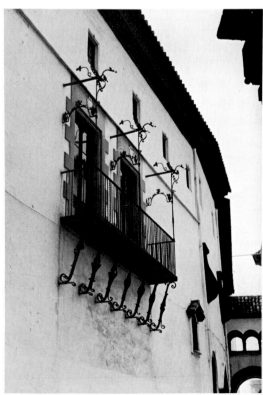

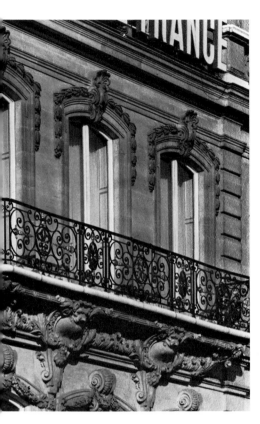

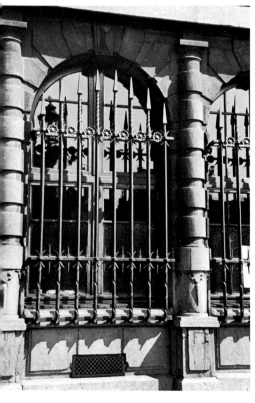

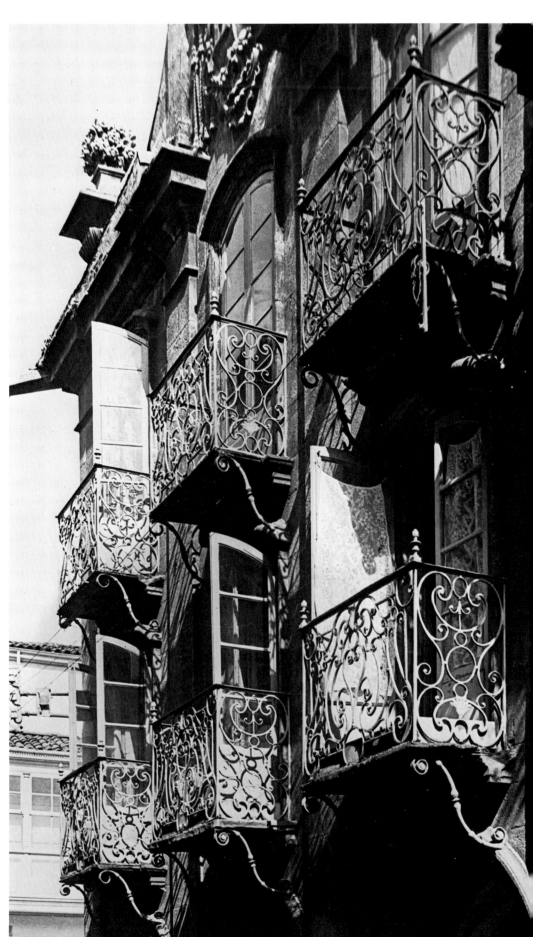

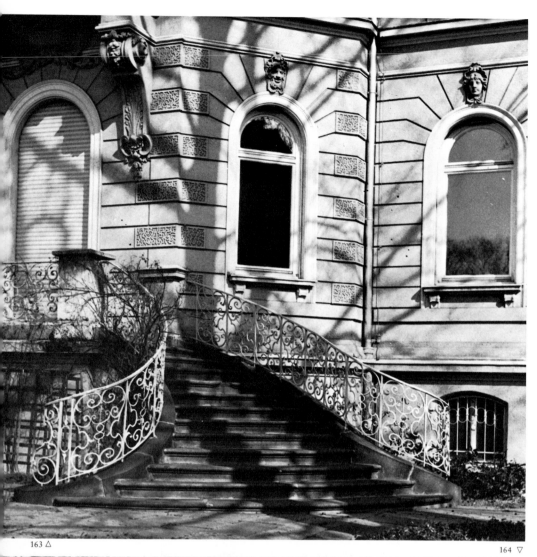

163 △

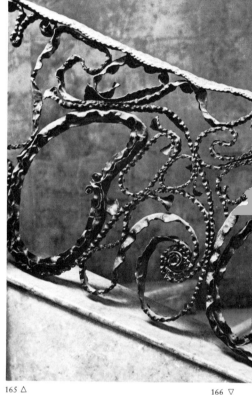

164 ▽ 165 △ 166 ▽

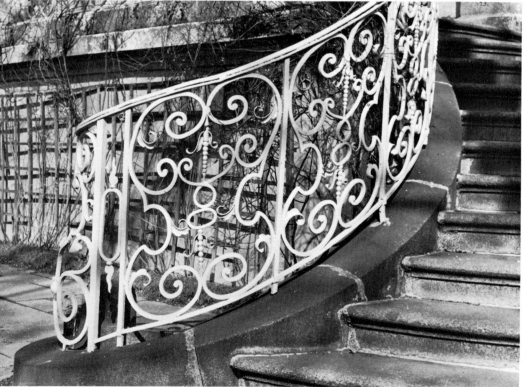

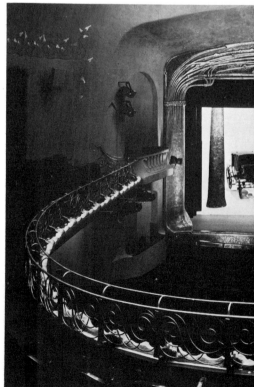

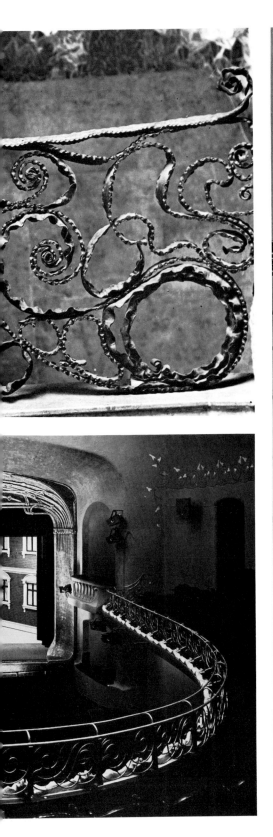

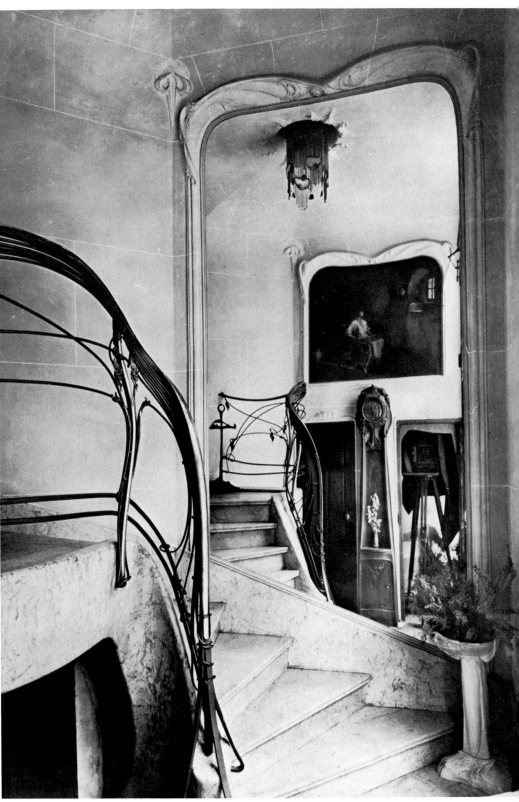

Tombs and Fountains

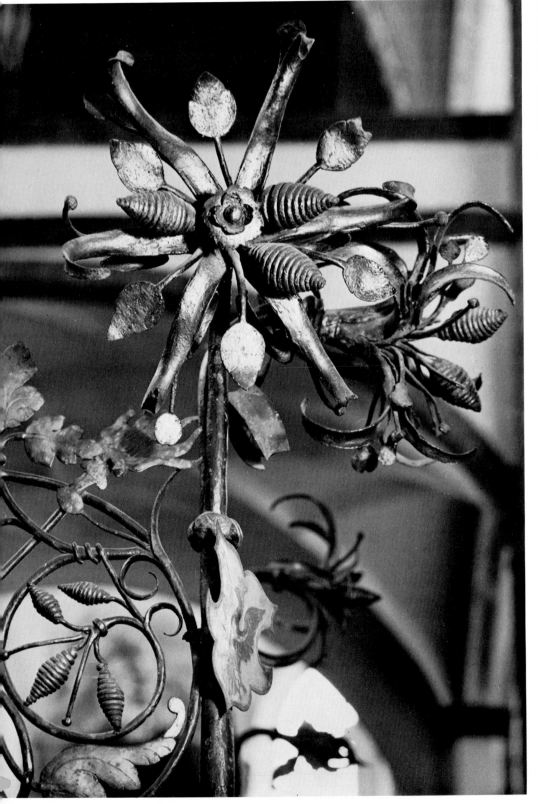

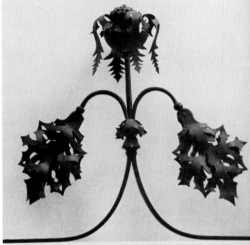

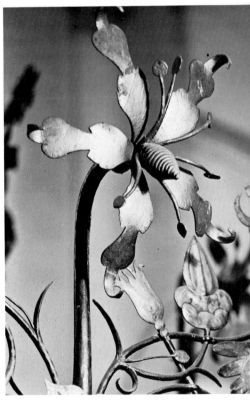

168. (Left) Cross and spindle flowers, railing around Maximilian's Tomb, Court Church, Innsbruck, designed by Paul Trabel, Innsbruck, built by Jörg Schmidhammer, Prague, 1568-1573.

171 △

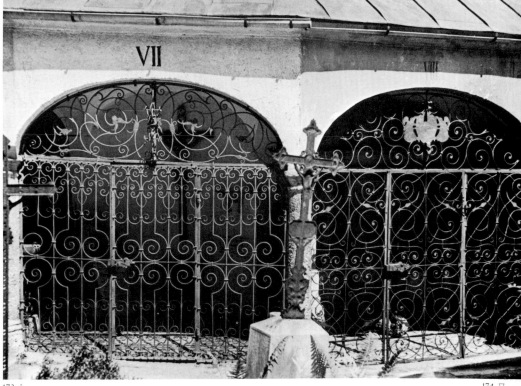

172 ▽

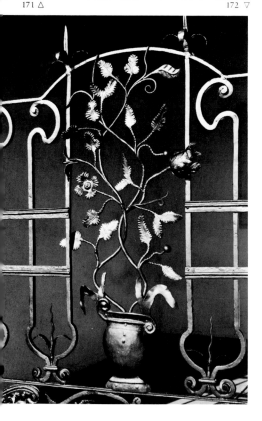

173 △

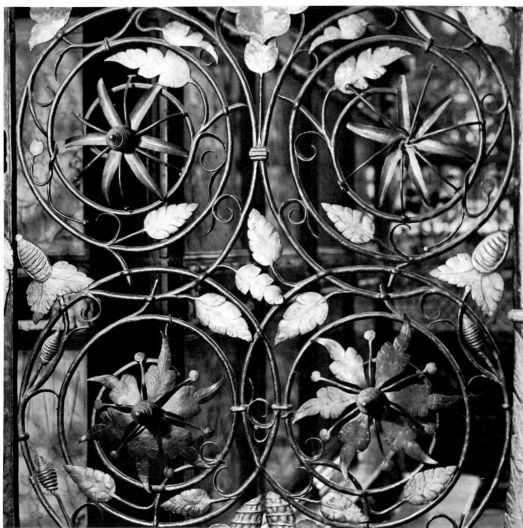

174 ▽

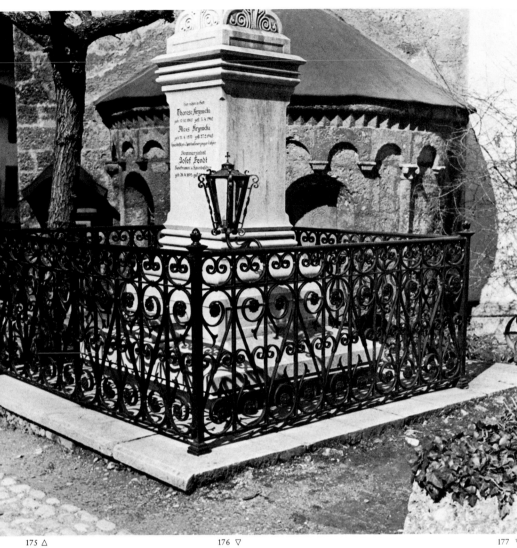

175. Grave enclosure, St. Peters' Cemetery, Salzburg, second half, 19th century.

176. Grave cross, south German, 18th century, Victoria & Albert Museum, London.

177. Grave cross from Hall in Tyrol, mid-17th century, Tyrolean Folk Art Museum, Innsbruck.

178. Grave cross from South Tyrol, 18th century, Diocesan Museum, Brizen.

175 △ 176 ▽ 177 ▽

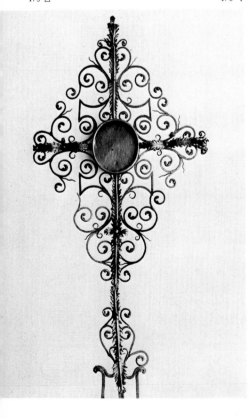

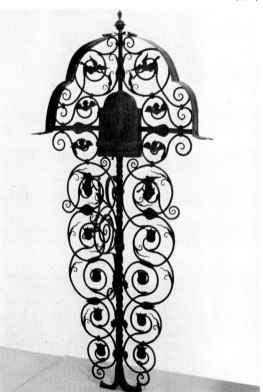

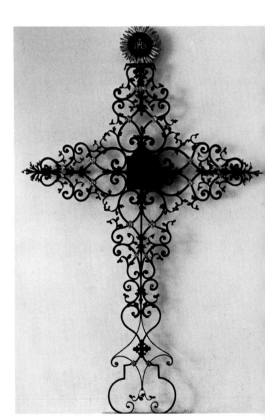

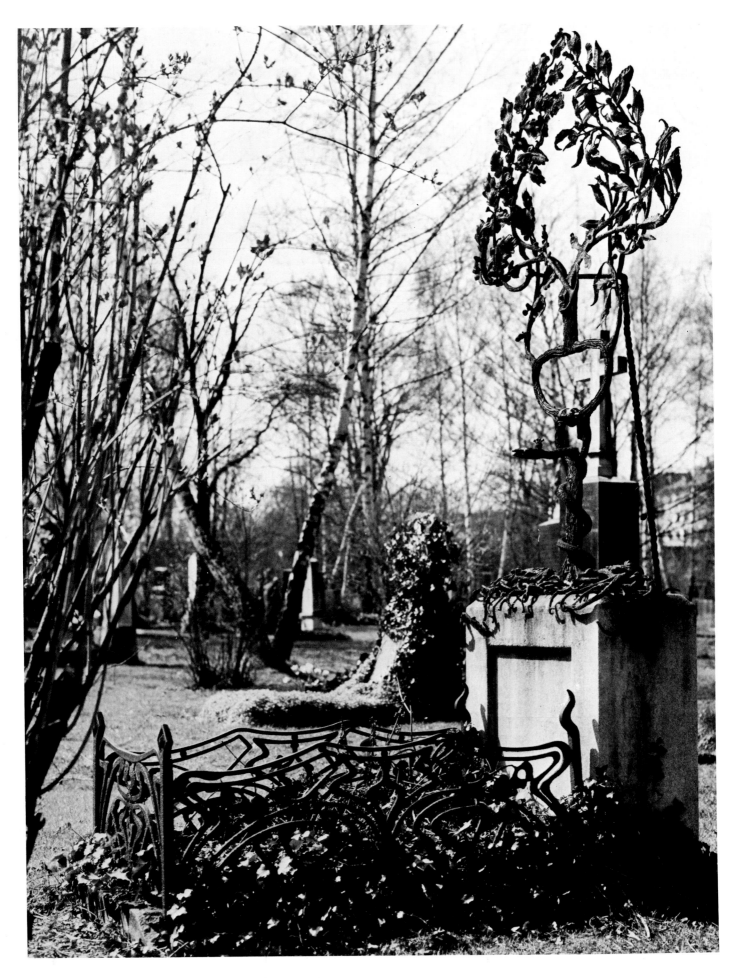

180. Well canopy, Vordernberg, Leoben, Styria, Austria, dated 1668.

181. Well canopy in courtyard of St. Florian Abbey, Upper Austria, 1603.

182, 184. Well canopy, Hvar Island, Dalmatia, 17th century.

183. Well canopy, Spontin Castle, Namur, France, late 15th century, late Gothic.

180 △

181 △

182 ▽

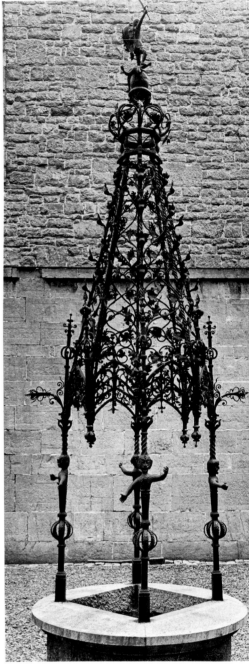

183 △

184 ▽

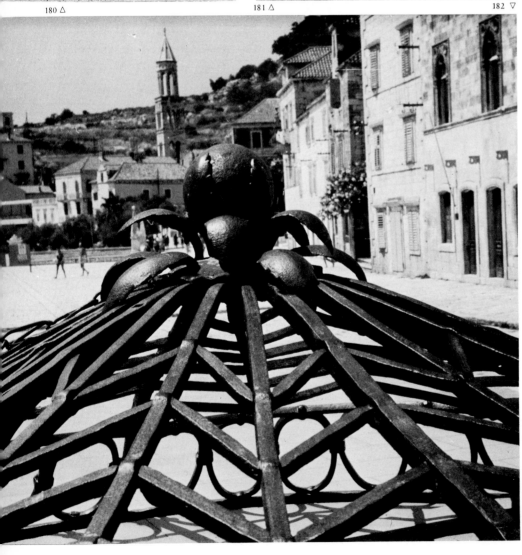

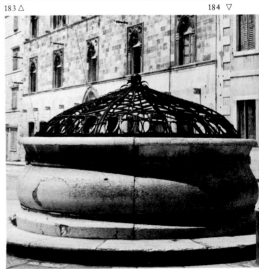

98

185. Well with forged iron bars, Vezelay, Burgundy, France, late Gothic.

186. Well canopy in the square of Bruck an der Mur, Styria, Austria, stone enclosure and canopy, 1626, grating 1693.

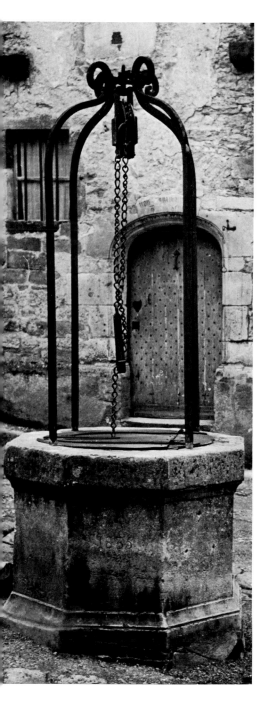

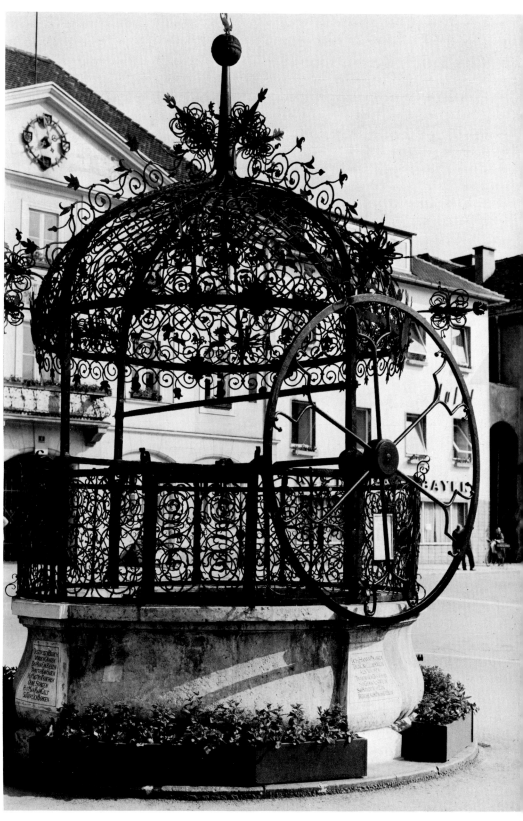

187-190. "Beautiful Fountain", Old Market, Nuremberg, Gothic fountain column built in 14th century, original grating by Andreas Kühn of Augsburg, 1587, present crown on 16th-century substructure by locksmith Pickel, 1823.

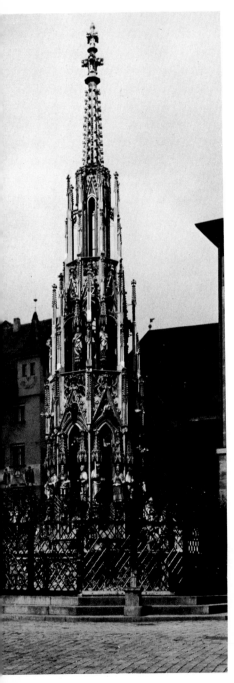
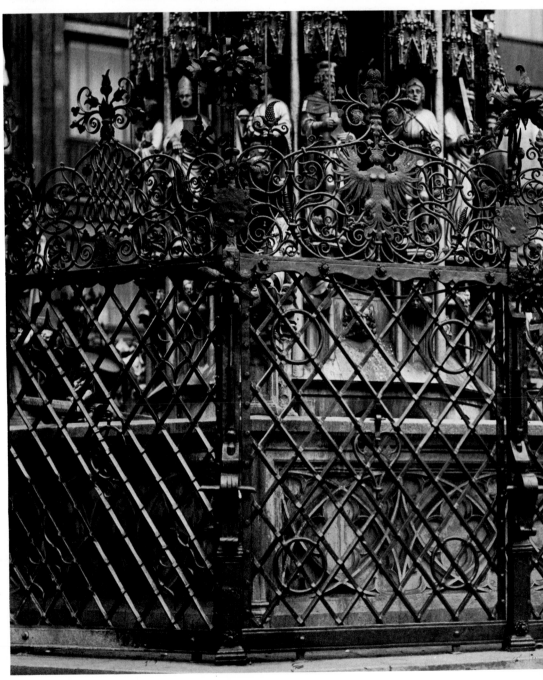

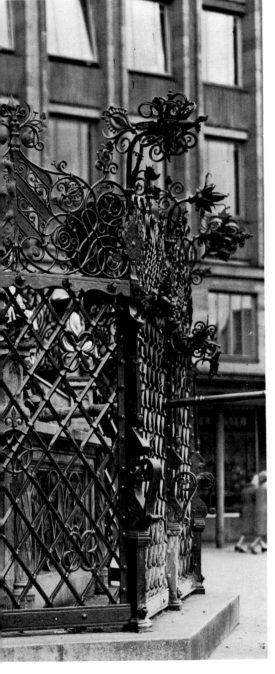

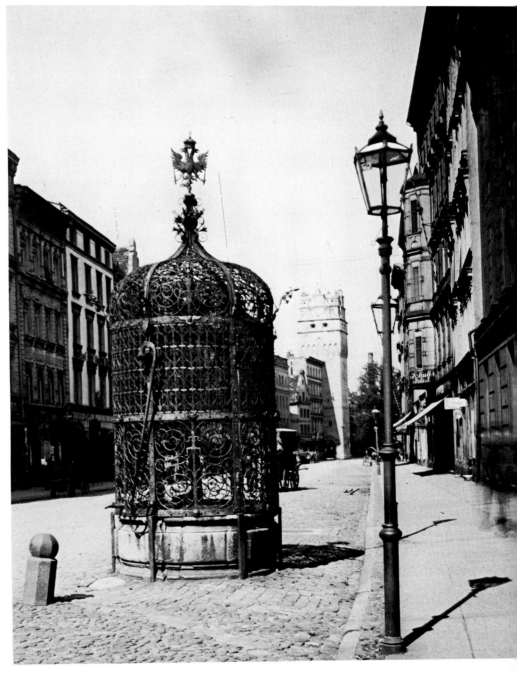

194, 196. Canopy in courtyard of St. Peter's Abbey, Salzburg, circa 1760.

193, 195. Neptune Fountain, popularly called "Fork-Man's Fountain", Bamberg, Franconia, dated 1698, mid-18th-century grating.

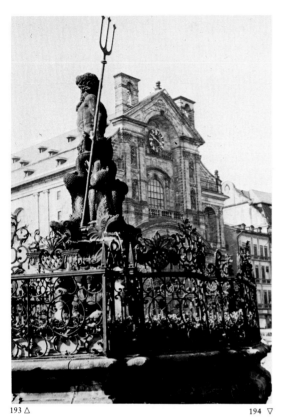

193 △

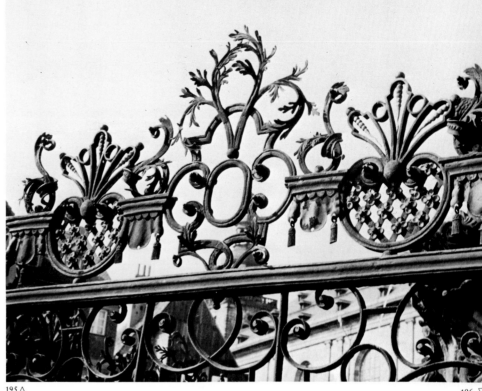

194 ▽

195 △

196 ▽

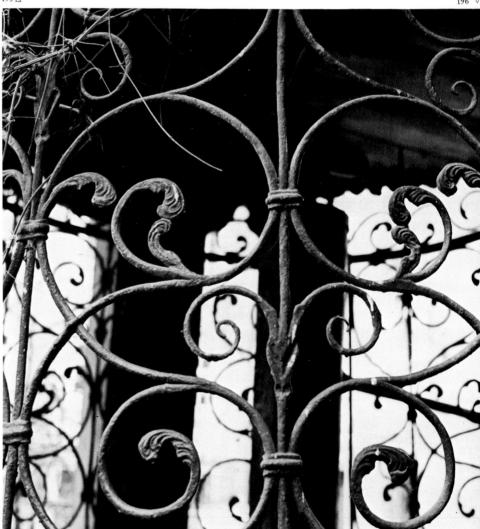

197, 199. "Roeckl Fountain" at Roeckl Square, Munich, designed by Eugene Delacroix, Art Nouveau fountain in operation since 1908, originally gilded, now green-painted wrought iron.

198. Fountain railing aeound Danube Spring in Donaueschingen, Baden, designed by Adolf Weinbrenner, finished 1896.

200. Fountain for ritual washing at the mosque in Mostar, Yugoslavia, perhaps circa 1900.

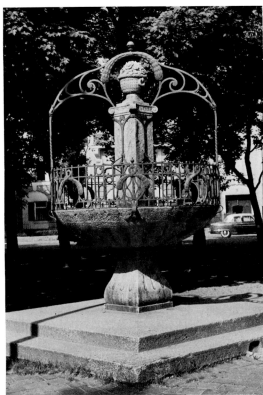

197 △

198 ▽

199 △

200 ▽

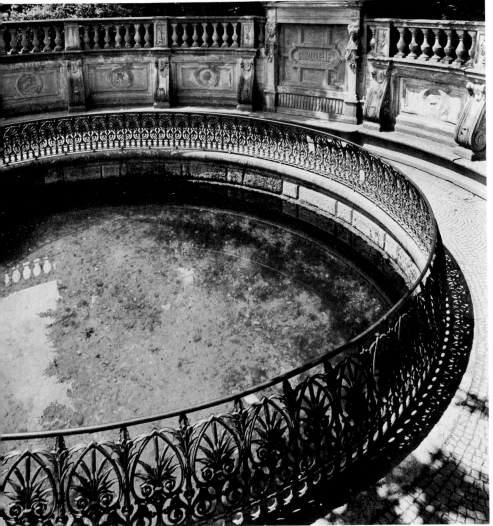

Gates and Park Fences

201, 204. *Fence and gate of the Scaliger tombs, Verona, circa 1380.*

202, 203. *Enclosure and gate of the baptistry, Bergamo, circa 1350.*

205. *Entrance gate to the south side of St. Lorenz Church, Nuremberg, 1649.*

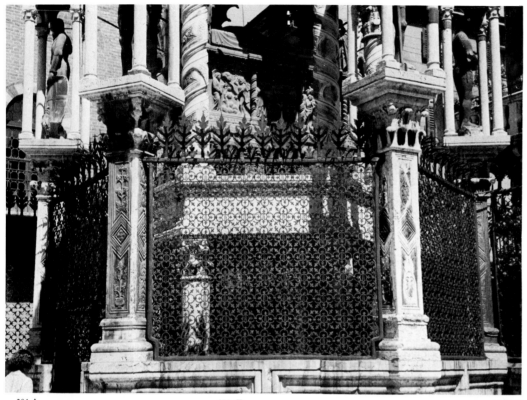

201 △ 202 ▽ 203 ▽ 204 △ 205 ▽

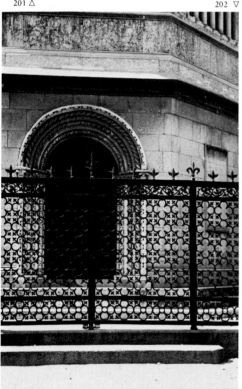

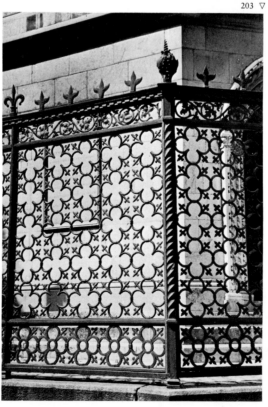

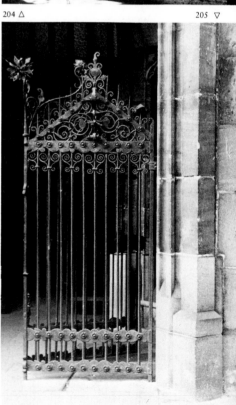

206. Gate to St. Margaret's Church, London, early 17th century.

207. Gate to the Strachov Church at the Hradschin, Prague, mid-17th century.

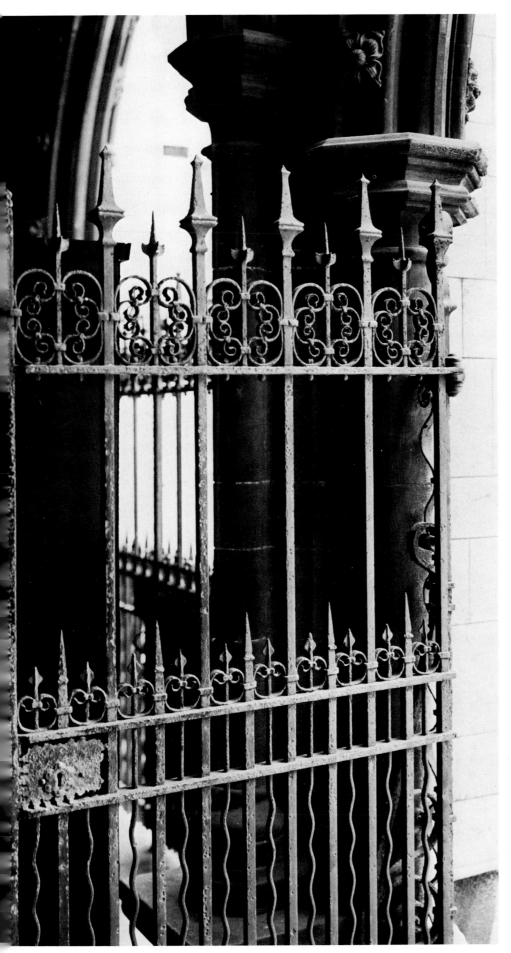

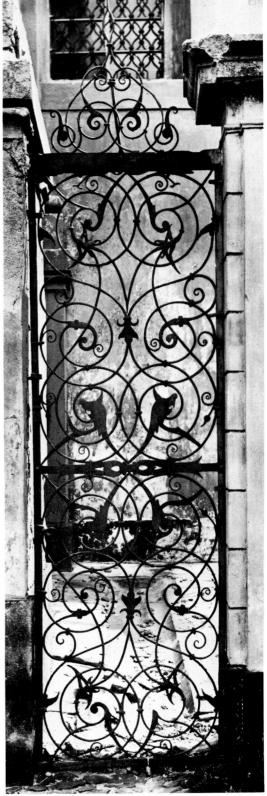

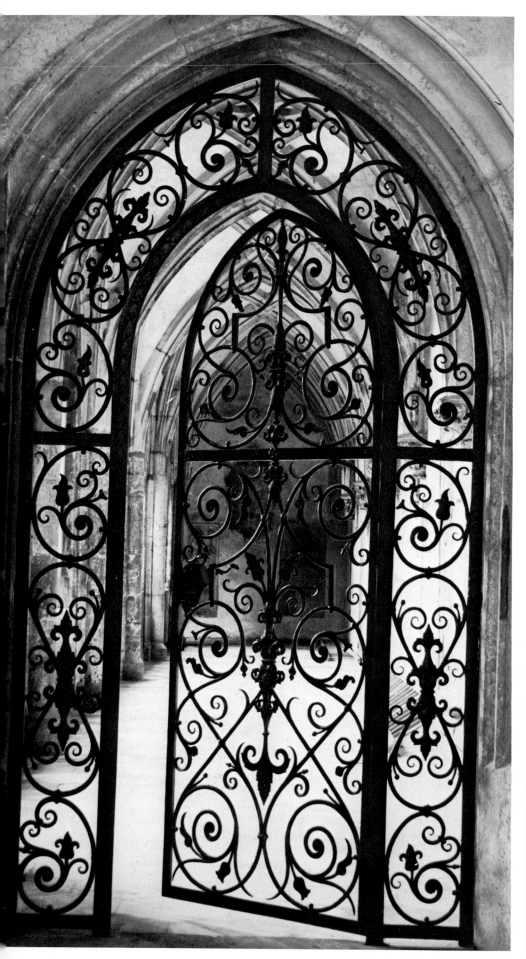

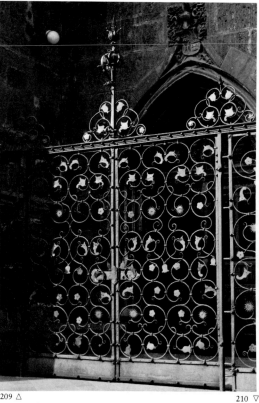

209 △

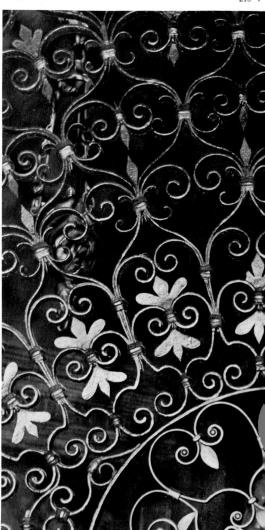

210 ▽

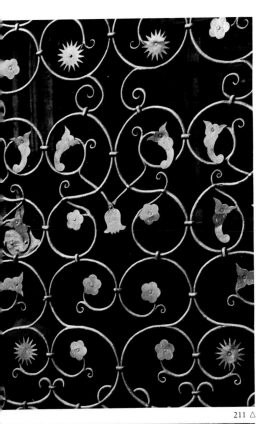

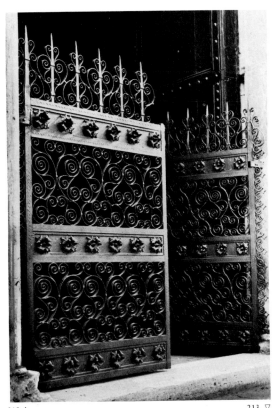

212. *Church portal, Chiesa di Santa Chiara, Assisi, circa 1600.*

213. *Entrance to a tomb, St. Peter's Cemetery, Salzburg, 17th century.*

211 △ 212 △ 213 ▽

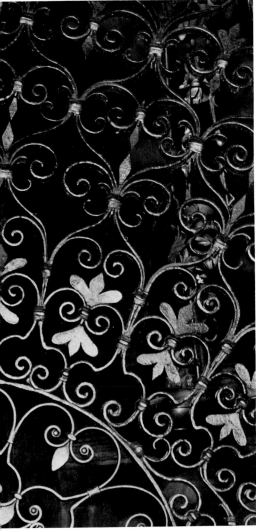

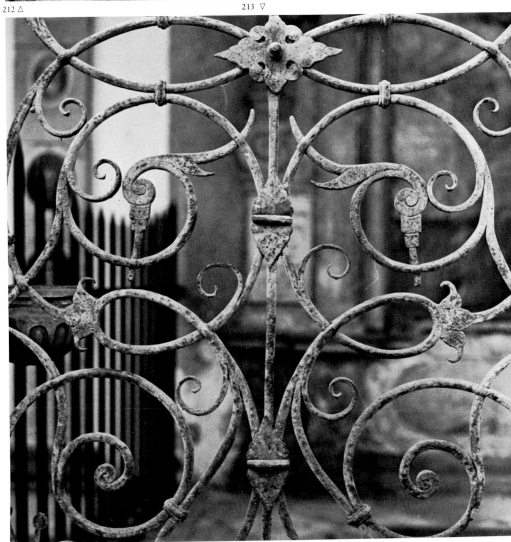

214. Entry gate to St. Peter's Cemetery, Salzburg, second
half of 17th century.

216. Detail of #215.

215. Portal of Castle Maisons-sur-Seine, made by
François Mansart, 1642-1651, for René de Lonqueil.
From same period as Jean Marot's gratings. Now at the
Apollo Gallery in the Louvre, Paris.

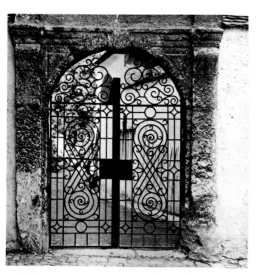

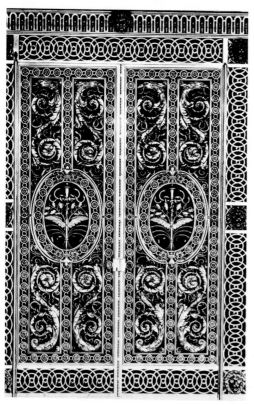

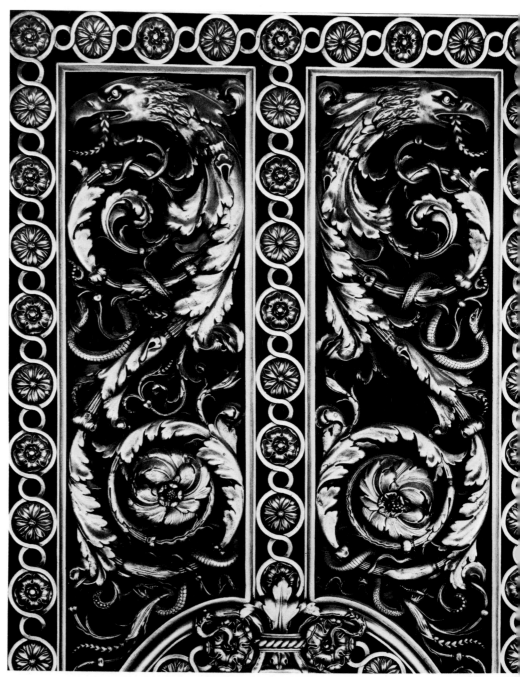

108

217, 219, 220. *Entry gate and details, from the cemetery in Lenggries, Bavaria, 17th century.*

218. *Tomb chapel in the cemetery, Lenggries, Bavaria, 17th century.*

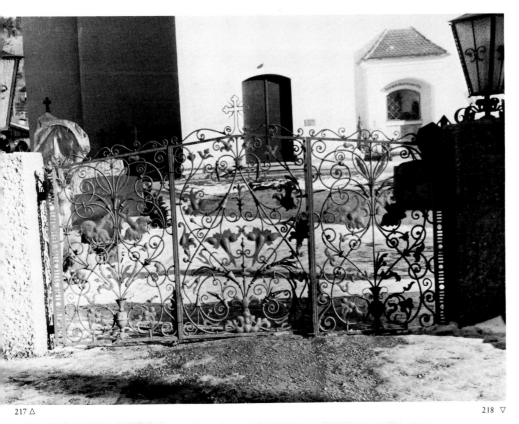

217 △

218 ▽ 219 △ 220 ▽

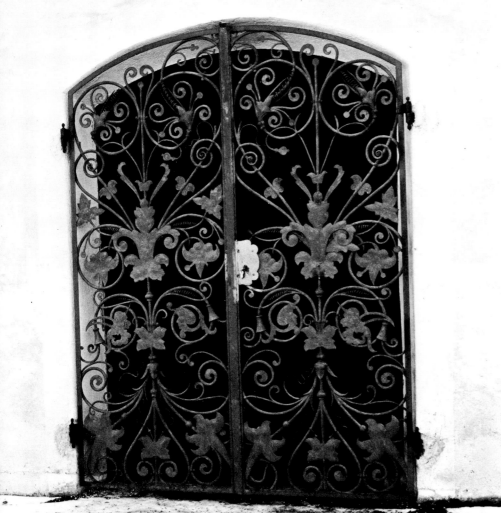

221. Gate grating, Britain, 17th century, dealer's photo.

222. Door grating at Undeloh, Lüneburg Heath, late 17th century.

223. Park gate, Italy, mid-18th century, Victoria & Albert Museum, London.

224. Eight-piece park fence, Italy, 17th century, Victoria & Albert Museum, London.

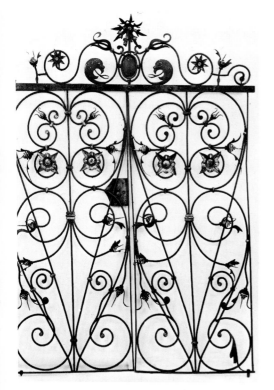

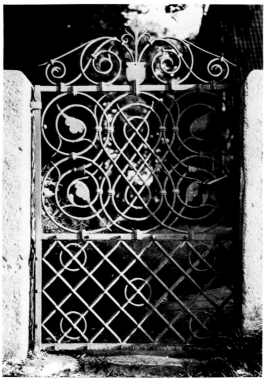

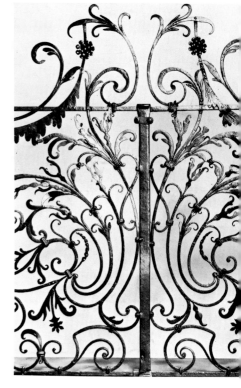

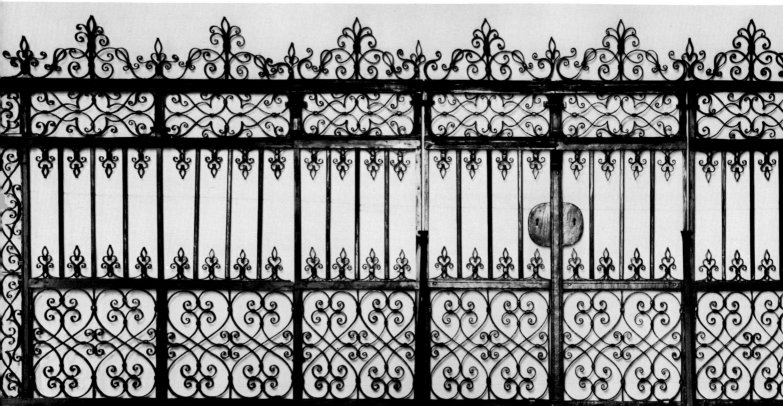

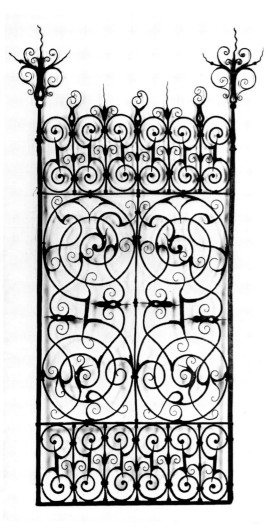

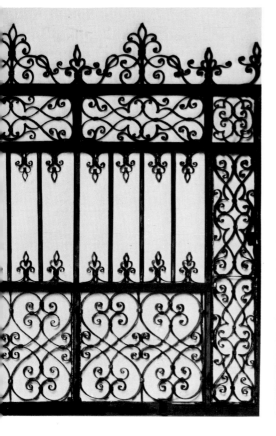

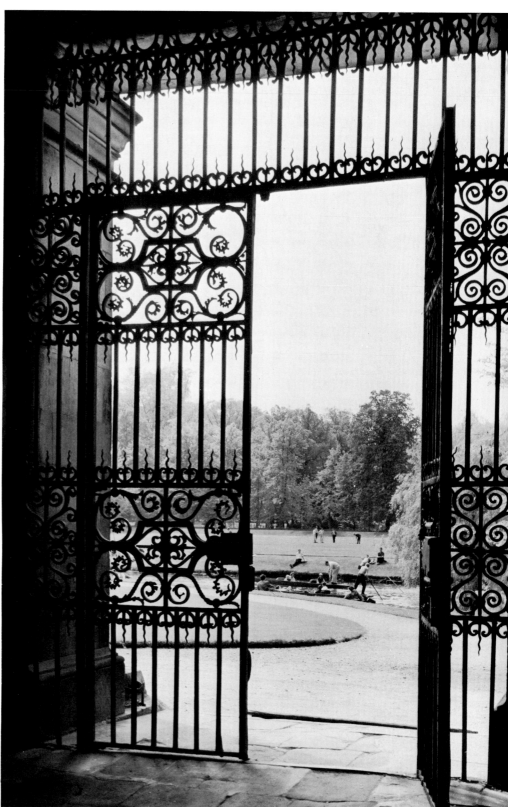

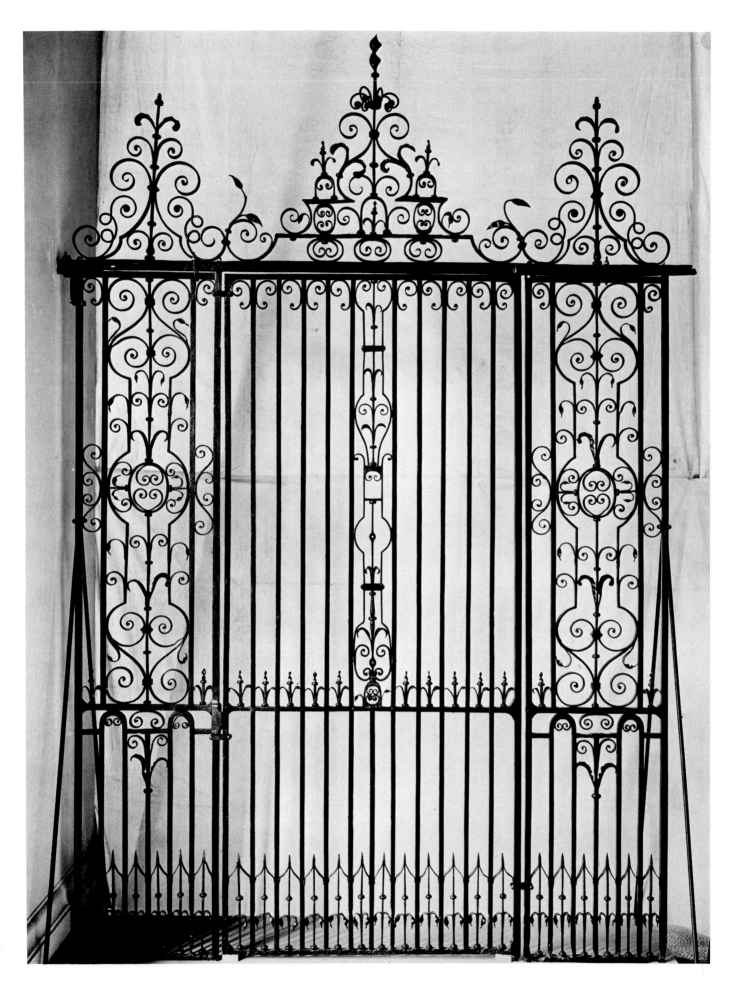

228. St. Jacques Hospital, Besançon, France, buildings from 1674, grating made 1703 by Maître serrurier Nicolas Chapuis.

229. Portal to stairway at Cour de Marbre, Versailles, circa 1680.

230. Fence at Stanislas Place in Nancy, France, finished circa 1760 by Jean Lamour.

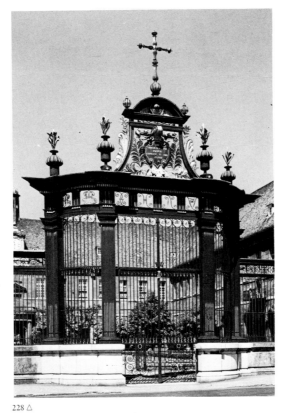

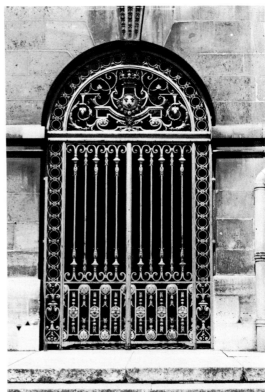

228 △

229 △

230 ▽

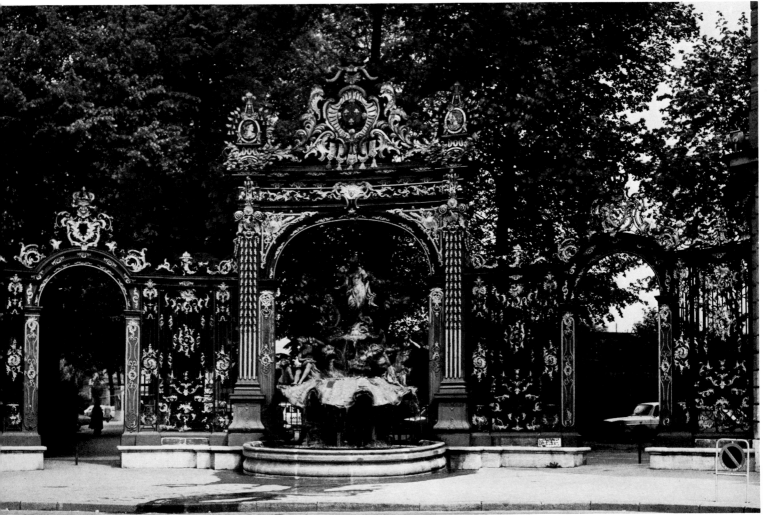

113

231, 232. *Grille d'honneur, at Cour (or Avant Cour) de Ministres, Grand Château, Versailles, erected in time of Louis XIV, largely destroyed in the French Revolution, rebuilt in somewhat changed form under architect Dufour in First Empire, with the lilies of France and symbol of the "Sun King".*

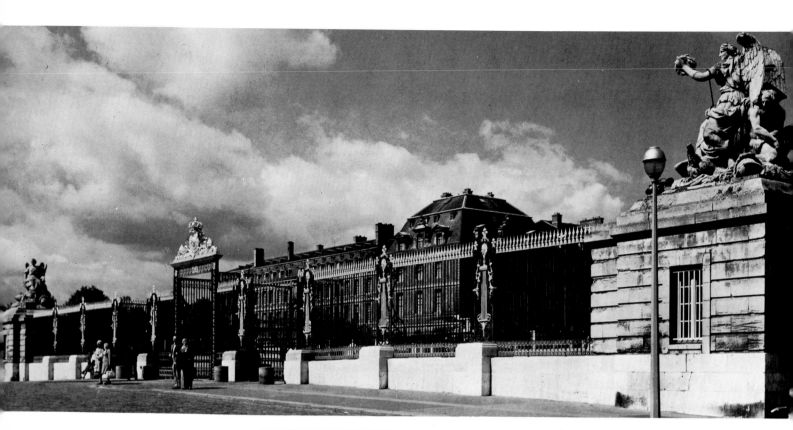

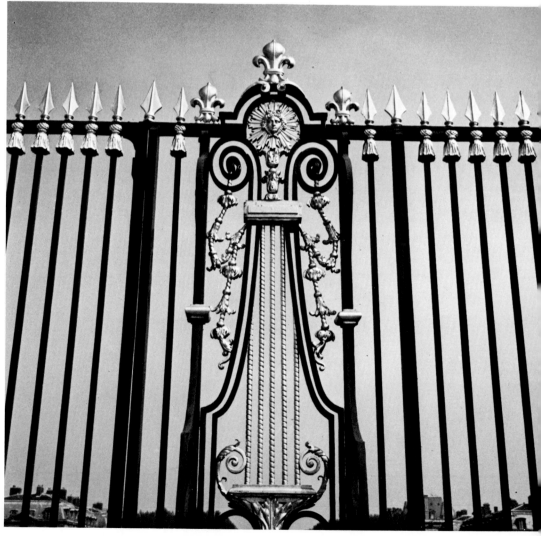

233. Gate to the court of honor and balcony of Château Rohan, Strasbourg, Place du Château, second half of 18th century.

234-236. Gate to the court of honor, Grand Trianon Palace, Versailles park, presumably erected under Louis XV in second quarter of 18th century.

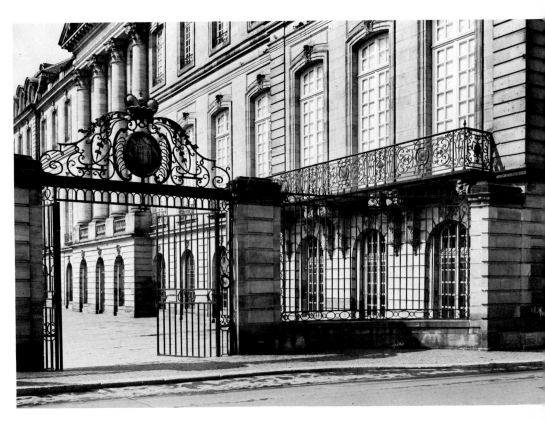

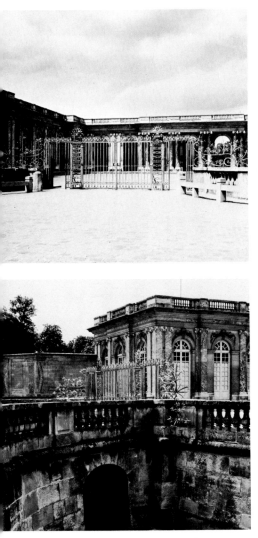

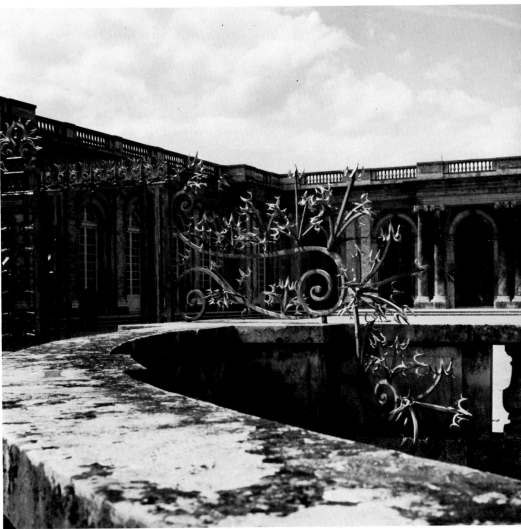

237, 238. Gate to the front courtyard of the Palais Potocki, Warsaw, built by Fontana and Deybel, circa 1730.

239. Park gates at Belvedere Castle, Vienna, built by Lukas von Hildebrandt for Prince Eugene of Savoy, 1721-1723.

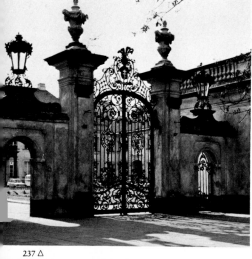

237 △

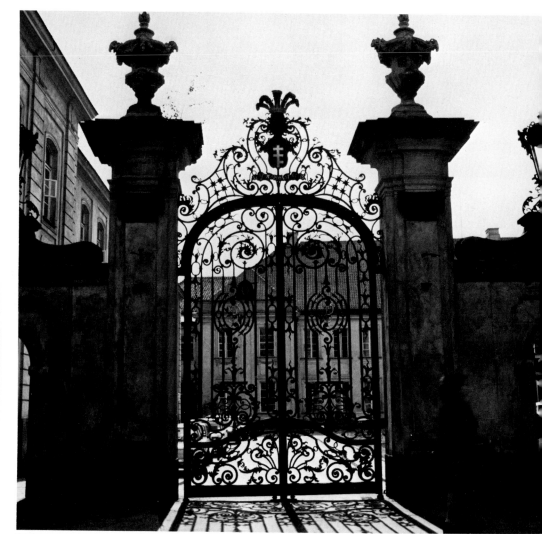

238 △

239 ▽

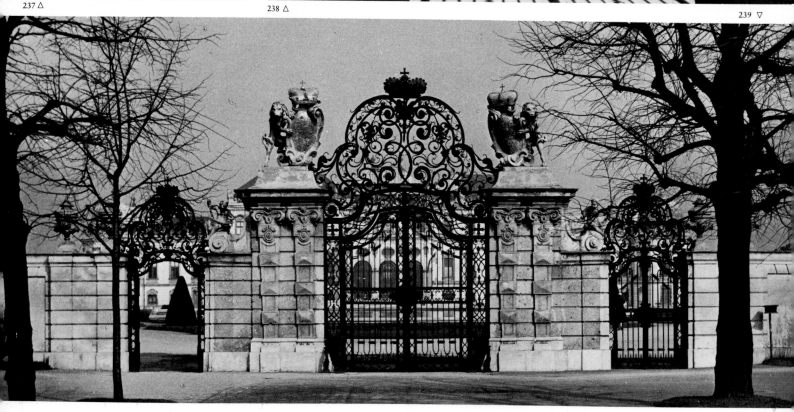

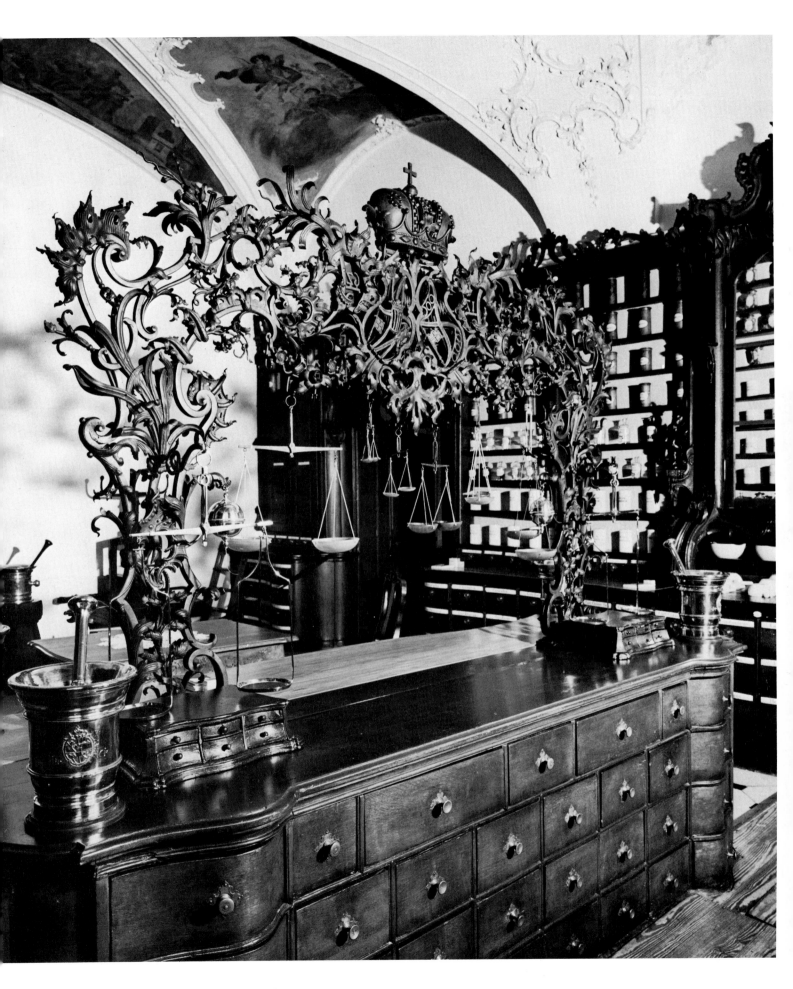

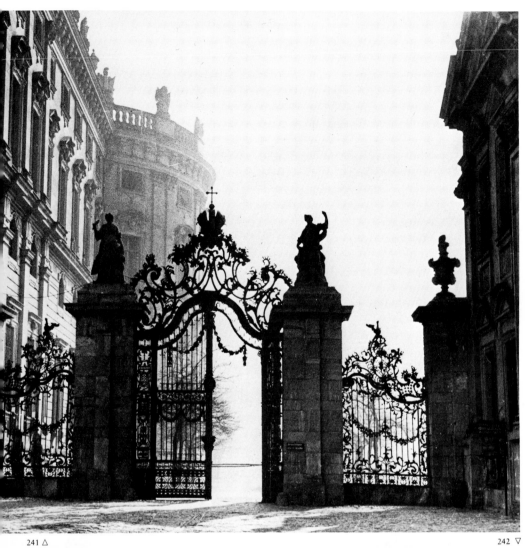

241 △ 242 ▽ 243 △ 244 ▽

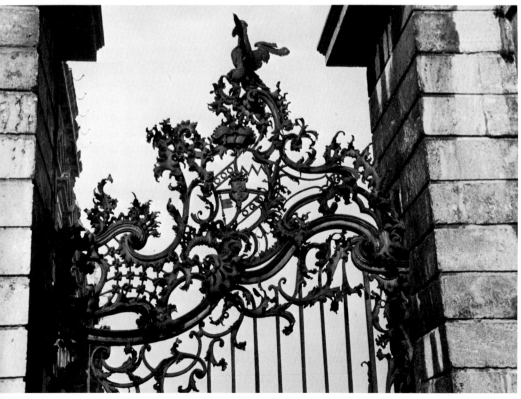

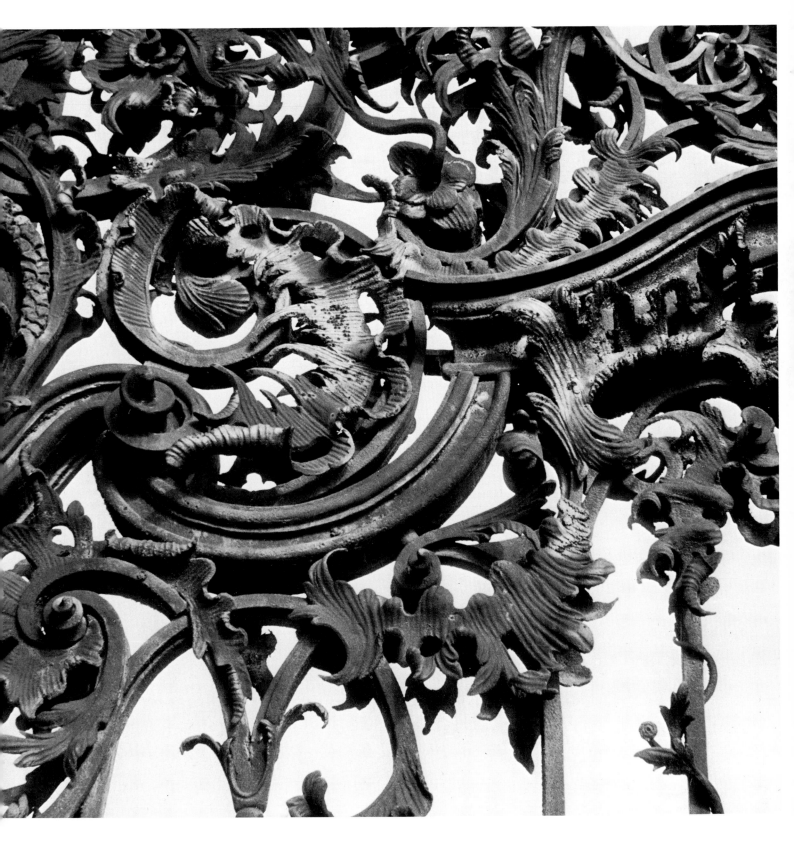

246. Gate and gratings of the former royal villa in
Berchtesgaden, Bavaria, first half of 18th century.

247. Park gate at Schillingsfürst Castle, Hohenlohe, 1723-
1750.

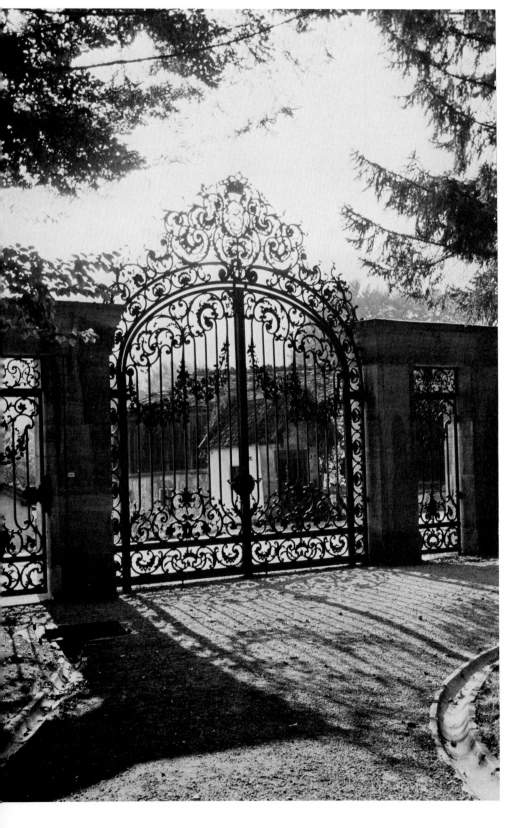

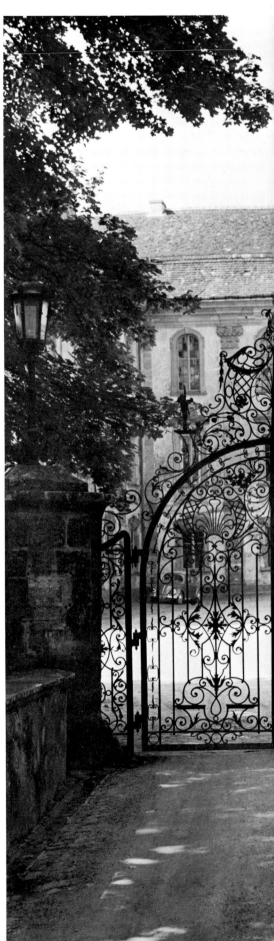

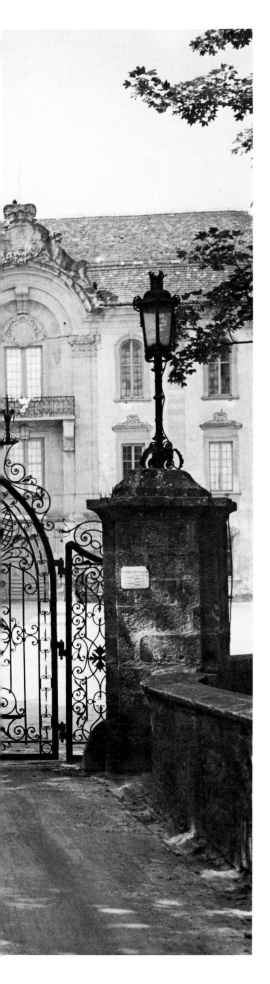

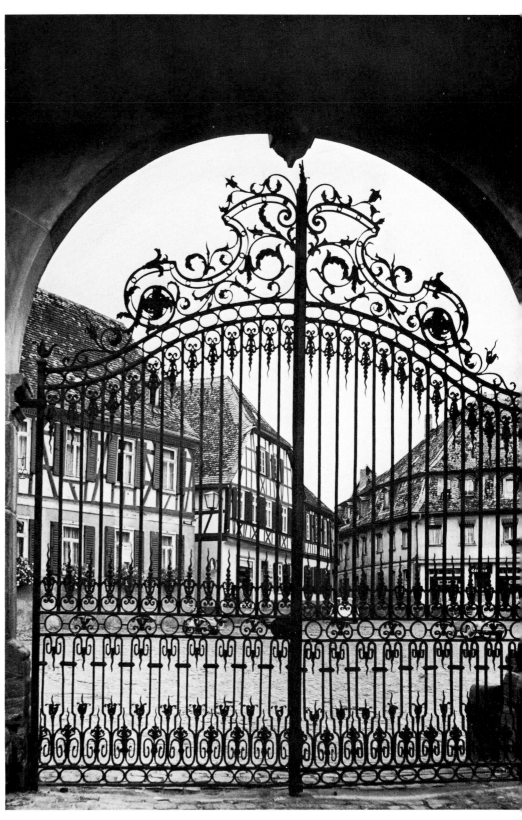

249. Gate to the stairway to Meersburg Castle, Lake Constance, before 1740.

250. Lantern over the gate to Michelsberg Abbey, near Bamberg, Franconia, mid-18th century.

251. Detail of a crypt grating, Ansbach Cemetery, Franconia, mid-18th century.

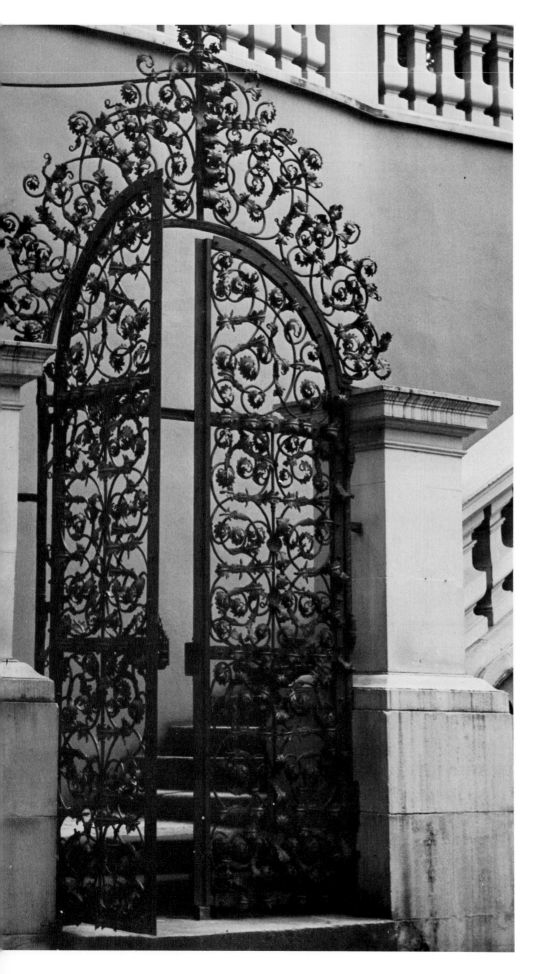

◁ 249

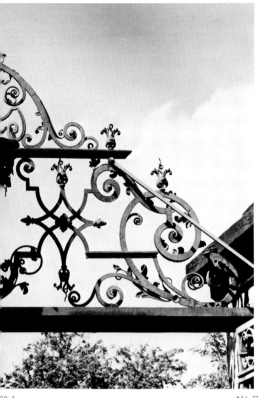

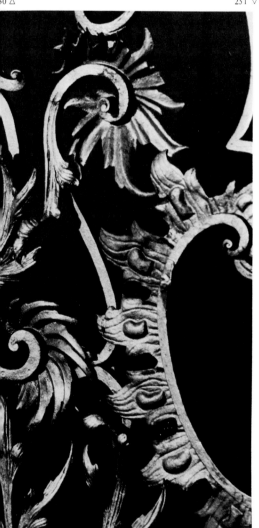

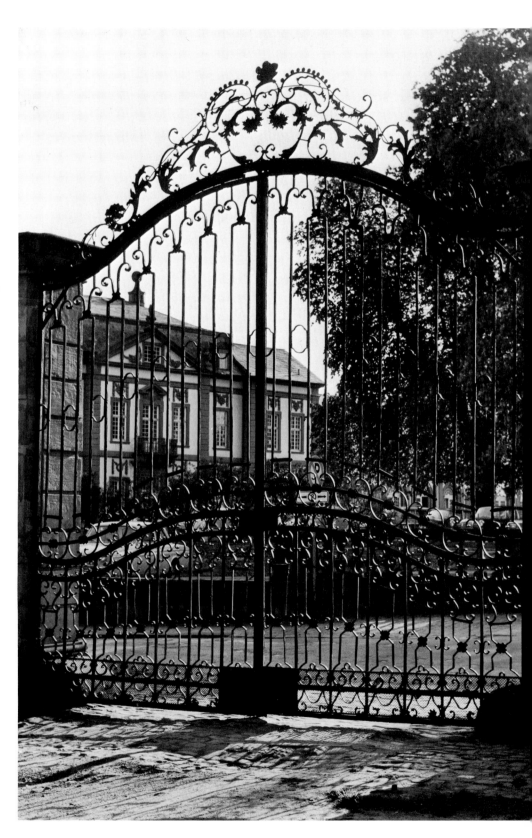

50 △ 251 ▽

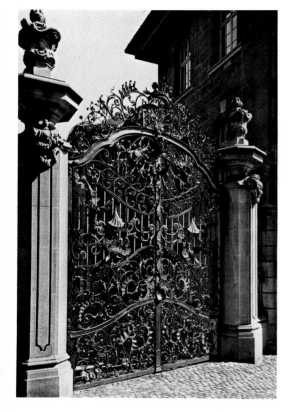

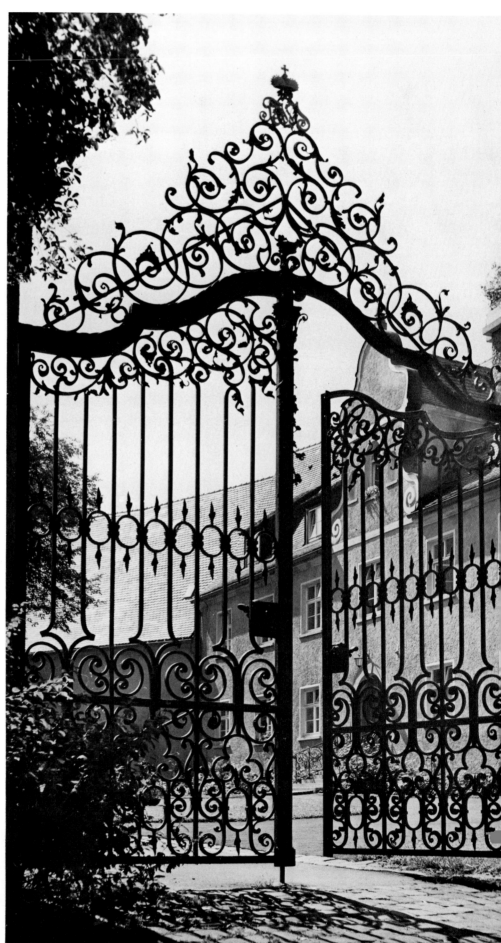

255. *Gateway to Spital am Pyhrn, Carinthia, by Matthias Lindermayr, circa 1720.*

256. *Guildhouse zur Meise, Zürich, Münsterhof, mid-18th century.*

257. *St. Florian Abbey, Upper Austria, gate to the upper hall, first half of 18th century.*

258. *Gates at Mondsee Castle, Salzburg, first half of 18th century.*

259. *Castle garden gate, Neuburg am Inn, Bavaria, end of 18th century.*

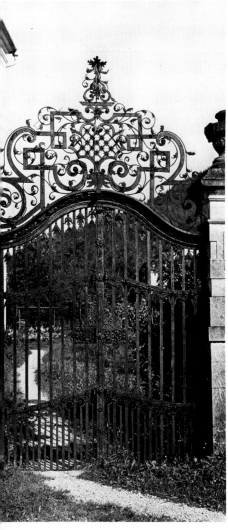

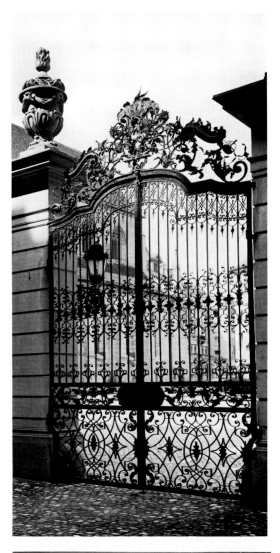

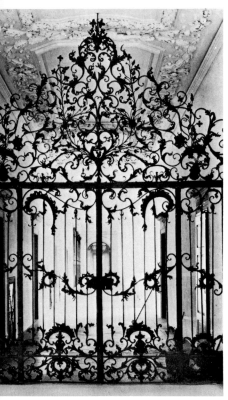

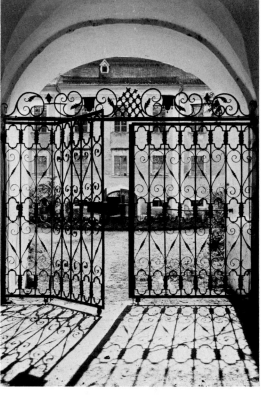

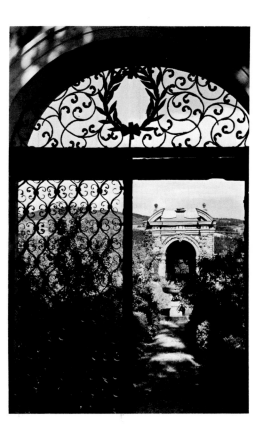

260. Gate of the Plaza Mayor, Madrid, 17th century.

261, 262. Stair railing, Cathedral of Santiago de Compostela, Spain, by Antonio Garcia, circa 1760.

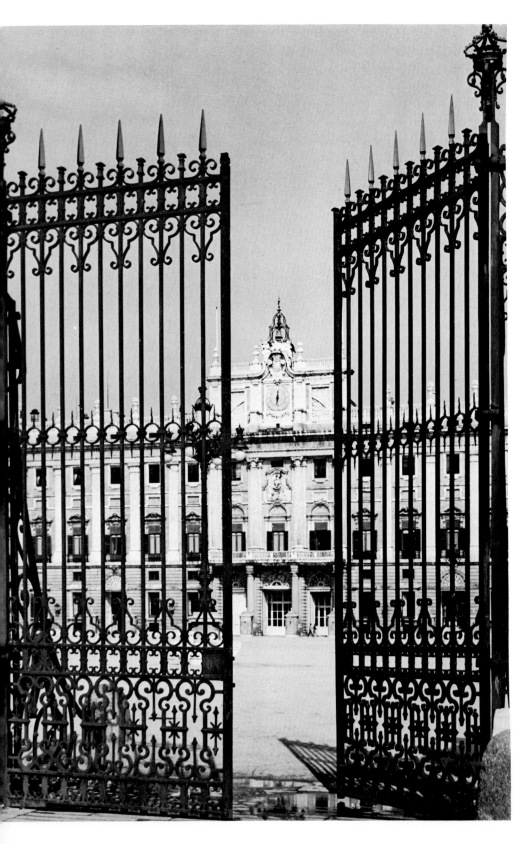

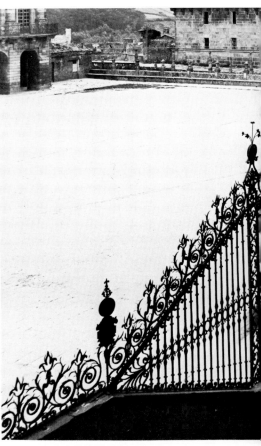

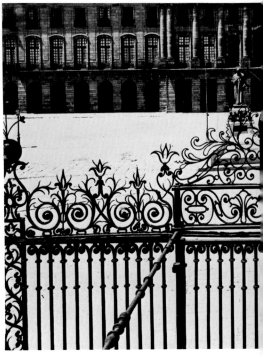

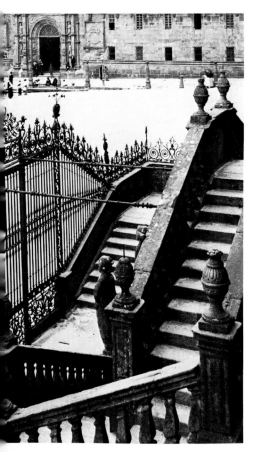

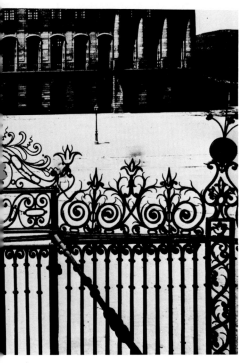

263. Gate with view into a patio, Cordoba, Spain, mid-18th century.

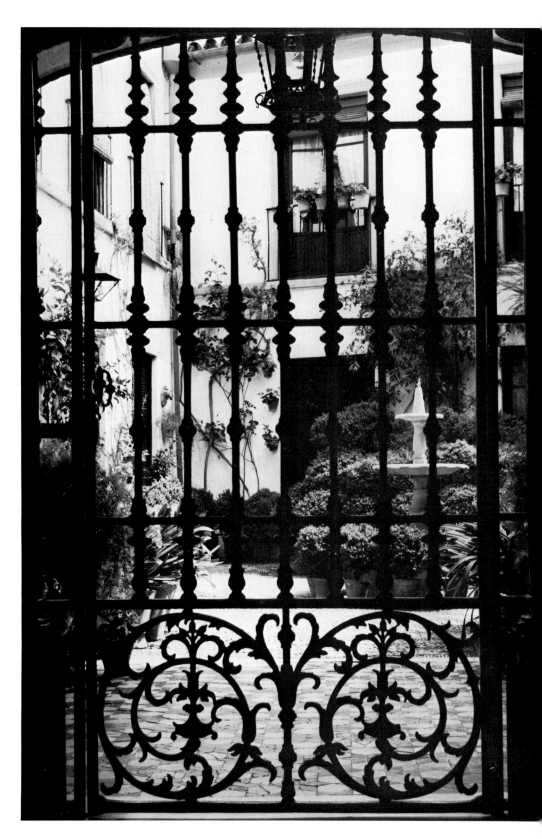

264-266. Details of the grating around the equestrian statue of Josef Poniatowski, Warsau, sculpted by Bertel Thorvaldsen in 1822. The grating was presumably made by the sculptor at the same time.

267. Detail of #269.

264 △

265 ▽

266 △

267 ▽

268. The Lansdowne Gate, London, end of 18th century,
Victoria & Albert Museum, London.

269. Gate to the vestibule of Salzburg Cathedral, dated
1774.

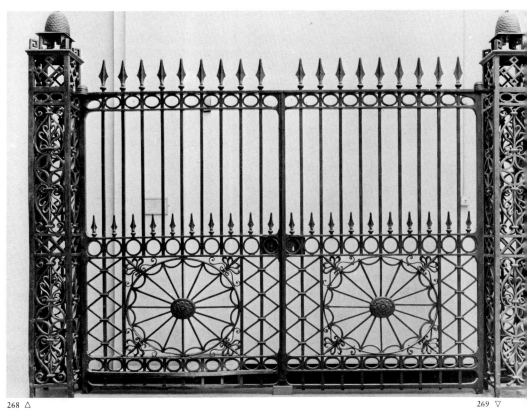

268 △

269 ▽

270. *Gate to the former cemetery of the cathedral in Brixen, South Tyrol, Biedermeier style, circa 1820.*

271. *Grating at the Houses of Parliament, Westminster, London, circa 1880, sheet iron with filed-out quatrefoils, Tudor Roses, cross-flowers and crowns.*

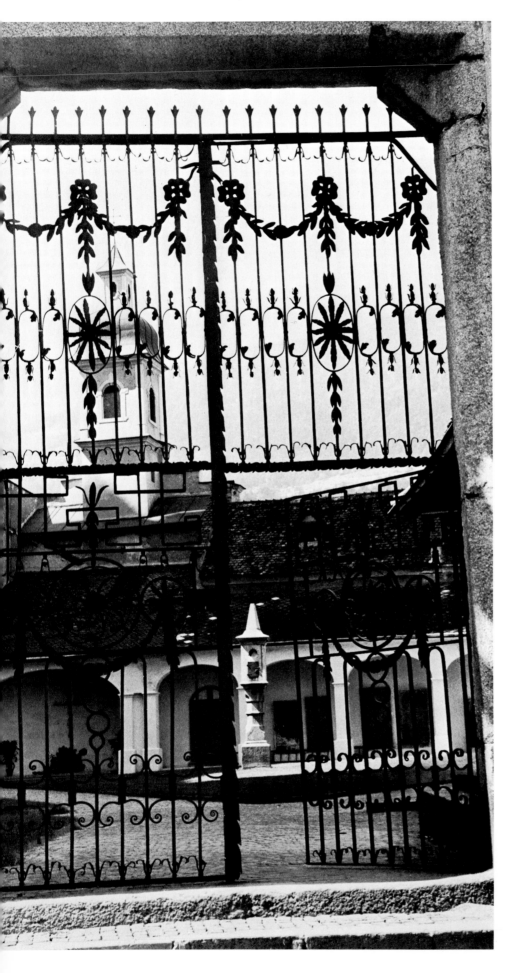

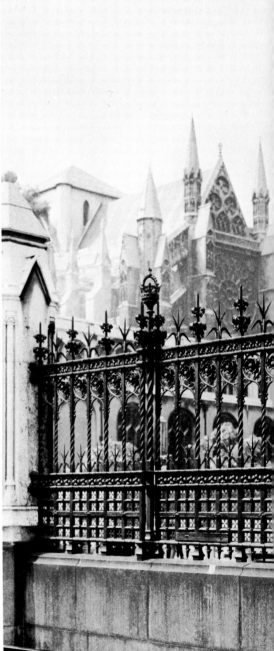

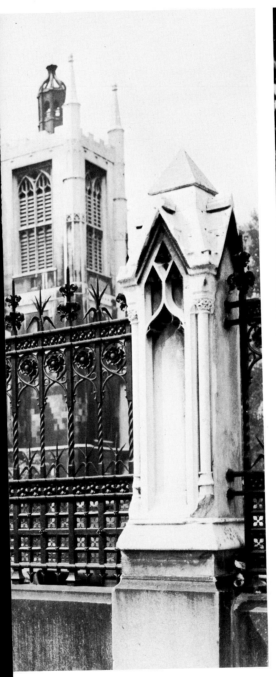

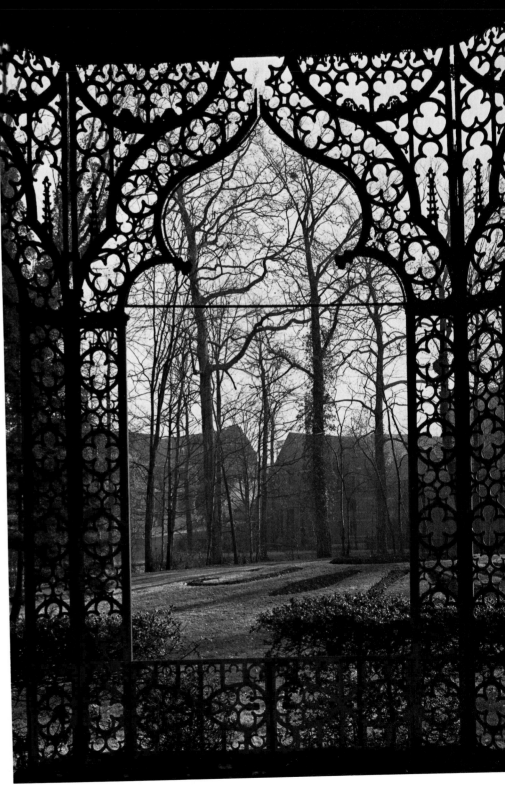

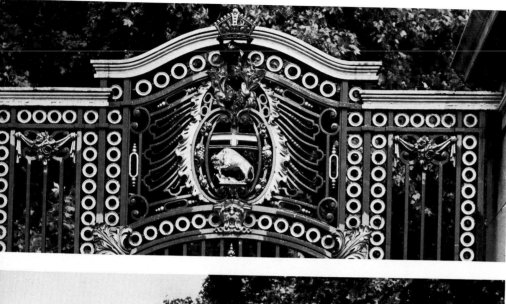

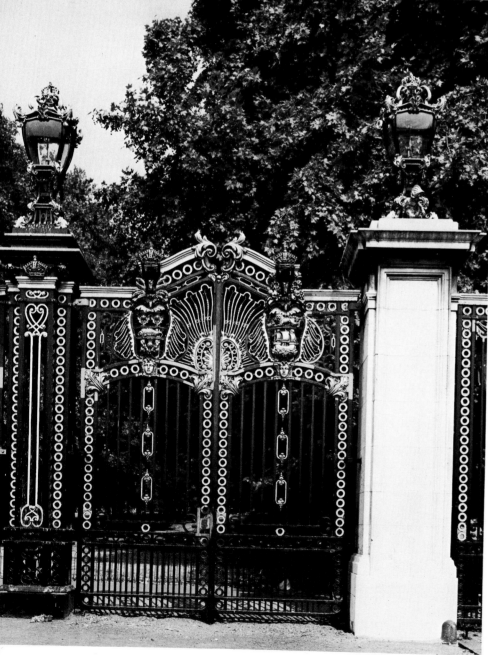

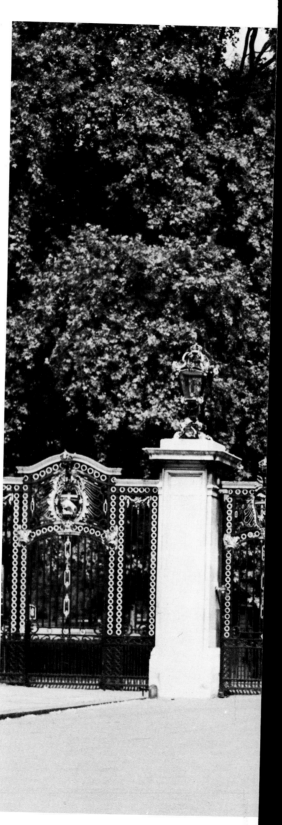

132

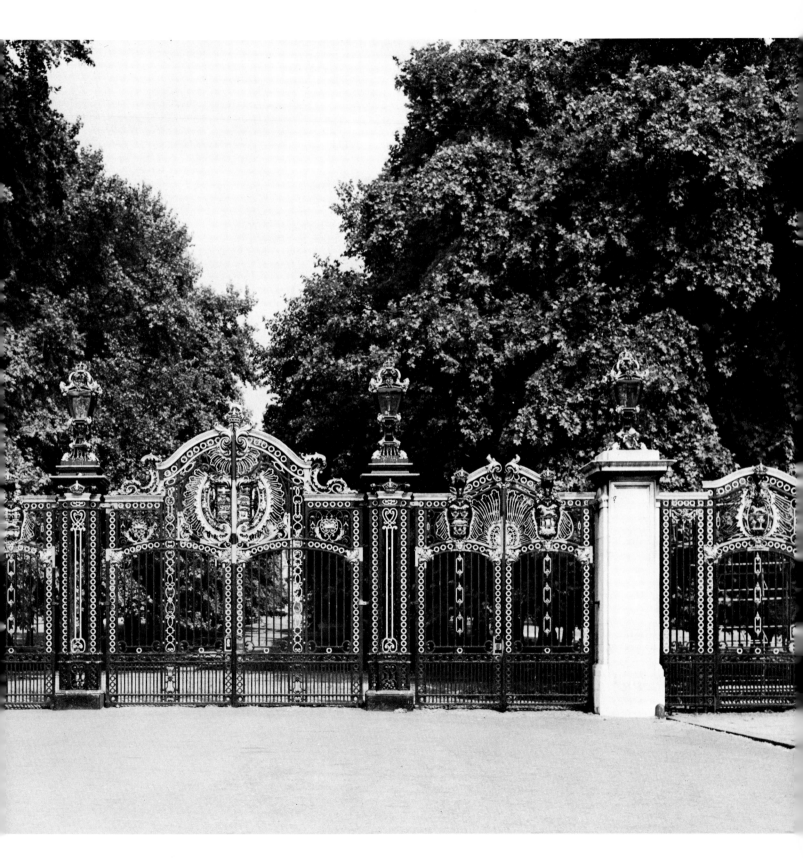

276-279. Alexandra Gate, Kensington Park, London, second half of 19th century, combination of wrought and cast iron.

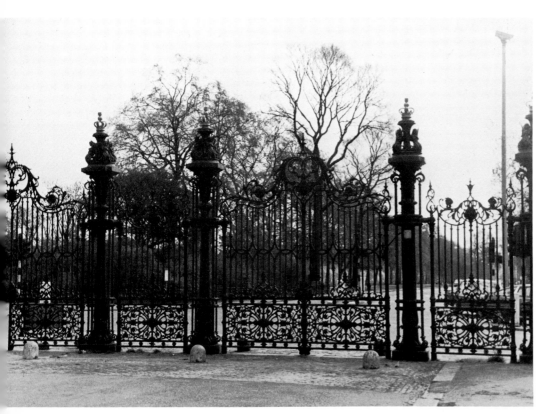
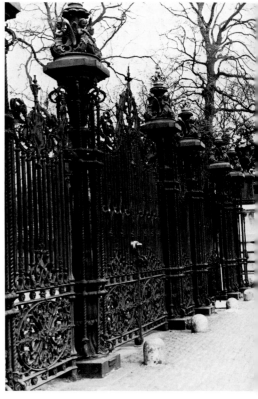
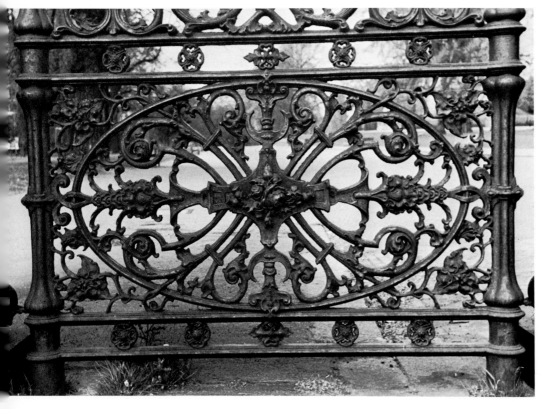
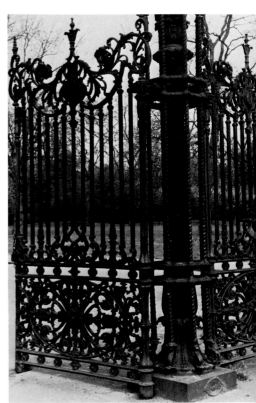

280. Gate to the palace garden, Roth, Franconia, dated 1900.

281. Gate to Freiberg Cathedral, Saxony, early 20th century.

282. Crown of the entrance gate to the Michaelertrakt of the Hofburg in Vienna, second half of 19th century.

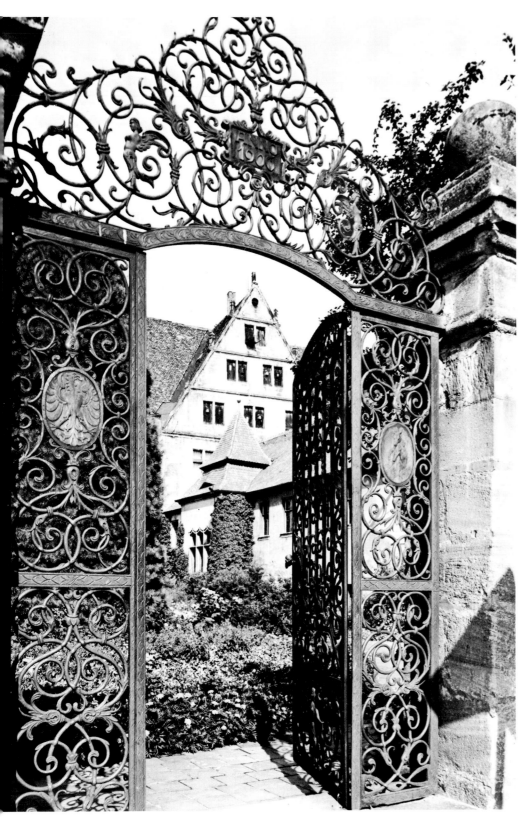

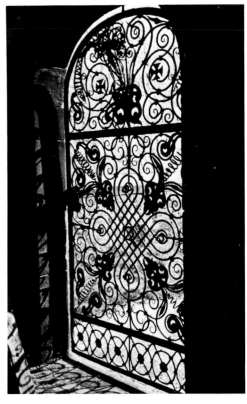

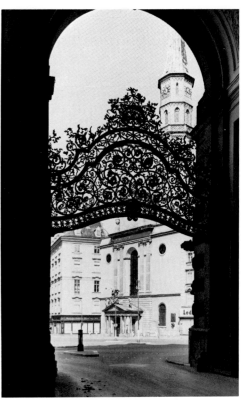

283, 284. *Park gate of a villa in Munich-Solln, circa 1900.*

285. *Grating in the grove at the Mathildenhöhe in Darmstadt, Art Nouveau, circa 1912.*

283 △

285 ▽

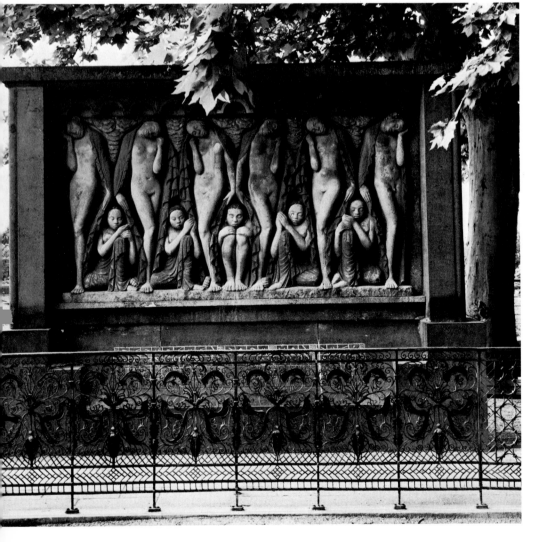

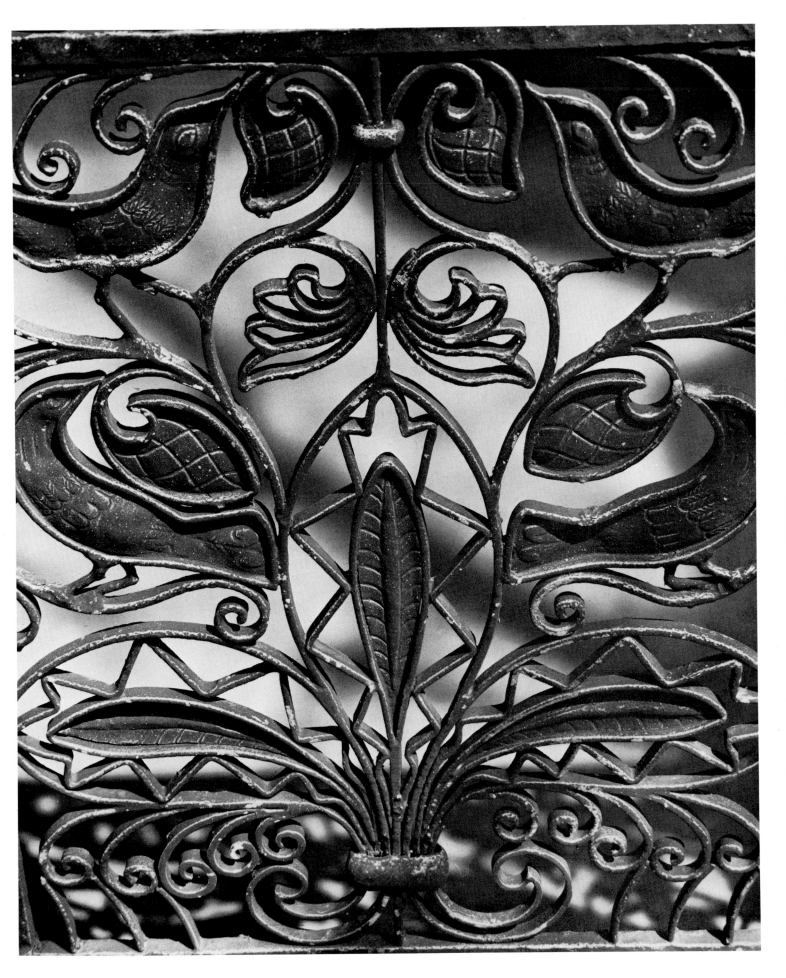

287-288. Gate of a villa in Munich-Bogenhausen, circa 1900 (see also #291).

289. Park gate from #292.

290. Park gate of a villa in Fahrwangen, Aargau, Switzerland, Art Nouveau, circa 1900.

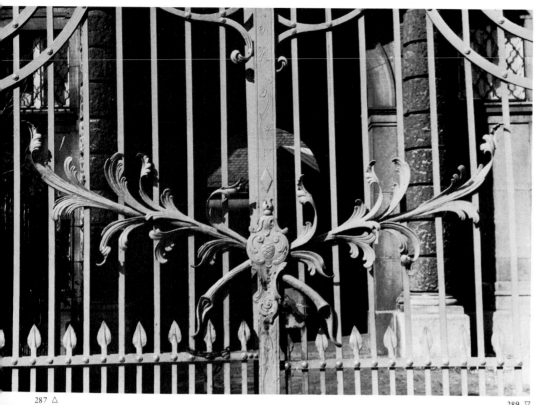

287 △

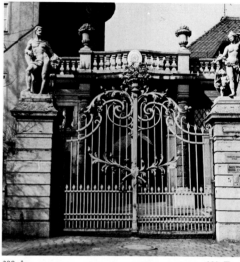

289 ▽ | 288 △

290 ▽

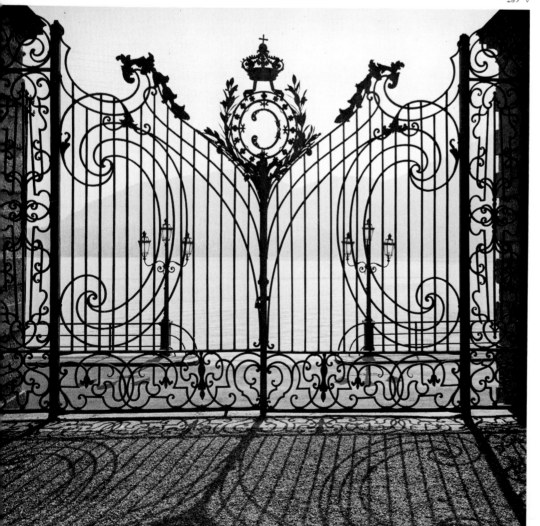

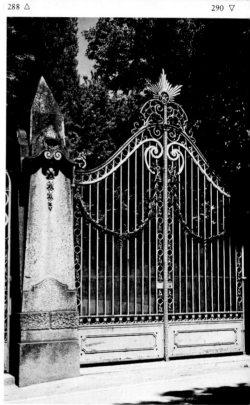

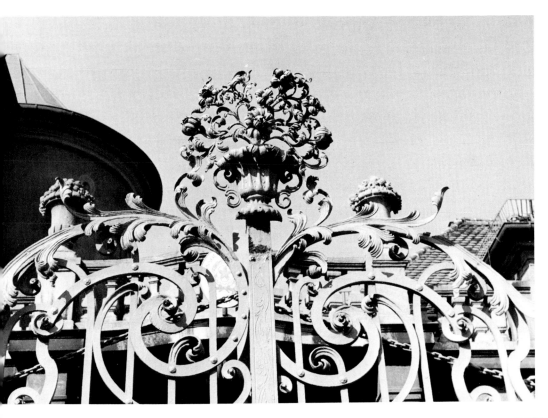

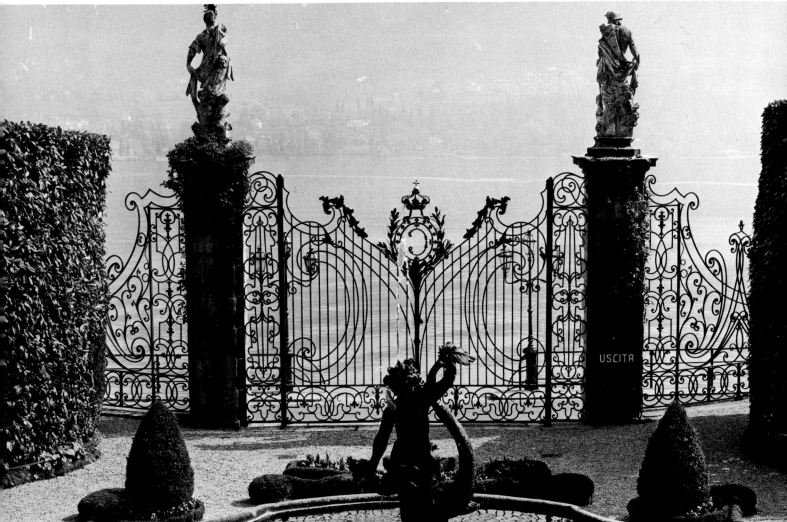

293, 294. *Gate and park fence in Munich-Bogenhausen,*
Art Nouveau, circa 1905.

295, 296. *Park fence in Munich-Bogenhausen, circa 1910.*

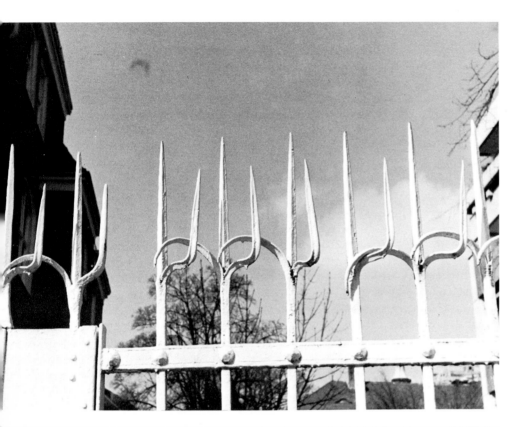

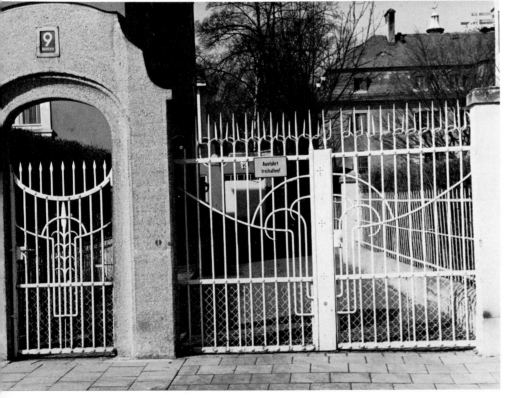

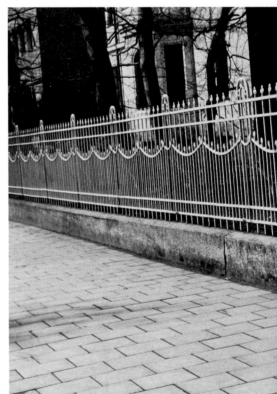

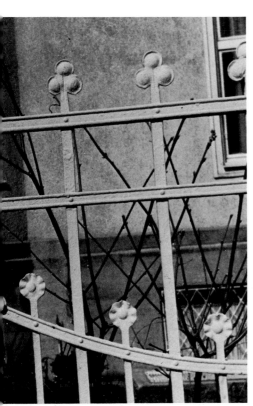

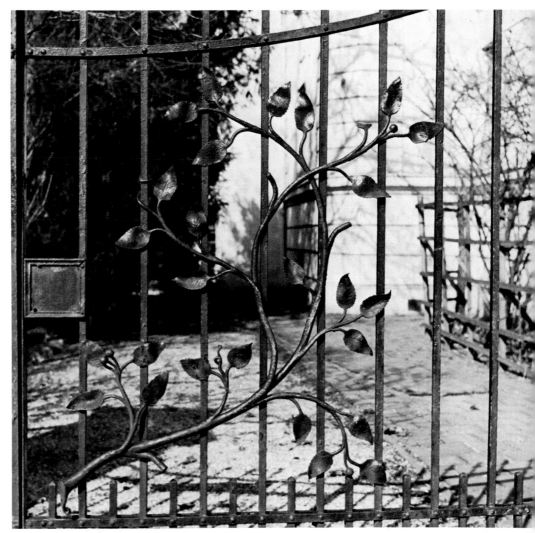

297, 298. *Gate to the garden of a villa in Munich-Bogenhausen, Möhl Street, circa 1910.*

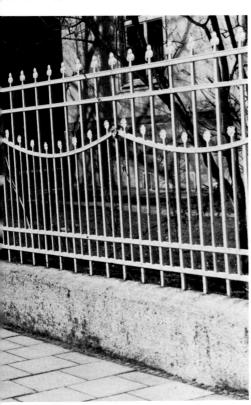

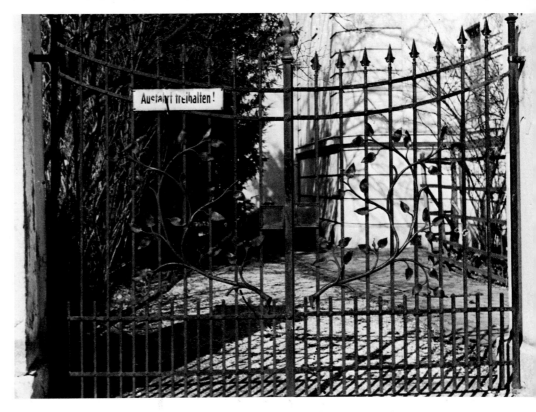

Church Gratings

299, 300. Gothic grating, Waldauf Chapel, Pfarrkirche, Hall in Tyrol, near Innsbruck, circa 1500.

301. Chapel grating, Hospital Real, Santiago de Compostela, Spain, first third of 16th century.

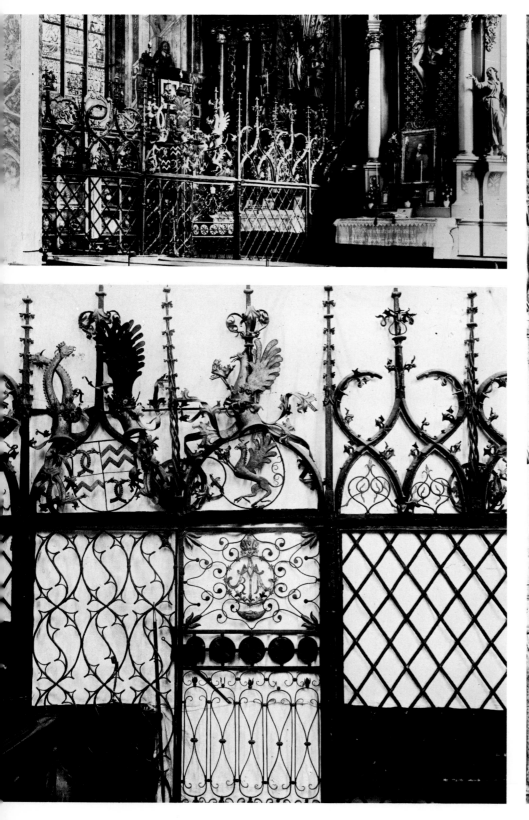

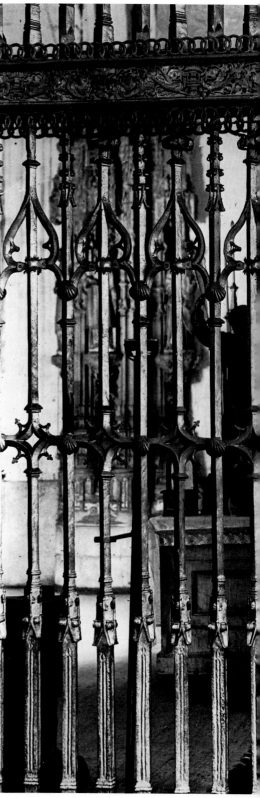

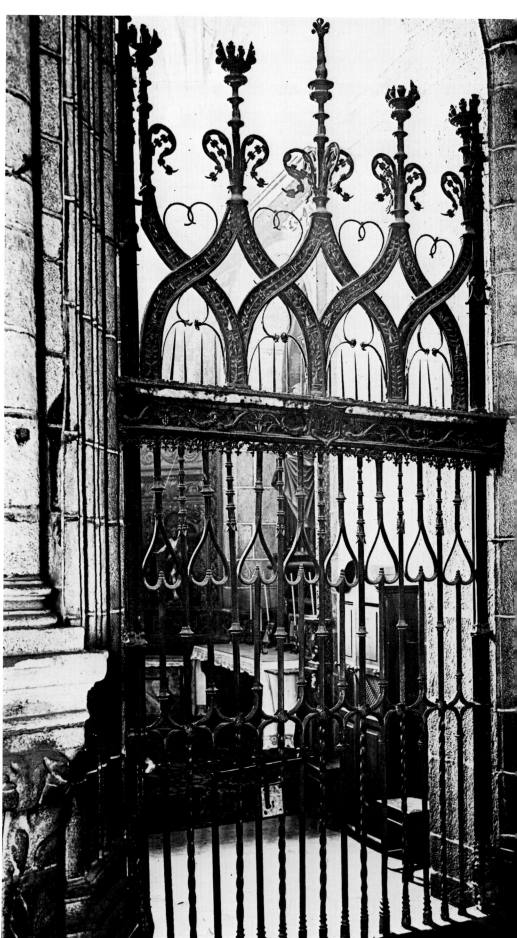

302. *Chapel grating, gift of Canon Mondragon, attributed to Guillen de Bousse, Cathedral of Santiago de Compostela, 1522.*

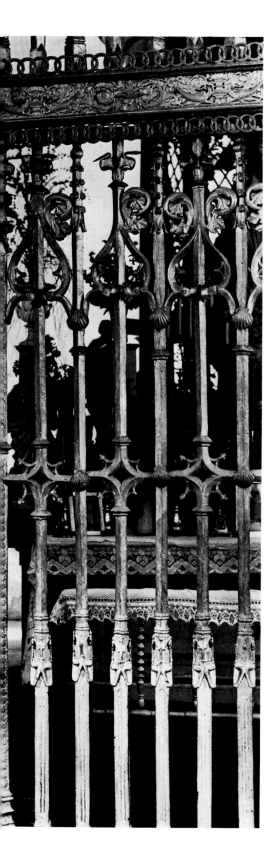

303, 305. *Chapel grating and detail at Gran Hospital Real, Santiago de Compostela, attributed to Juan Frances, so-called Plateresco style, first half of 16th century.*

304. *Large chapel grating, Toledo Cathedral, Spain, 16th century, with coats of arms, angels and trophies in the crown.*

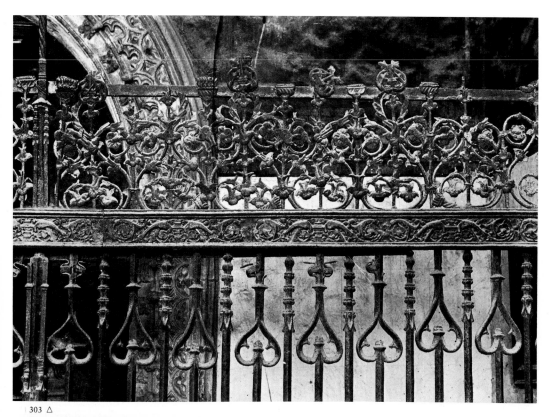

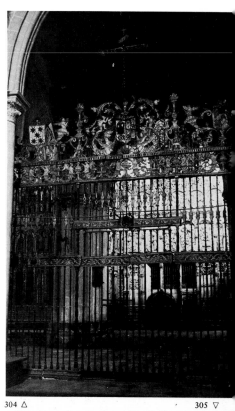

303 △

304 △ 305 ▽

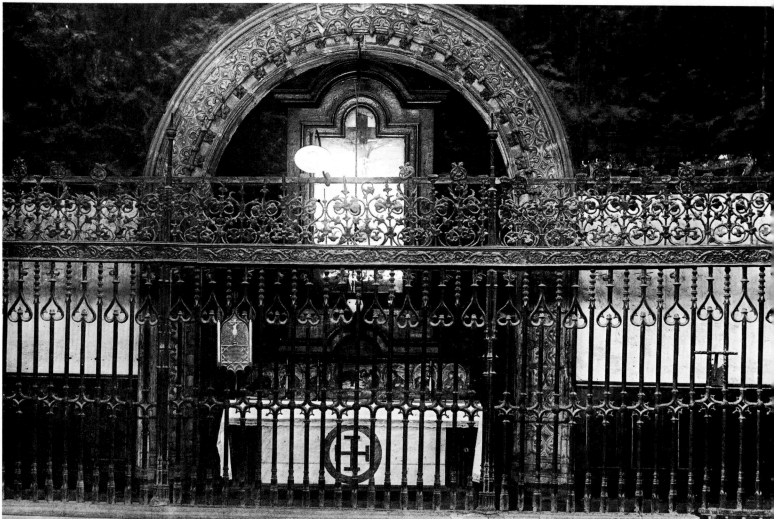

306. Crown of a choir grating with winged imaginary creatures and the inscription "Fit esta obra maestre Joan Frances, maestre major de las obras de fiero", late Gothic, Victoria & Albert Museum, London.

307. Chapel grating, Gran Hospital Real, Santiago de Compostela, attributes to Juan Frances, Plateresco style, first third of 16th century.

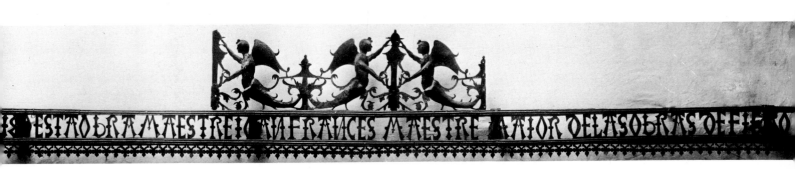

307 ▽

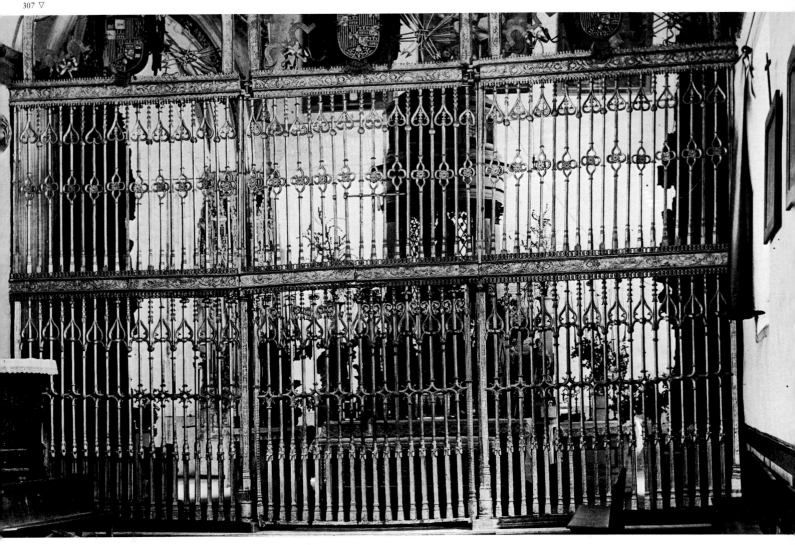

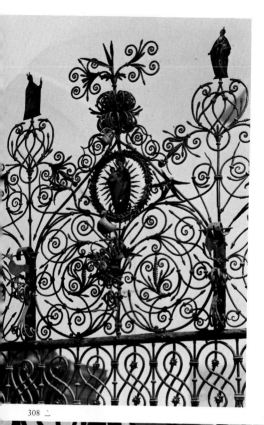

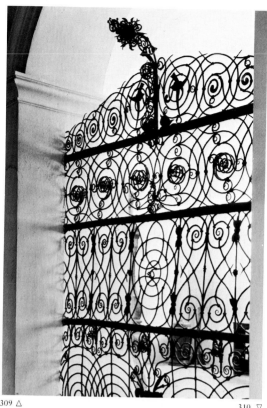

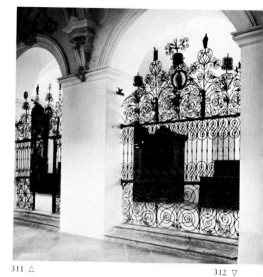

308 ⊥ 309 △ 310 ▽ 311 △ 312 ▽

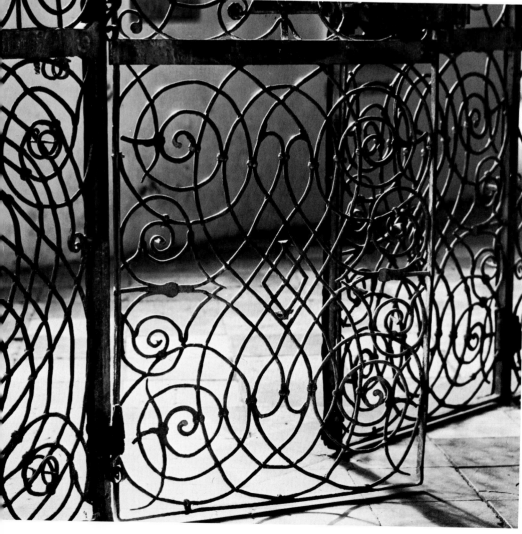

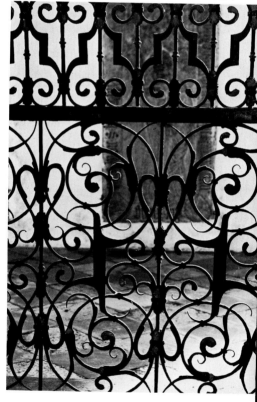

313-315. Grating in Freising Cathedral, Bavaria, mid-17th century.

313, 314. Details of a chapel grating, south transept.

315. Large door to south gallery.

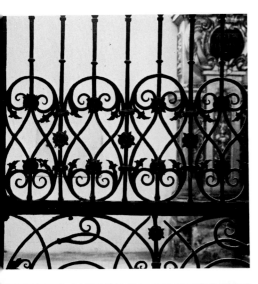

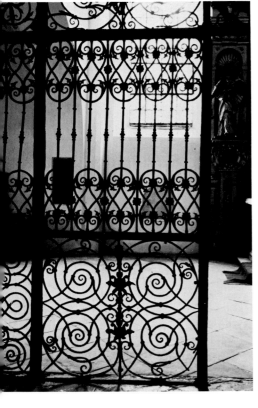

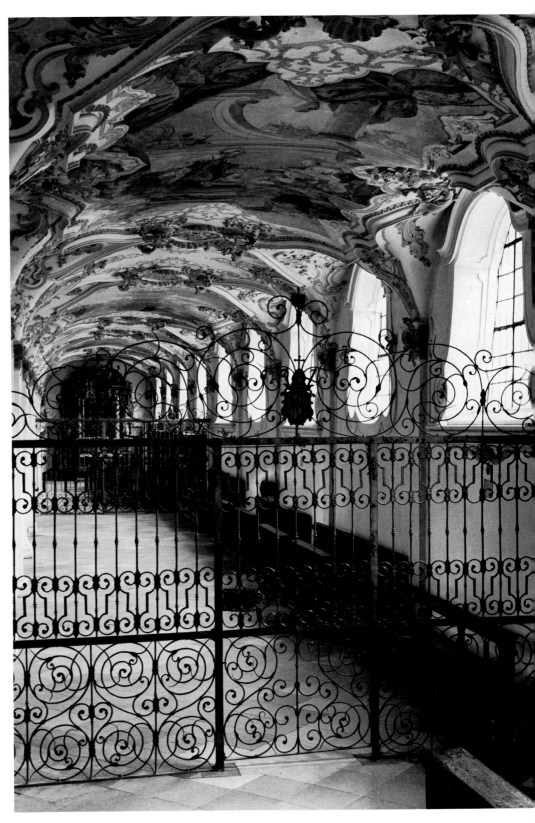

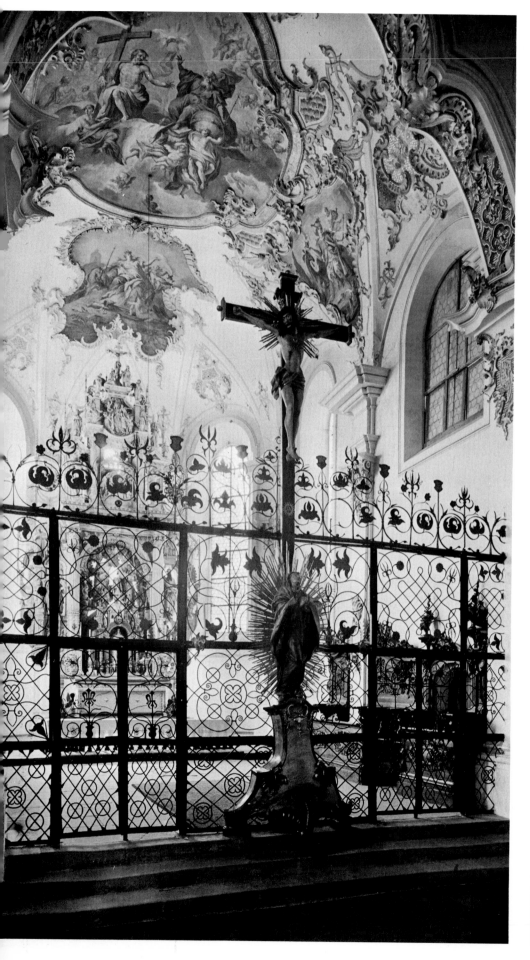

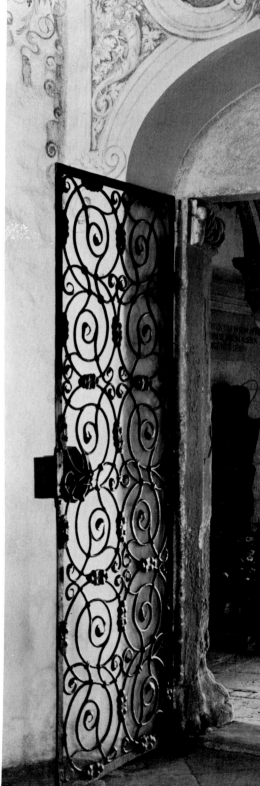

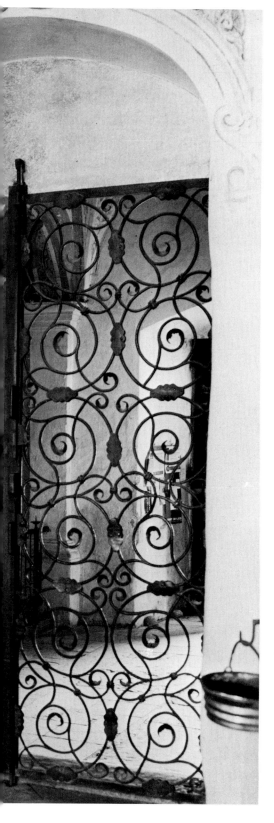

318. Entry grating, former abbey church, Lambach, Upper Austria, near Wels, dated 1662.

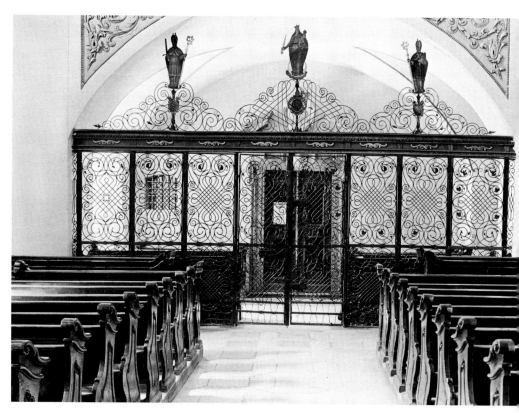

319. Chapel grating, St. Peter's Church, Munich, 17th century.

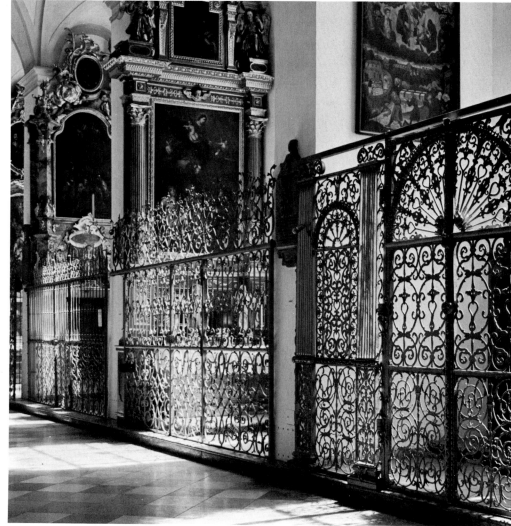

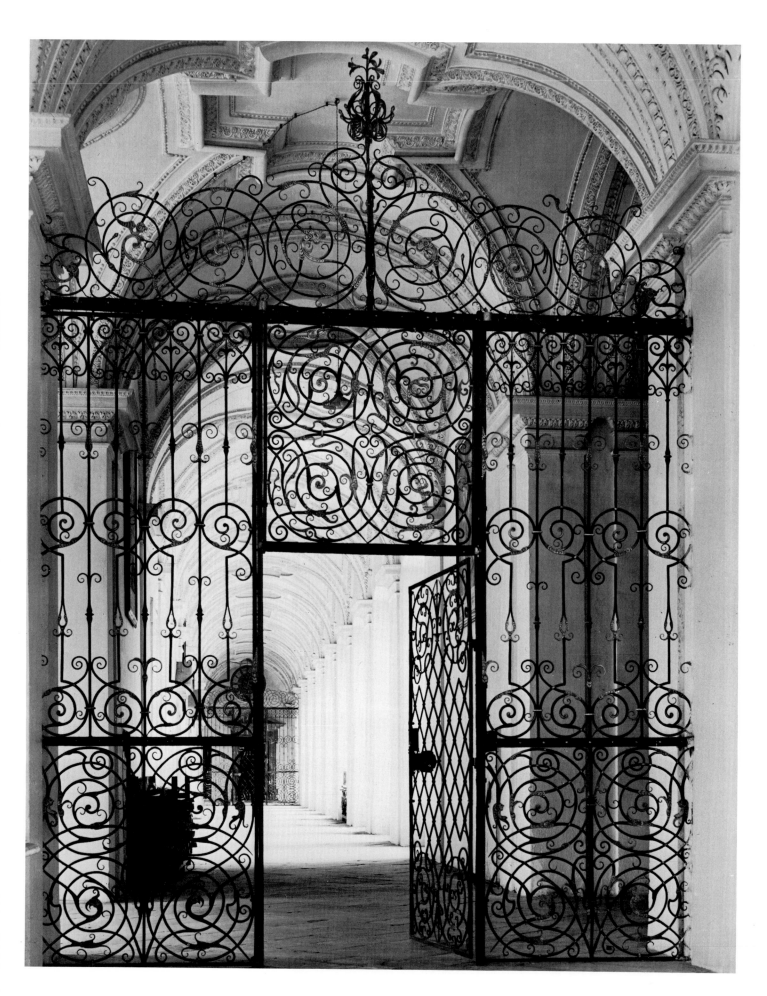

321. Large entry grating in the Servite Church, Vienna, 17th century.

322. Choir grating, seen from transept, Laon, France, 17th century.

323. Entry grating in the Pfarrkirche, Lenggries, Bavaria, 17th century.

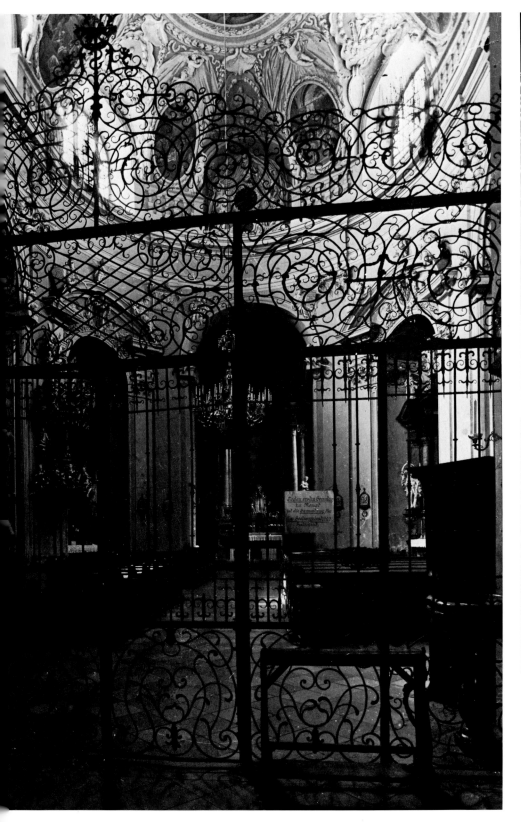

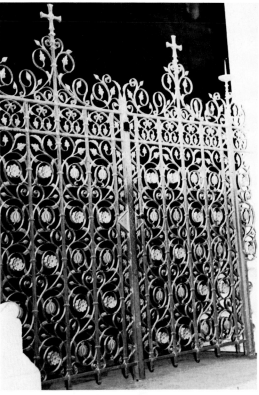

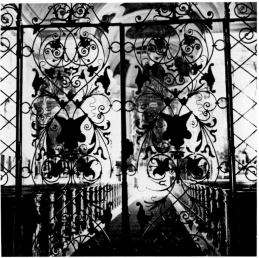

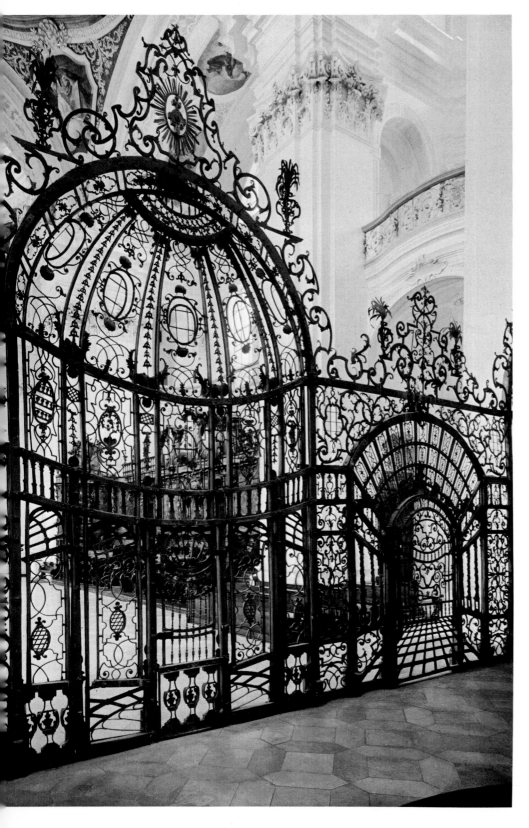

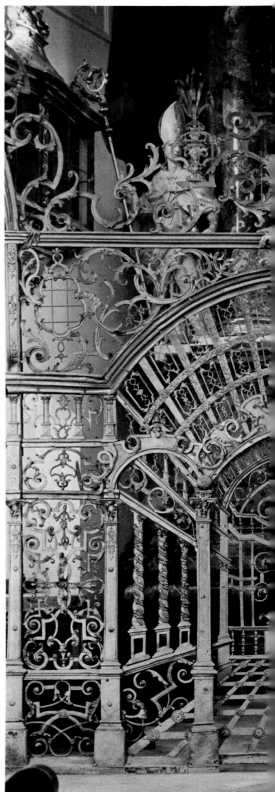

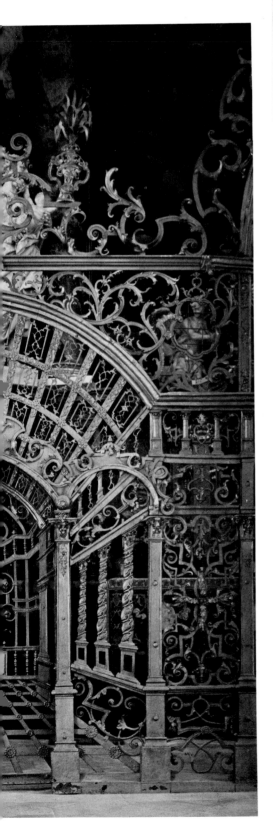

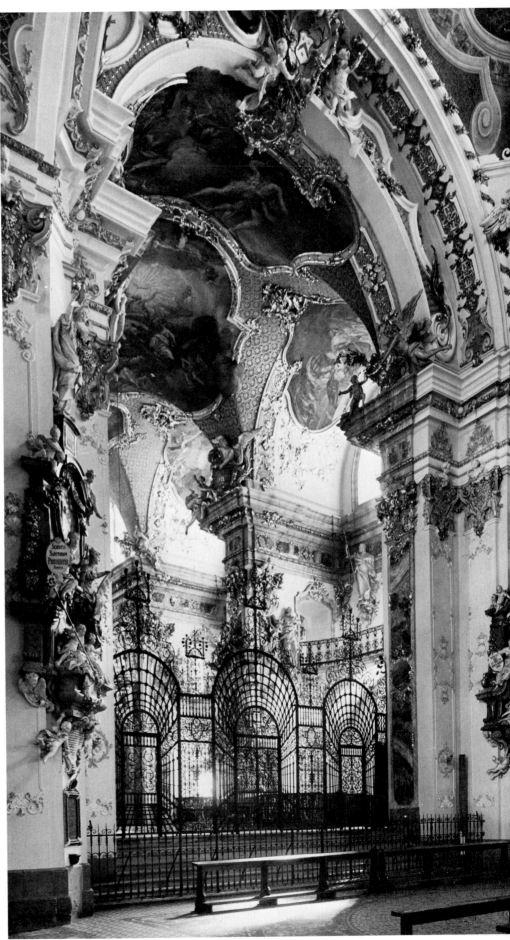

326. Entry grating with three perspective gates in the abbey church, Einsiedeln, Switzerland, presumably by Brother Vinzenz Nussbaumer, 1675-1785.

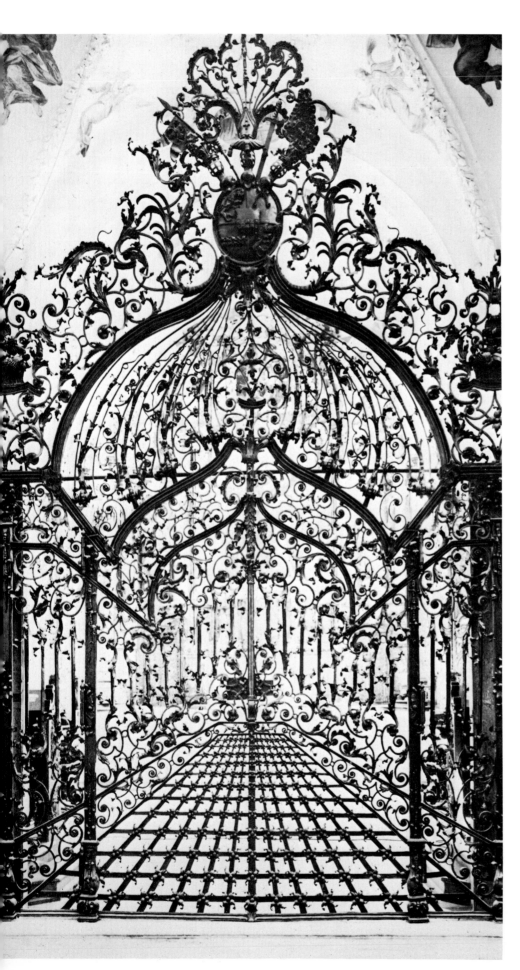

327. *Perspective choir grating in the Benedictine abbey, Muri, Switzerland, by J. J. Hoffner of Constance, 1744-1746.*

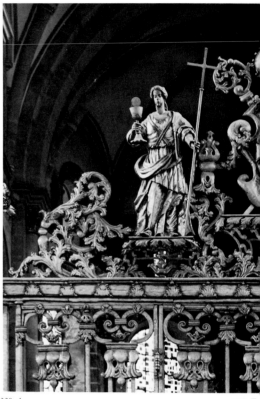

328. *Crown of the grating in the east choir of Trier Cathedral, circa 1725, with coat of arms between allegorical figures of church and papacy.*

328 △

329 ▽

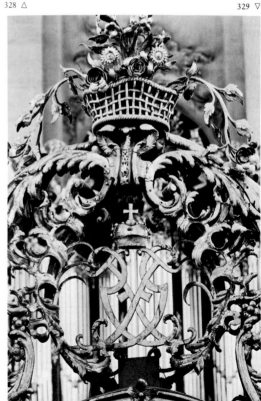

329. *Detail of choir grating, St. Paulin Church, Trier, by court locksmith Johann Eberle, 1767.*

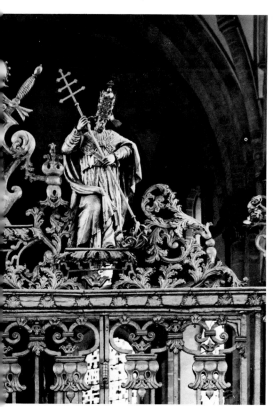

330 ▽ 331 △ 332 ▽

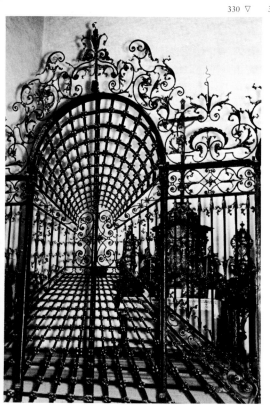

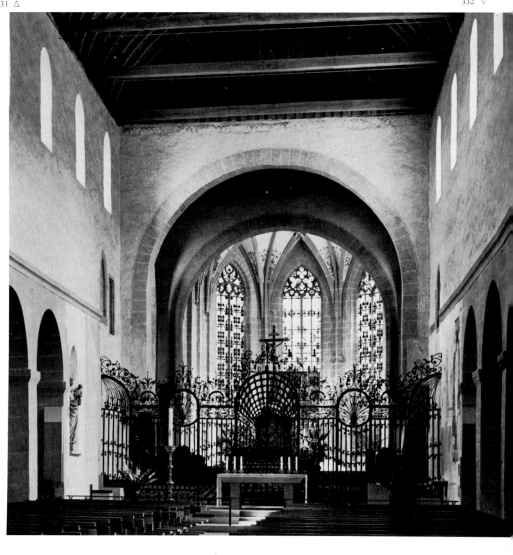

155

333. *Closing grating, Abbey Church of St. Florian, Upper Austria, by Hans Messner, 1698.*

334. *Crown detail of #333.*

335. *Closing grating, Dominican Church, Regensburg, Bavaria, by David Nordmann, circa 1724. Bavarian National Museum, Munich.*

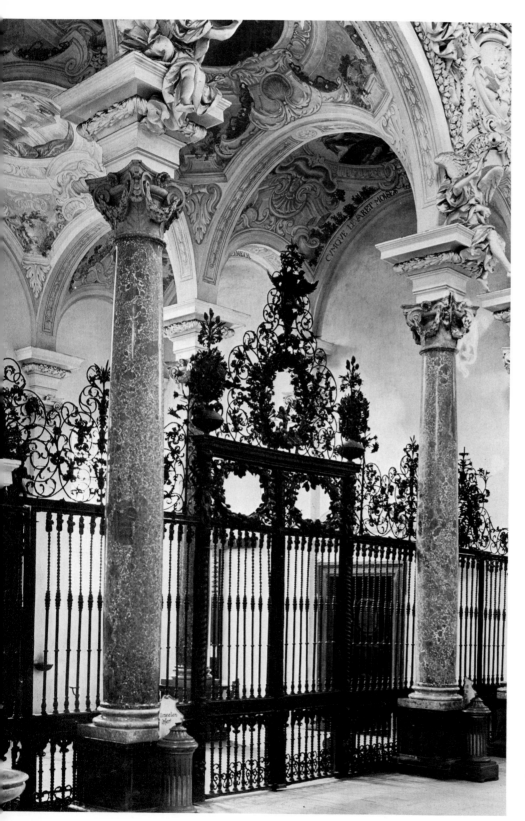

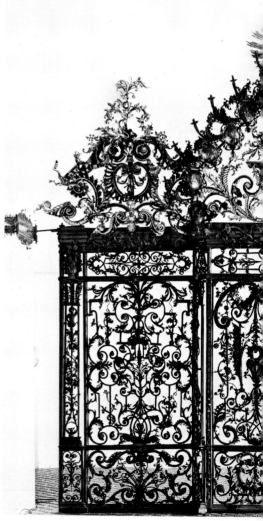

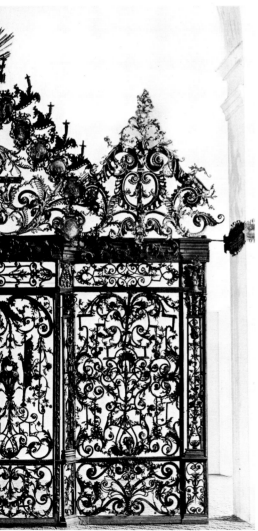

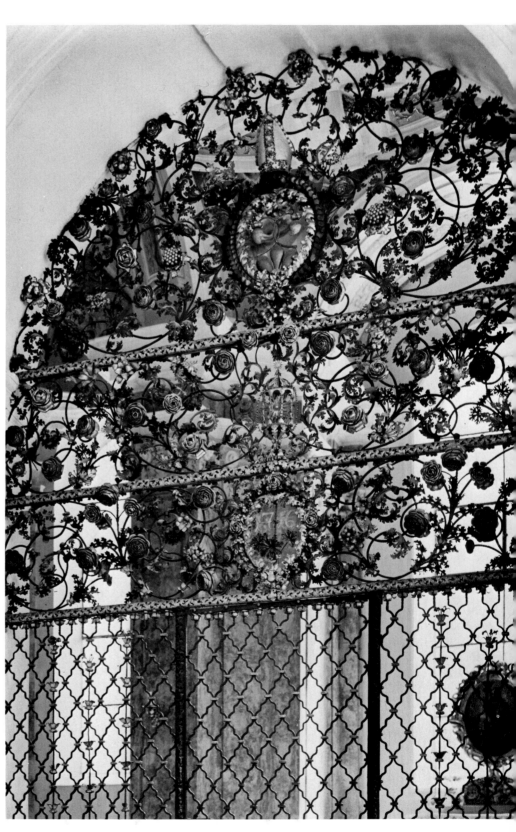

336. Rose grating in the entry of the Cistercian abbey church, Stams, Tyrol, by cloister locksmith Bernhard Bachnetzer, 1716.

337. *Entry grating, Abbey Church, Ebrach, Franconia, 1743.*

338. *Entry grating, church of the former Benedictine abey, Zwiefalten, Württemberg, mid-18th Century.*

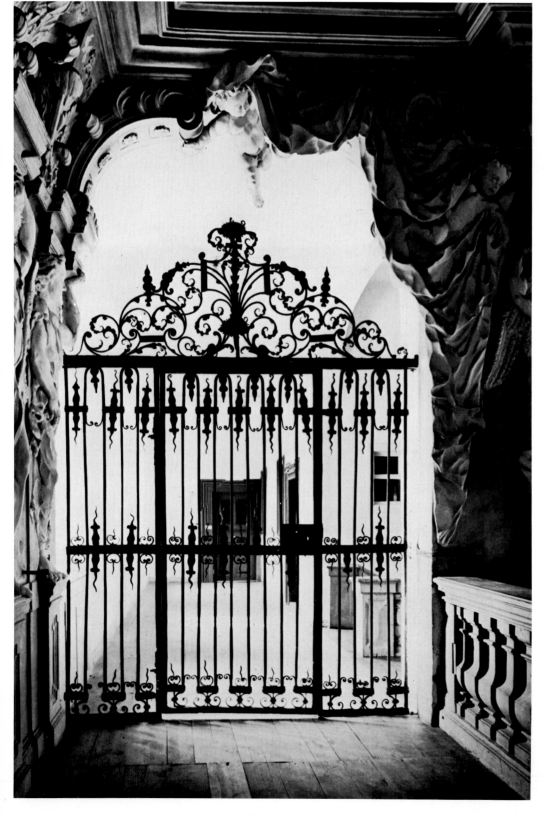

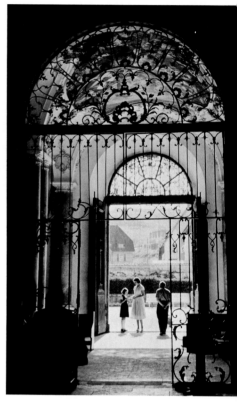

*339. Choir grating detail, Einhards-Basilica, Seligenstadt
am Main, Hesse-Darmstadt, 1720-1725.*

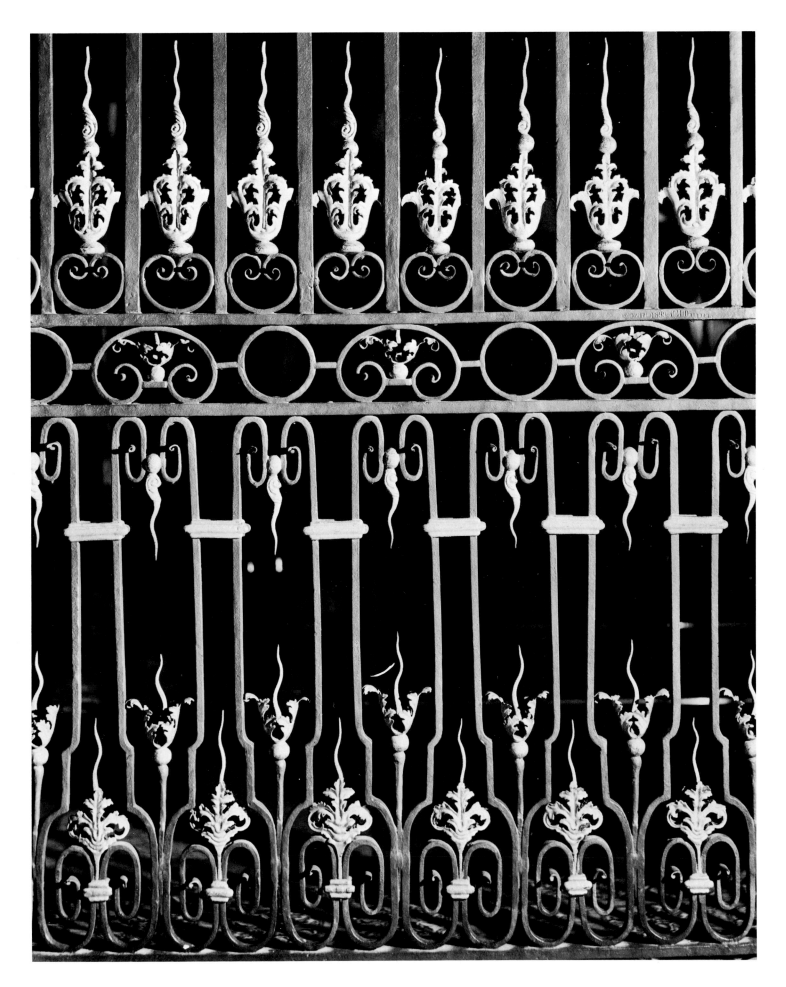

340, 341. Choir grating, St. Gallen, Switzerland, by court
locksmith Josef Meyer of Bütschwil, 1772.

342. Choir grating in the former abbey church, Amorbach,
Franconia, circa 1750.

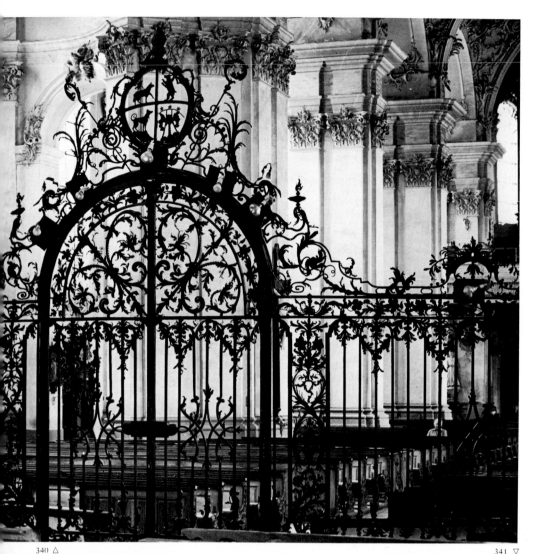

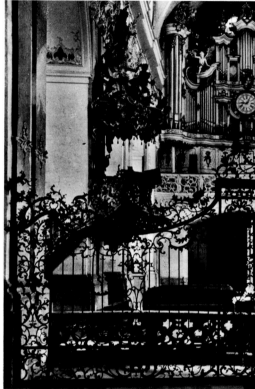

340 △

341 ▽ 342 △

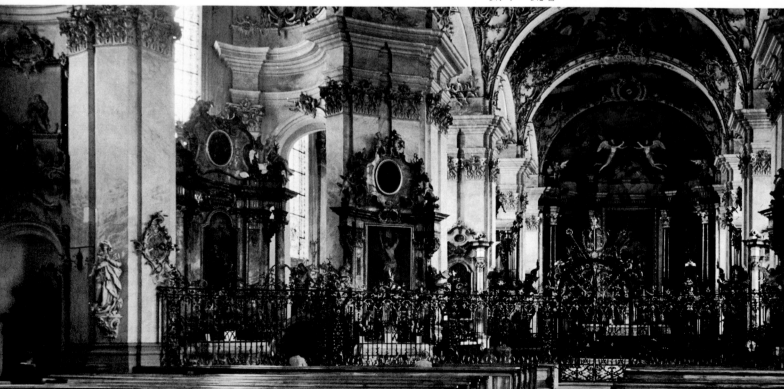

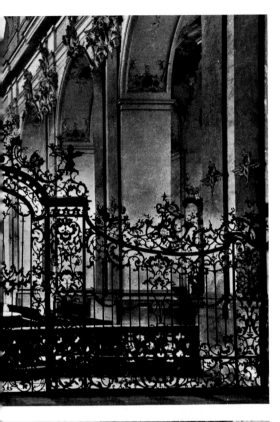

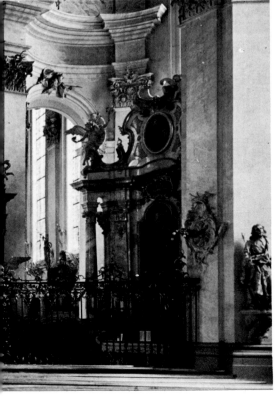

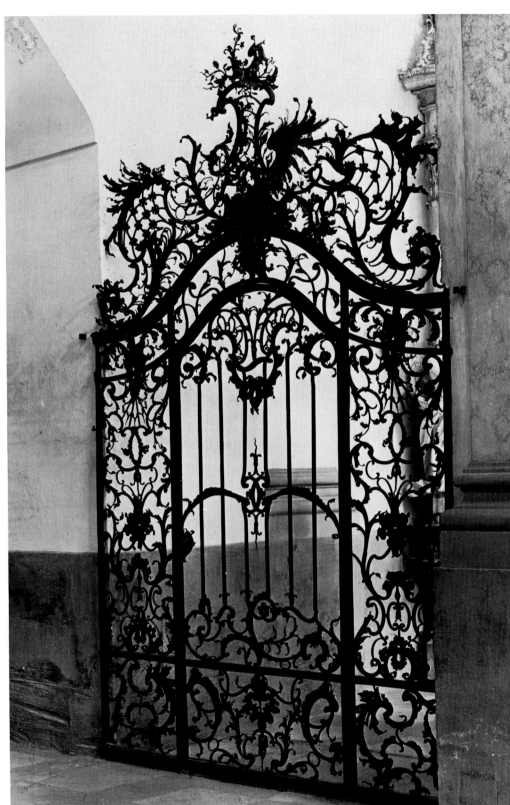

343. *Grating in the south transept, former abbey church, Amorbach, Franconia, by Markus Gattinger, 1749.*

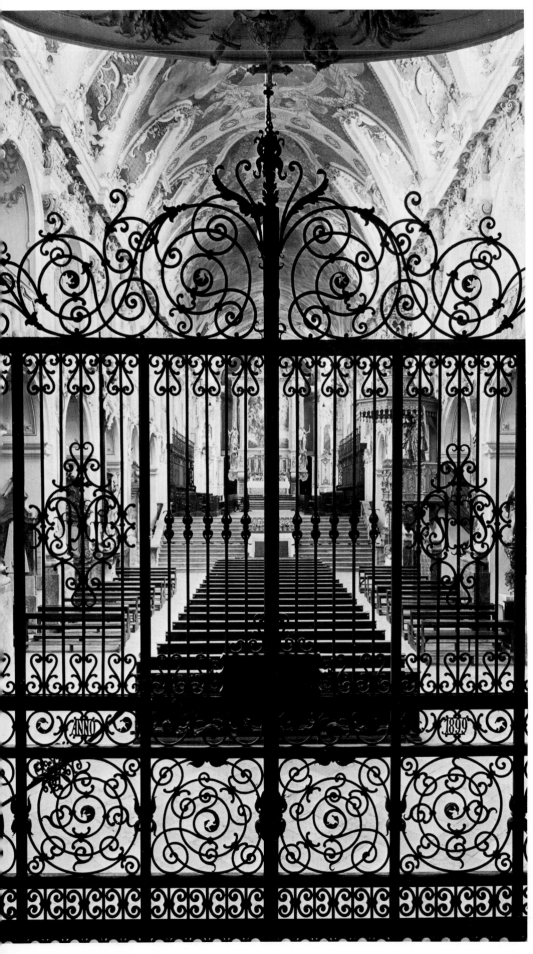

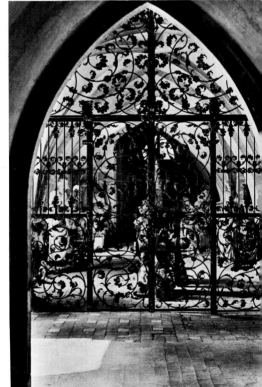

*346. Choir grating, Franciscan Church, Salzburg, 1780,
middle section with fully three-dimensional cherubs and
masks.*

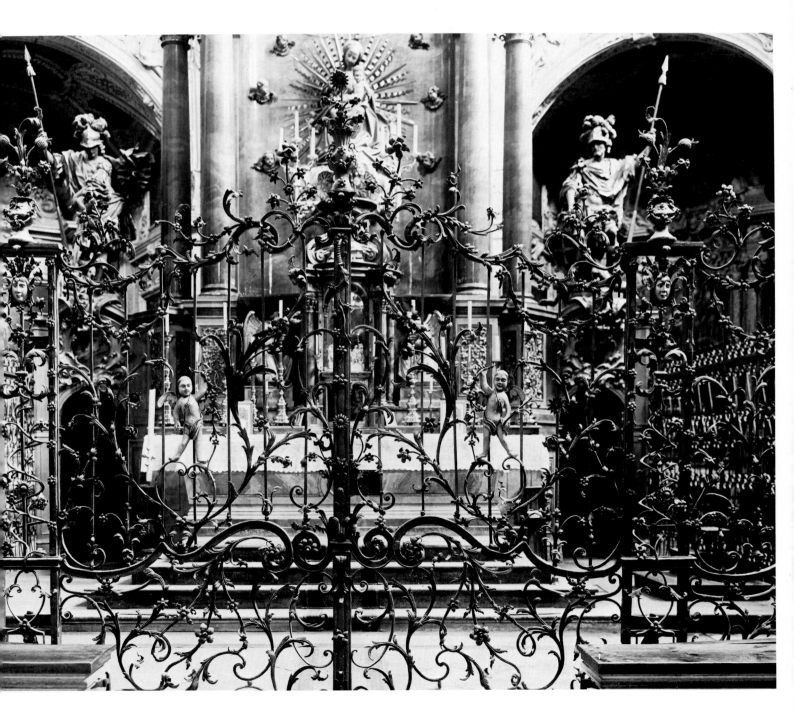

163

Modern Times

347, 348. Garden gate, two-wing design, crossed bars with rivets, circa 1955, entry to a villa at Prinz-Ludwigshöhe, Munich.

349. Door of the church in Munich-Obermenzing, mid-20th century, with pierced square bars, made by Otto and Manfred Bauer, Munich.

348 △

349 ▽

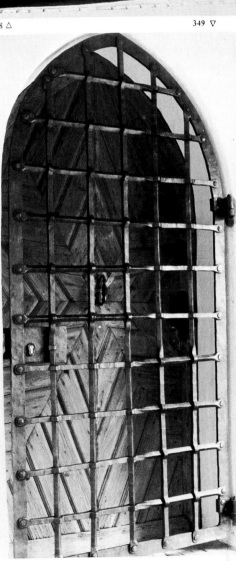

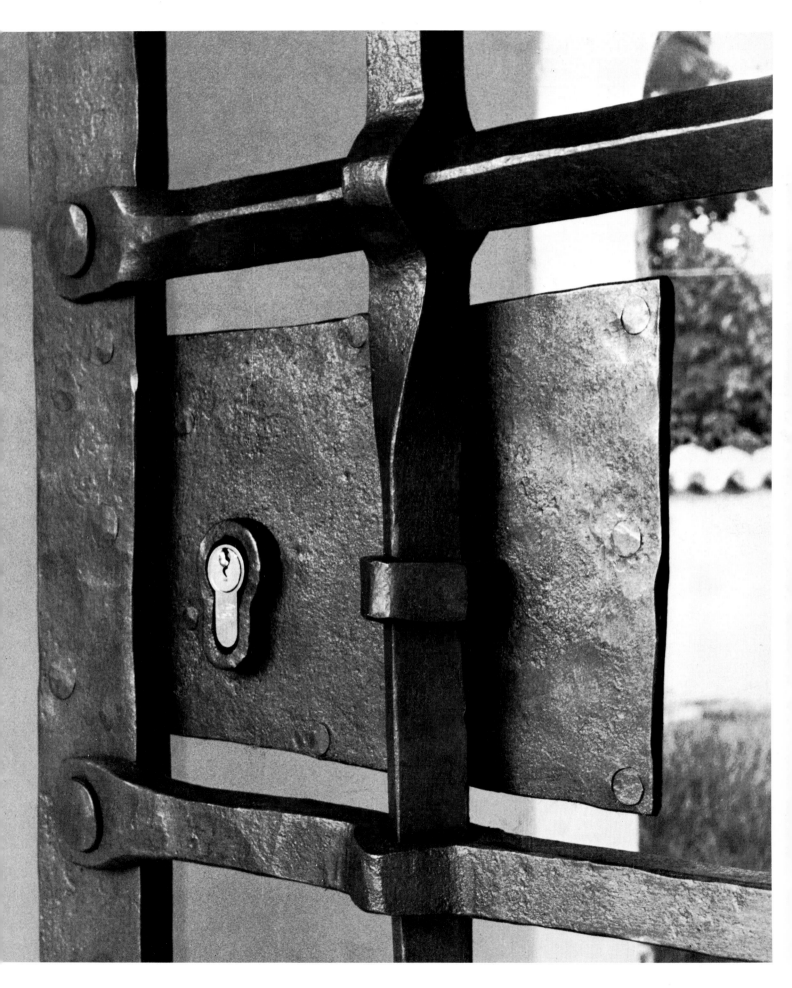

351. Grating with quatrefoils, mausoleum of Kemal Ataturk, Ankara, Turkey, first half of 20th century.

352. Detail of #353.

353. Gate with riveted-on squares, newly replicated after rebuilding, Old City, Warsaw.

354. Gate to Forest Cemetery, Munich-Solln, with diamonds, circles, scrolls, circa 1950.

355. Detail of a garden gate of a private home in Lenggries, Bavaria, circa 1965, curved square bars and bands.

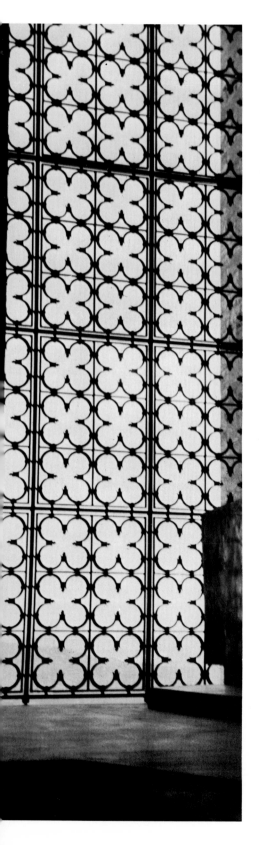

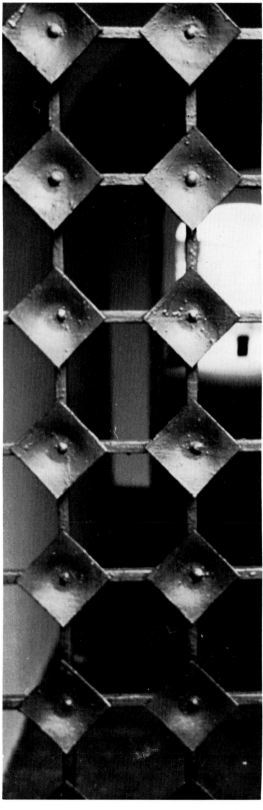

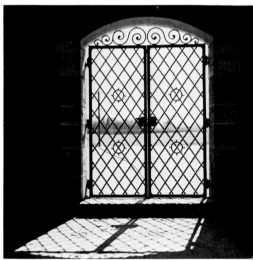

356, 357. Two-wing gate with quatrefoils, at a private home in Pullach, near Munich, third quarter, 20th century.

358. Window gratings on a farmhouse in Vintl, Pongau, Austria, first half of 20th century, with crossed bars and crowns.

359. Window grating in 17th-century style, Lenggries, Bavaria, first half of 20th century.

360. Window grating, Hohenburg Castle near Lenggries, Bavaria, mid-20th century, crossed bars and crowns.

361. Small garden gate with flat bars and hearts, in Lenggries, Bavaria, made by Robert Oberlechner, 1975.

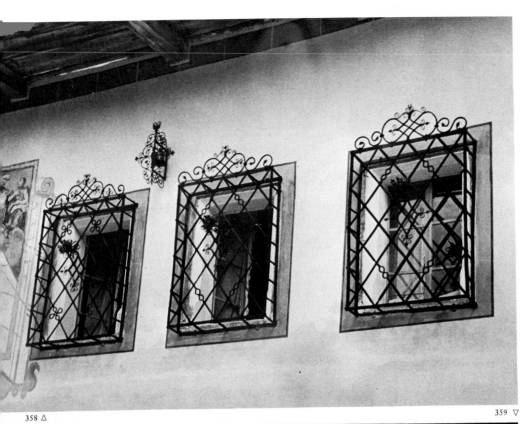

358 △

359 ▽ 360 △

361 ▽

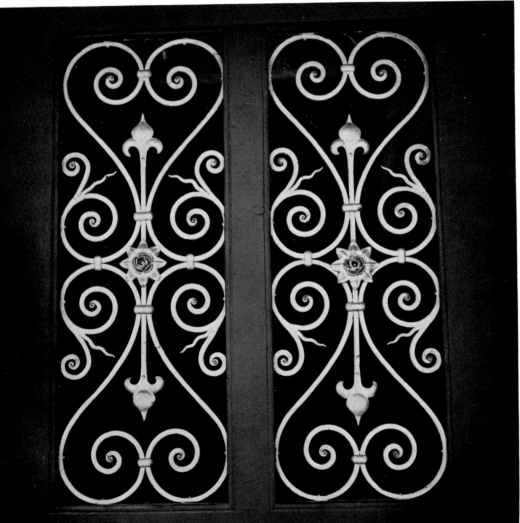

362-364. *Parts of a stair railing in a private home in Lenggries, woth scrolls and C chapes, made by Robert Oberlechner, 1975.*

365-367. *Gates and window gratings in a private house in Lenggries, with crossed bars, flowers in center, made by Robert Oberlechner, 1975.*

368. *Garden gate in Lenggries, with diamonds and central piece, 1970.*

369-370. *Window grating in Lenggries, with loops and rosettes, mid-20th century.*

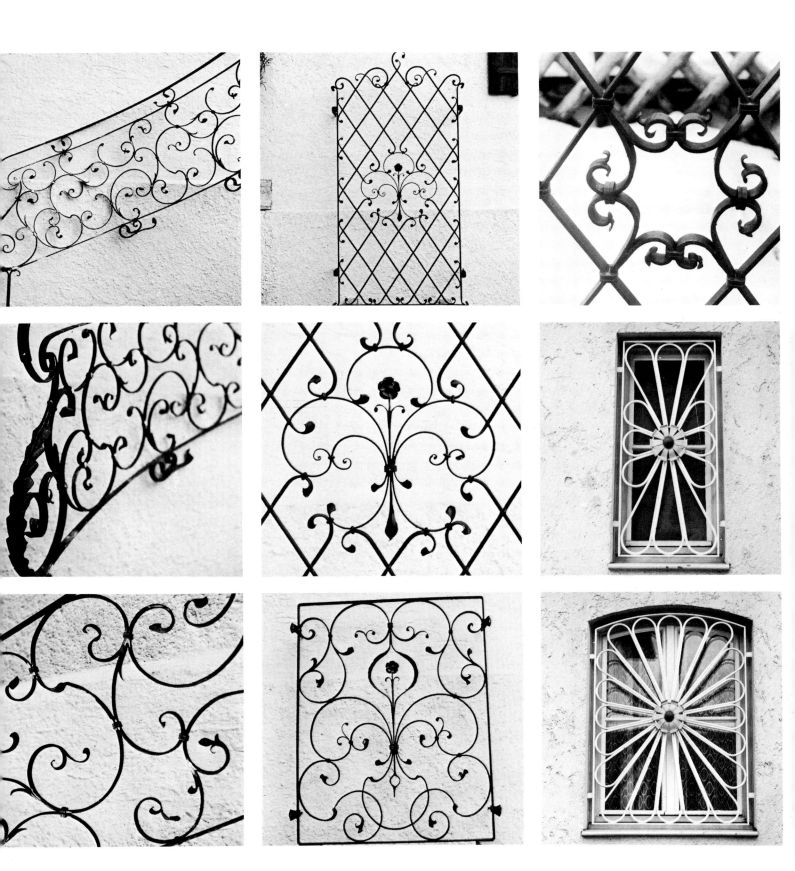

371. Garden gate with broken diamonds in Pullach near
Munich, mid-20th century.

372, 373. Garden gate and fence, crossed and turned bars,
C-chapes, Munich-Grosshesselohe, circa 1960.

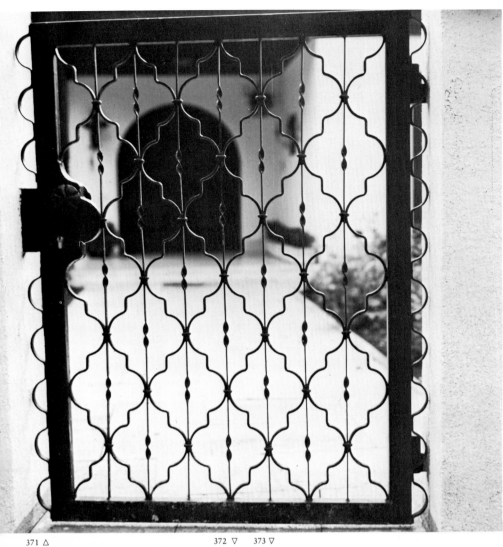

371 △

372 ▽ 373 ▽

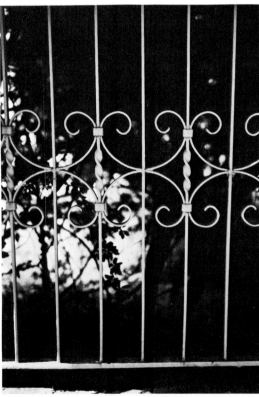

374. Window grating with spirals in squares, for a private home, made by Otto and Manfred Baier, Munich, mid-20th century.

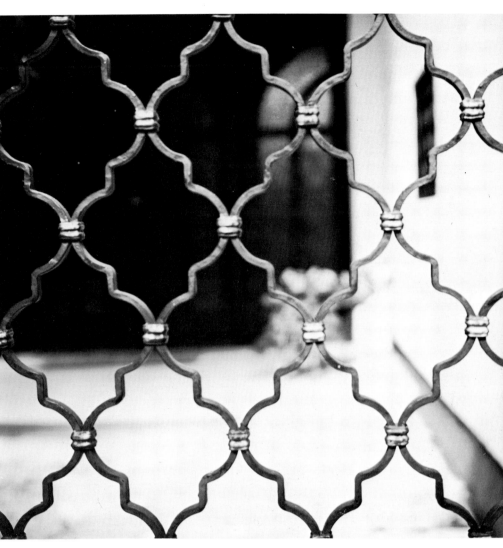

375, 376. Garden gate with broken diamonds, black with gilded bands, Pullach near Munich, circa 1960.

Bibliography

17th- and 18th-century works

Breslau, J., Livre de Serrurerie, Paris, no date, late 18th century.

Brisville, Hughes, Pattern Book, Paris, 1663, reissued London, 1888.

Cuvilliés, François, Nouvellement Inventé par François Cuvilliés, conseiller et Architecte de sa Majesté 1742-1745, livre de serrurerie.

Daviler, Cours d'architecture, Paris chez Nicolas Langlois, 1691, German edition, Amsterdam 1699.

Duhamel du Monceau, L'Art du Serrurier, 1767, German edition "Die Schlosserkunst" by Daniel Gottfried Schreber, Leipzig and Königsberg, 1769.

Fontaine, J. V., Schlosserbuch, Reifes, üppiges Rokoko.

Forty, François, Führender Meister unter den Ornamentstechern des Louis XVI.

Habermann, Franz Xaver, "Schlosser Riss", "Dessins de serrureries", Augsburg, Georg Hertel.

Hasté, Michel, six pages of patterns with gratings, Paris.

Huquier, Gabriel (1695-1772), most significant Rococo metalwork book: "Nouveau Livre de Serrurerie"

"Premier Livre de nouveaux Caprices d'ornaments"

Jousse, Mathurin, Le fedèle ouverture de l'art de Serrurier, La Fleche on the Loire, 1627.

Mariette, Jean, Architecture française, 1745.

Lalonde, Différentes Grilles pour les Châteaux et les Chapelles de Communion, Paris, 1789.

Lamour, Jean, Recueil des ouvrages en Serrurier, 1767.

Lepautre, Jean, Livre de serrurerie, ca. 1660.

Lorito, Différents portraits pour les Serruriers nouvellement inventé par moy Aubert Loriot, 1658.

Moreau, Collection of designs for balconies and railings, 1762.

Rummel, Johann Georg, Schlosserbuch, Augsburg, J. Georg Hertel.

Pierretz le Jeune, Livre de serrurerie, ca. 1600.

Schmittner, Frantz Leopold, Neu inventirtes Schlosser Reiss-Buch, gezeichnet von Frantz Leopold Schmittner, Schlossergesell, geb. 1761, Laub- und Bandelwerk, perspektivisches Gitter.

Tijou, Jean, Neues Vorlagewerk, entworfen und gezeichnet von Jean Tijou mit mancherlei Arten von Eisenarbeiten, London, 1693, cited by Brüning, p. 76.

Viollet-le-Duc, Dictionnaire Raisonne de l'Architecture Française du XIe au XVIe Siècle, Paris, 1863.

Weigel, Johann Christoph, Neues Bändel-Werck, Büchlein vor Schlosser aufgezeichnet, Nuremberg, 1710-1725.

Newer Literature

Artaria, Paul, Kunstschmiedearbeiten, Basel, 1950.

Batacchi, Franco, Schmiedeeisen für Haus und Garten, Stuttgart, 1973.

Baur-Heinhold, Margarete, Geschmiedetes Eisen vom Mittelalter bis um 1900, Königstein im Taunus, 1971.

Beck, Ludwig, Die Geschichte des Eisens, 5 vol, Braunschweig, 1884-1903.

Bergau, R., Der Schöne Brunnen zu Nürnberg, Berlin, 1871.

Bloss, Lothar, Alte Schmiedekunst, Düsseldorf, 1962.

Braun-Feldweg, Wilhelm, Metall, Werkformen und Arbeitswesen, Ravensburg, 1950.

————, Schmiedeeisen und Leichtmetall am Bau, Ravensburg, 1955.

Brüning, Adolf, & Alfred Rhode, Die Schmiedekunst bis zum Ausgang des 18. Jh., 2nd ed., Leipzig, 1922. Includess references to older literature.

Clouzot, H., Le Fer Forgé, Paris, 1932.

Coutel, F., Documents de ferronnerie ancienne de la seconde moitié du 18e siècle, Paris, 1909-1912.

Ehemann, F., Kunstschmiedearbeiten im Stile des Barock und Rokoko, Berlin, no date.

Ffoulkes, Charles, Decorative Ironwork from the XIth to the XVIIIth Century, London, 1913.

Gloag, John E. & Derek L. Bridgewater, A History of Cast Iron in Architecture, London, 1948.

Heintschel, H. & Helmuth Huemer, Schmiedeeisen, Innsbruck, 1973.

Hoffmann, Gretl & Jürgen Maurach, Schmiede- und Schlosserarbeiten von heute. 300 Beispiele von Gartentoren und Einfahrten, von Trenn- und Fenstergittern, von Treppen und Brüstungsgeländern, Leuchtern und Kerzen, Stuttgart, no date.

Höver, Otto, Das Eisenwerk, Die Kunstformen des Schmiedeeisens bis zum Ausgang des 18. Jh., Tübingen, 1953.

Ironwork, Encyclopedia Britannica, 1970, Vol. 12, pp. 630ff.

Jessen, Peter, Meister des Ornamentstiches. Eine Auswahl aus vier Jahrhunderten, no date.

Vol. 1: Gotik und Renaissance im Ornamentstich.

Vol. 2: Das Barock im Ornamentstich.

Vol. 3: Das Rokoko im Ornamentstich.

Vol. 4: Der Klassizismus im Ornamentstich.

Ilg & Kábdebo, Wiener Schmiedewerk des 17. und 18. Jh., Dresden, 1883.

Katalog Kunstschmiedearbeit heute, Internationale Ausstellung in Lindau/Bodensee, 1974.

Catalog of the Victoria & Albert Museum, London, English Wrought Iron Work, no date.

Kühn, Fritz, Stahlgestaltung, Entwurfslehre des Kunstschmiedens, Tübingen, 1956.

————, Stahl- und Metallarbeiten, Tübingen, 1959.

————, Geschmiedetes Gerät, Tübingen, 1957.

————, Geschmiedetes Eisen, Tübingen, 1962.

Lessing, Julius, Gitter aus Schmiedeeisen, 16-18. Jh., Berlin, 1889.

————, Oberlichtgitter aus Schmiedeeisen und Verwandtes, 16-18. Jh., Berlin, 1889.

Liger, F., La Ferronnerie ancienne et moderne, 2 vol, Paris, 1873-75.

Metalwork, Decorative, Encyclopedia Britannica, 1970, Vol. 15, pp. 245ff.

Miguel, Amelia Callegode, El arte del hierro en Galicia, Commercial Atheneum, Barcelona, no date.

Mrazek, Wilhelm, Schmiedekunst in Österreich, Sammlung des Österreichischen Museums für Angewandte Kunst, Hollabrunn, 1974.

Nabl, Franz, Schmiedeeisen, Langewiesche-Bücherei, Königstein im Taunus, no date.

Phleps, Hermann, Schmiedekunst, Pantheon Kunstbücher, Leipzig, 1949.

Ringler, Josef & Ingeborg Limmer, Das Maximiliansgrab in Innsbruck, Langewiesche-Bücherei, Königstein im Taunus, no date.

Roth, Erwin, Neue Schmiedeformen, Munich, 1962.

Schmirler, Otto, Der Kunstschmied, Tübingen, 1976.

Schramm, Julius, Über das Kunstschmiedehandwerk, Berlin, 1938.

Stuttmann, F., Deutsche Schmiedekunst, 5 vol, Munich, 1926-1930.

Scheel, Hans, Schmiede- und Schlosserarbeiten, Gestaltete Arbeiten aus Stahl, Sondermessing und Leichtmetall, Stuttgart, 1959.

————, Die Schmiedearbeiten, Stuttgart, 1937.

Schindler, Ernst, Colemans Entwurfsmappen für das metallverarbeitende Handwerk, Lübeck, no date.

Smetana, Günther, Entwürfe für gestaltete Schlosserarbeiten, Stuttgart, 1964.

Photo Credits

Aufsberg, Lala, Sonthofen: 248, 254

Baier, Otto & Manfred, Munich: 349, 350, 374, 377

Baur, Helmuth, Munich: 179, 237, 238, 264-266, 311, 313, 314, 352-354

Baur-Heinhold, Margarete, Munich: 11, 27, 49, 50, 64, 66-70, 74, 75, 77, 80, 93-96, 102-104, 114, 115, 118, 121-125, 130, 132, 139, 144-148, 151, 160, 161, 163, 164, 169, 171, 173, 175, 180- 182, 184, 185, 187, 188, 191, 193-197, 200-205, 213, 214, 217- 220, 229, 234-236, 241-245, 267, 269, 270, 276-279, 283, 284, 287, 288, 291, 293-298, 322, 323, 330, 331, 338, 347, 348, 351, 355-373, 375, 376

Bavarian National Museum, Munich: 335

Beringer & Pampaluchi Verlag, Zürich: 253

Bildarchiv Foto Marburg: 48, 105, 108, 141, 156, 183, 192, 255, 272, 282, 318, 329, 333, 334, 343, 344.

Bistritzki, Otto, Munich: 199

Documentation photographique de la Réunion des musées nationaux, Paris: 60

Federal Monument Office, Vienna: 321

Foto-Limmer, Bamberg: 55, 56, 150, 168, 170, 172, 174, 250, 251, 285, 286, 308-310, 312, 315, 337, 339

Gerling, Wilhelm, Verlag, Darmstadt: 342

German Museum, Munich: 4

Giraudon, Paris: 29, 31, 215, 216, 232

Hirmer Fotoarchiv, Munich: 113

Holder, Robert, Urach: 81, 109, 133, 149, 152, 208-211, 222, 226, 246, 249, 260, 289

Klitschka-Strempel, Inge, Klosterneuburg: 239

Kunstschmiedearbeit heute (Catalog of an exhibition in Lindau, p. 118): 43

Lichtbildwerkstätte Alpenland, Vienna: 140, 207

MAS, Barcelona: 47, 79, 162, 165, 261, 262, 301-303, 305, 307

Museum of Modern Art, New York: 167

Neumeister KG, ex-Weinmüller Auktionshaus, Munich: 221, 225

Peter, Christine, Heidelberg: 281

Photo Archives, Austrian National Library, Vienna: 299, 300, 346

Pfistermeister, Ursula, Fürnried: 65, 120, 129, 159, 178, 186, 252, 263, 280, 292, 317, 320

Rast, Benedikt, Fribourg: 212, 327

Rodriguez, Toledo: 304

Schmidt-Glassner, Helga, Stuttgart: 76, 78, 85, 100, 101, 106, 107, 111, 112, 135, 137, 138, 142, 154, 155, 157, 158, 189, 190, 198, 206, 228, 230, 231, 233, 240, 247, 259, 271, 273-275, 316, 319, 324-326, 328, 332, 336, 340, 341

State Graphic Collection, Munich: 21, 35

State Photo Agency of Northern Bavaria, Bayreuth: 97-99

Steiner, Hans, St. Moritz: 90-92, 126, 134

Steinmetz, Hildegard, Munich: 166

Stockhammer, A., Solbad Hall: 82-84

Stoja Verlag, Paul Janke, Nuremberg: 345

Tyrolean Folk Museum, Innsbruck: 177 (photo by Otto Vogth)

Ulmer, Roland, Stuttgart: 44

Verlag V. Altenwiesel, Mondsee: 258

Victoria & Albert Museum, London: p. 2, #37-42, 45, 46, 51, 53, 54, 57, 61-63, 71, 86-89, 153, 176, 223, 224, 227, 268, 306

Wegner, Josef, Freilassing: 110

Zeller, Willy, Zürich: 72, 116, 117, 119, 127, 128, 131, 136, 256, 290

Index